"Wonderful images of our universe by photographers from all over the planet."

MAREK KUKULA

 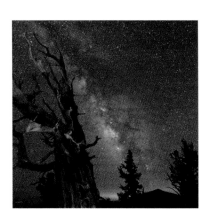 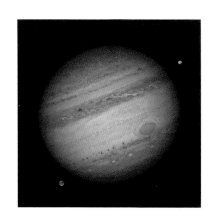 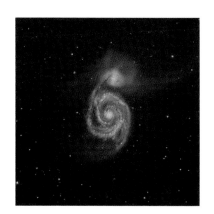

ASTRONOMY ✦ PHOTOGRAPHER
OF THE YEAR

ASTRONOMY PHOTOGRAPHER OF THE YEAR

Published by Collins
An imprint of HarperCollins Publishers
Westerhill Road
Bishopbriggs
Glasgow G64 2QT
www.collinsmaps.com

In association with the
National Maritime Museum
Greenwich
London SE10 9NF
www.rmg.co.uk

First edition 2012 © HarperCollins Publishers
Text © National Maritime Museum 2012
Background text written by Olivia Johnson and Marek Kukula
Sir Patrick Moore photograph page 11 © Chris Jackson/Getty Images
Photographs © individual photographers see pages 221–224
Guide to astrophotography © *Sky at Night Magazine* 2012
FLICKR logo reproduced with permission of Yahoo! Inc. © 2012 Yahoo! Inc.
FLICKR and the Flickr logo are registered trademarks of Yahoo! Inc.

ISBN 978-0-00-748280-1

The contents of this publication are believed correct at the time of printing.
Nevertheless the publisher can accept no responsibility for errors or omissions,
changes in the detail given or for any expense or loss thereby caused.

Printed in China

British Library Cataloguing in Publication Data
A catalogue record for this book is available from the British Library

ASTRONOMY ✦ PHOTOGRAPHER
OF THE YEAR

ROYAL
OBSERVATORY
GREENWICH

CONTENTS

FOREWORD
Sir Patrick Moore CBE

Publication of the *Astronomy Photographer of the Year* has been a much awaited event. This first edition highlights the quite remarkable standards reached by the entrants. Remember, photographs shown here, many of them taken by amateurs, surpass anything that the world's telescopes could have taken 40 to 50 years ago. There are several different sections in the book. Earth and Space makes up the first, then follows the Solar System, and of course there is great scope here. We then turn to Deep Space and a very interesting section for the Best Newcomer. Next is People and Space, then the pictures from the Robotic Scope, followed finally by Young Astronomy Photographer of the Year. Each image is accompanied by a full caption.

This book will prove to be an inspiration for astronomers of all kinds, from the newcomer to the highly trained professional. Contributions have come in from astronomical photographers all over the world so the book really is international.

There is also a very useful guide to taking astronomical pictures, which will give novice photographers invaluable advice, so that they too might be able to enter the competition in future years.

The book is published by Collins in association with the Royal Observatory, Greenwich, which is home to the Prime Meridian of the world, making it the official starting point for each new day and year. Browse though these photographs and then study them really closely. It is probably true to say that there is no annual book quite like this one.

The aspiring astronomical photographer will find everything he needs here to make a useful start. One's first efforts are bound to be relatively poor but practice, as always, makes perfect! You will already be taking acceptable pictures after a few months, although you will soon realise there is always so much more to learn.

Patrick Moore

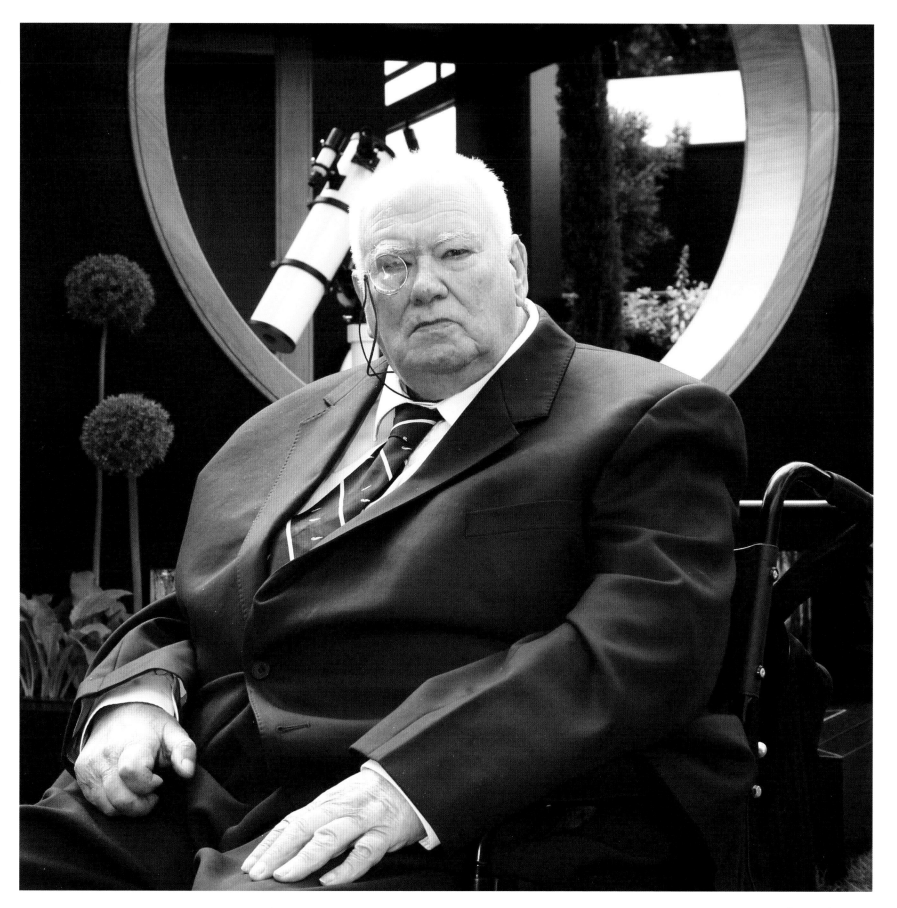

INTRODUCTION TO COMPETITION

ASTRONOMY PHOTOGRAPHER OF THE YEAR

2012 is the fourth year of the Royal Observatory, Greenwich's competition to uncover the best photographs of the planets, stars, galaxies and other objects which make up our universe. With the help of *Sky at Night Magazine*, and the photo-sharing website Flickr, the competition invites amateur astrophotographers from around the world to submit photographs in the categories of 'Earth and Space', 'Our Solar System', 'Deep Space' and 'Young Astronomy Photographer of the Year'.

In each category the competition's judges select a winner, a runner-up and three highly-commended entries, and the four winning images then go forward to compete for the title of Astronomy Photographer of the Year.

Over the four years of the competition, the Royal Observatory has responded to the changing trends in entries and the huge range of experience of the photographers who take part. Three new special prizes have been created – 'Best Newcomer', 'People and Space', and 'Robotic Scope'.

This book brings together all of the winning images from the first four years of Astronomy Photographer of the Year. For 2012, to showcase the astonishing range of entries, we also present all the shortlisted entries alongside this year's winners.

COMPETITION CATEGORIES

EARTH AND SPACE
Photos that include landscapes, people and other 'Earthly' things alongside an astronomical subject.

Planet Earth is a special place; even powerful instruments like the Hubble Space Telescope have yet to find another planet with a landscape and environment as varied and beautiful as our own world. Photographs submitted in this category showcase the Earth's amazing variety against the backdrop of the heavens, reflecting our planet's relationship with the wider universe around us.

OUR SOLAR SYSTEM
Photos of the Sun and its family of planets, moons, asteroids and comets.

We can see the Moon, the Sun and our local planets on a daily basis, even with the naked eye. But the photographs in this category present our cosmic neighbours in a new light, using equipment which reveals incredible levels of detail and imaginative compositions that highlight their unique beauty.

DEEP SPACE
Photos of anything beyond the Solar System, including stars, nebulae and galaxies.

Deep space images give us a window into some of the most distant and exotic objects in the Universe; from the dark dust clouds where new stars are born to the glowing embers of supernova remnants, and far beyond, to distant galaxies whose light set out towards us millions of years ago. These pictures take us to the depths of space and the furthest reaches of our imaginations.

YOUNG ASTRONOMY PHOTOGRAPHER OF THE YEAR
Photos by people under 16 years of age.

The mission of the Royal Observatory, Greenwich is to explain the wonder and excitement of astronomy and space-science to the public. Inspiring young people and encouraging them to study science is an important part of this mission. The Young Astronomy Photographer category is a way to showcase the amazing skill and imagination of younger photographers, and to nurture their curiosity about the Universe.

SPECIAL PRIZES

PEOPLE AND SPACE
Photos that include people in a creative and original way.

At some time or another we have all experienced that moment when you look up at the vastness of the night sky and suddenly realise that you are a very small part of the Universe. This category juxtaposes human and cosmic scales, with effects ranging from the profound to the humorous. Since we are all made of stardust, people are astronomical objects too!

BEST NEWCOMER
Photos taken by people who have taken up astrophotography in the last year and have not entered the competition before.

If the incredible skill and experience displayed by some of the winners of Astronomy Photographer of the Year can sometimes seem a bit intimidating, this special prize is a reminder that everyone was a beginner once upon a time. Indeed, imagination and an eye for the perfect shot can be just as important, and not every winning image was taken by an old hand. This prize celebrates the new entrants who are embarking on an exciting and creative future in astrophotography.

ROBOTIC SCOPE
Photos taken remotely using a robotic telescope and processed by the entrant.

Combining modern telescope technology with the power of the internet, robotic telescopes offer a new way for astronomy enthusiasts to experience the sky. Members of the public can sign up for time on state of the art equipment in some of the best observing sites in the world, controlling the telescope remotely and downloading their images via the web. Robotic scopes give amateur astronomers access to equipment that previously only professional research observatories could afford.

THE JUDGES
The judging panel is made up of individuals from the world of astronomy, photography and science:

Chris Bramley
Editor of *Sky at Night Magazine*, launched in 2005

Will Gater
Features Editor of *Sky at Night Magazine*, science writer and author

Melanie Grant
Picture Editor of *Intelligent Life* magazine at *The Economist*

Rebekah Higgitt
Curator of the History of Science and Technology at the Royal Observatory, Greenwich

Dan Holdsworth
Photographic artist

Olivia Johnson
Astronomy Programmes Manager at the Royal Observatory, Greenwich

Marek Kukula
Public Astronomer at the Royal Observatory, Greenwich

Pete Lawrence
Astronomer, presenter of *The Sky at Night*, writer for *Sky at Night Magazine* and world-class astrophotographer

Chris Lintott
Co-presenter of the BBC television programme *The Sky at Night* and an astronomy researcher at the University of Oxford

Sir Patrick Moore
Author, presenter of *The Sky at Night* on BBC television for over fifty years and a noted lunar observer

Graham Southorn (2009–2011)
Former Editor of *Sky at Night Magazine*

Royal Museums Greenwich would also like to thank Darren Baskill, Rob Edwards, Dan Matthews and Natasha Waterson, without whom Astronomy Photographer of the Year would not have been possible.

FEELING INSPIRED?

You really do not need to have years of experience or expensive equipment to take a brilliant astrophoto so why not have a go and enter your images into the Astronomy Photographer of the Year competition? There are great prizes to be won and you could see your photo on display at the Royal Observatory, Greenwich, part of Royal Museums Greenwich. Visit us online for more information about the competition and accompanying exhibition at rmg.co.uk/astrophoto.

JOIN THE ASTROPHOTO GROUP ON FLICKR
Astronomy Photographer of the Year is powered by the photo-sharing community Flickr. Visit the Astronomy Photographer of the Year Flickr group to see hundreds of amazing astrophotos, share astro-imaging tips with other enthusiasts and share your own photos of the night sky. Visit flickr.com/groups/astrophoto

Astronomical photography at the Royal Observatory, Greenwich
Each year the winning images from Astronomy Photographer of the Year go on display in a free exhibition at the Royal Observatory's Astronomy Centre. This elegant building was constructed in the 1890s as the 'New Physical Observatory', providing facilities for the Greenwich astronomers to develop new tools and observing techniques, including astrophotography.

Photography had become an increasingly important part of astronomy from the 1870s, with the arrival of technologies that allowed faster exposures, improved resolution and smoother tracking. A department devoted to photography and spectroscopy was founded at the Royal Observatory in 1873.

At Greenwich, photography was used to record sunspots, study solar eclipses and measure the distance and motion of stars. The Observatory was also a partner in an international project to produce a photographic map of the sky, the *Carte du Ciel*, and the New Physical Observatory housed telescopes, cameras and photographic laboratories. More than a century later the building is a fitting home for the Astronomy Photographer of the Year exhibition.

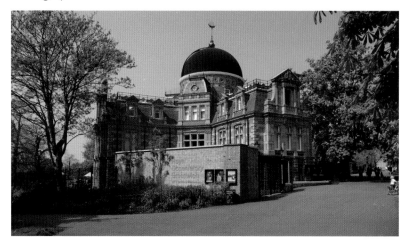

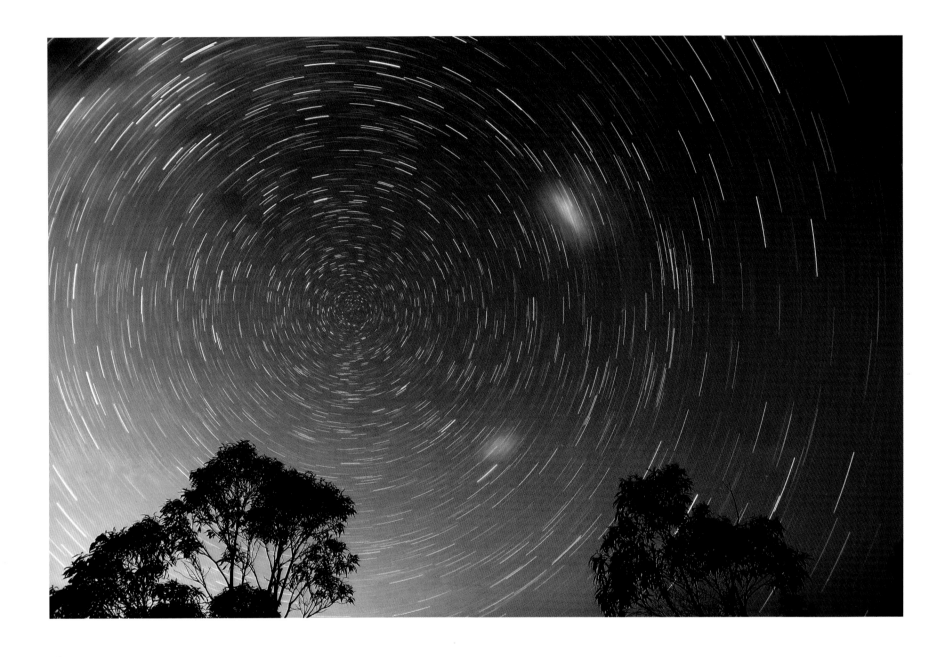

TED DOBOSZ (*Australia*)

Star Trails, Blue Mountains
[*28 March 2009*]

TED DOBOSZ: I recall clearly the night I grabbed an old film camera and placed it on a tripod and, using a cable release, I was able to keep the shutter open for a few minutes. Imagine my delight and surprise when a myriad of star streaks appeared in my pictures! Today that delight is still there whenever I again decide to try my hand at the most basic form of astrophotography, simple star trails from a long exposure. Anyone with a camera can do it: try it and enjoy the beauty of the night sky!

BACKGROUND: As the Earth spins during the 30-minute exposure of this photograph the stars make trails around the sky's South Pole. The orange glow at the bottom of the photograph is caused by light pollution from streetlights and other artificial illumination. A similar picture taken in the northern hemisphere would show Polaris (the Pole Star) apparently unmoving at the centre of the star trails. In the southern hemisphere there is no equivalent to the Pole Star but instead the Large and Small Magellanic Clouds, two companion galaxies to the Milky Way, are visible.

Canon 40D DSLR camera; Tamron 17mm lens at f/3.5; 30-minute exposure

"It is the ghostly images of the Milky Way's two companion galaxies that make this image something very special. The trees give a sense of being rooted on Earth as the heavens turn above you."
CHRIS LINTOTT

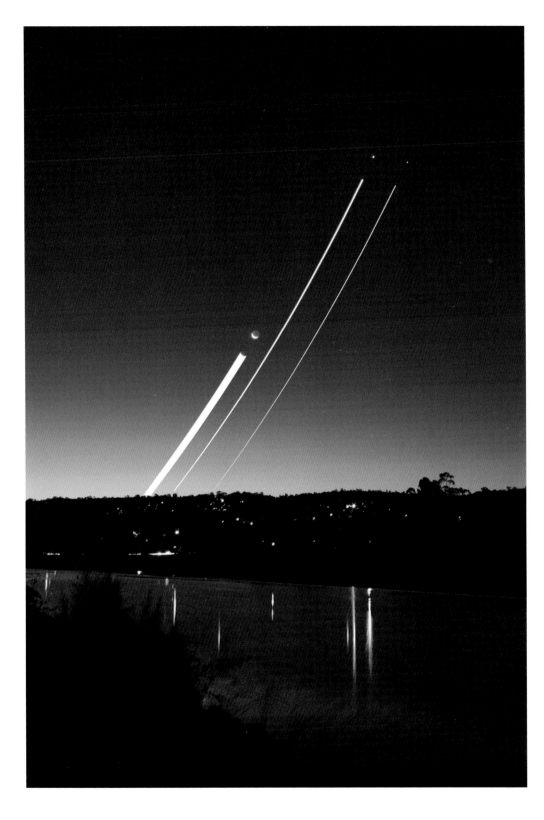

VINCENT MIU *(Australia)* *RUNNER-UP*

Venus, Jupiter and Moon Trails over the Nepean River
[*30 November 2008*]

VINCENT MIU: The concept of long exposures was inspired by a similar image I saw in a book many years ago. I was desperately scouting for a location with an unobstructed view towards the west. Finally, I settled for this spot along the river bank before it got too dark. I was setting up my tripod while others were packing up their fishing gear.

BACKGROUND: This orientation of the Moon (left), Venus (centre) and Jupiter (right) is rarely photographed. Taken with an exposure of two hours, the photograph shows the trail of the three bodies in the sky at sunset. Venus and Jupiter are five of the planets which are visible at various times with the naked eye from Earth, the others being Mercury, Mars and Saturn.

Canon 400D DSLR camera; EF–S17 85mm IS USM lens; ISO 400; exposure range from 6 seconds to 2 hours

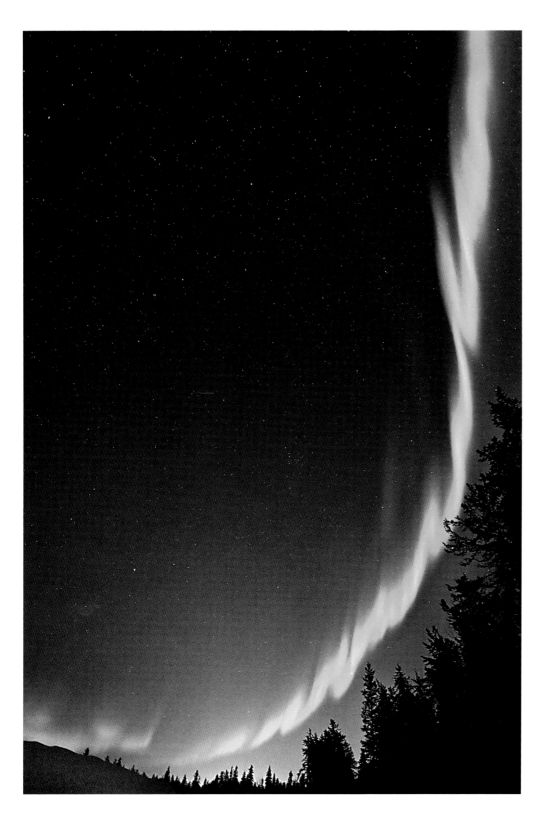

<
KARL JOHNSTON (*Canada*) HIGHLY COMMENDED

Bow of Orion
[*13 February 2009*]

KARL JOHNSTON: I always loved viewing the majestic *aurora borealis*, and I would always wonder why it would only be me out there watching them on the cold nights growing up in Fort Smith, NWT, Canada. Every night I would go for miles and miles to escape the light pollution, into the sub-arctic wilderness, trudging through three-and-a-half-foot snow and -40 °C weather or below to eventually stop, look up, and attempt to orchestrate the dance of the *aurora borealis* through my camera.

BACKGROUND: The aurorae or Northern and Southern Lights are caused by the interaction between the Earth's atmosphere and a stream of particles from the Sun known as the solar wind. The Earth's magnetic field funnels these particles down over the planet's poles, giving rise to 'glowing curtains' of coloured light which are best seen in the night sky.

Canon 50D DSLR camera; Tokina 11–16mm lens; ISO 800; 20-second exposure

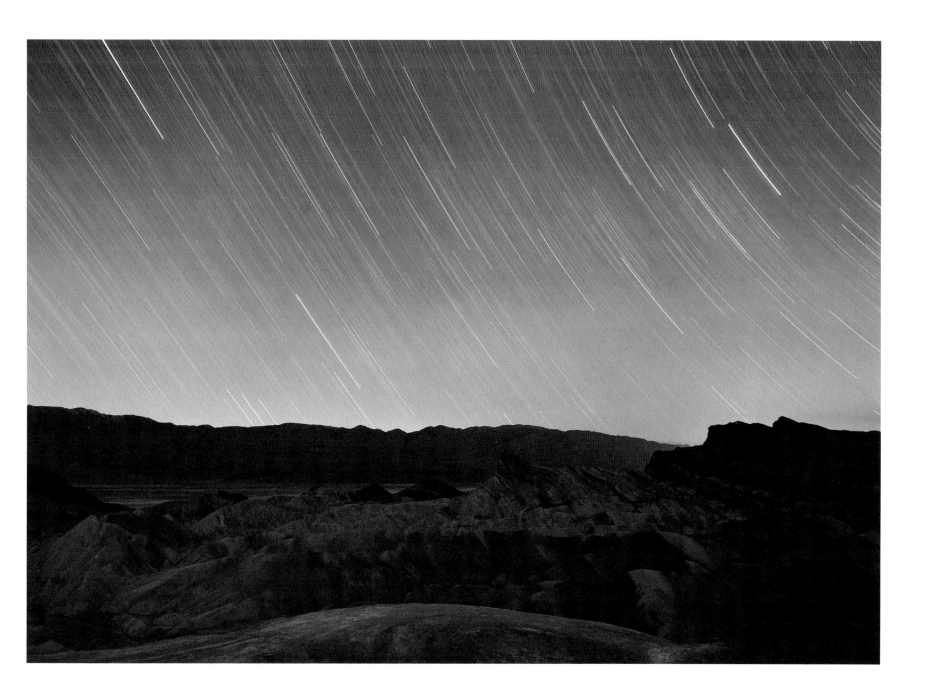

NIKHIL SHAHI *(USA)*

Death Valley Star Trails
[27 December 2008]

NIKHIL SHAHI: While camping in Joshua Tree a few months ago, I saw how bright the stars appeared in a place far away from civilization. Since I first visited Death Valley, I wanted to capture the stark beauty of Zabriskie Point at night. This shot was taken around 3 a.m. on a cold winter morning facilitated by endless cups of hot coffee!

BACKGROUND: Although this photograph appears to show a dramatic shower of meteors in the night sky, it is actually a 40-minute exposure of the trails made by the stars as the Earth rotates. The three parallel lines near to the horizon on the left of the photograph are the trails of the stars that make up Orion's Belt.

Nikon D700 DSLR camera; Nikon 24–70mm lens at 24mm; ISO 200; 40-minute exposure

NIK SZYMANEK (UK) *HIGHLY COMMENDED*

Milky Way
[24 March 2009]

NIK SZYMANEK: The night sky is full of mystery and romance and it's brought to life by long-exposure astrophotography. This picture was planned very carefully. The planning certainly paid off, as the picture came out exactly as intended and captures the evocative view of our home galaxy seen from the inside!

BACKGROUND: The Milky Way Galaxy is a collection of over 200 billion stars, together with clouds of dust and gas. It is a flat disc-like structure more than 100,000 light years across. Our own Sun is just one of the billions of stars situated within this disc; so when we look out into space we see the Milky Way as a band of bright stars and dark dust encircling the sky. This photograph was taken from La Palma in the Canary Islands; the Roque de los Muchachos Observatory can be seen on the right.

Canon 20D DSLR camera; Canon 28mm lens; eight 3-minute sub-exposures combined into a mosaic

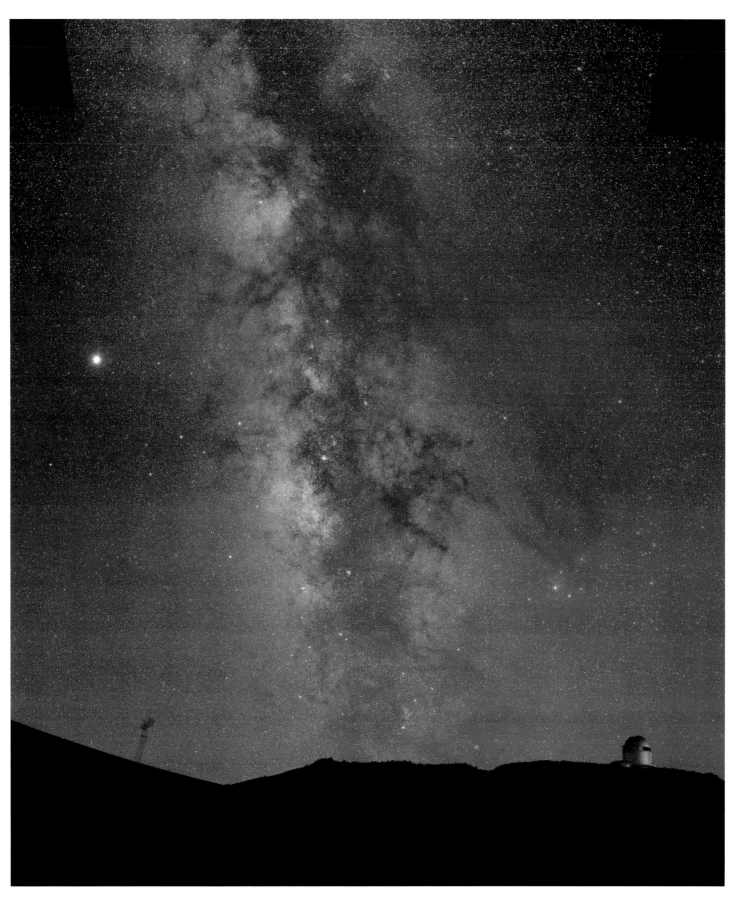

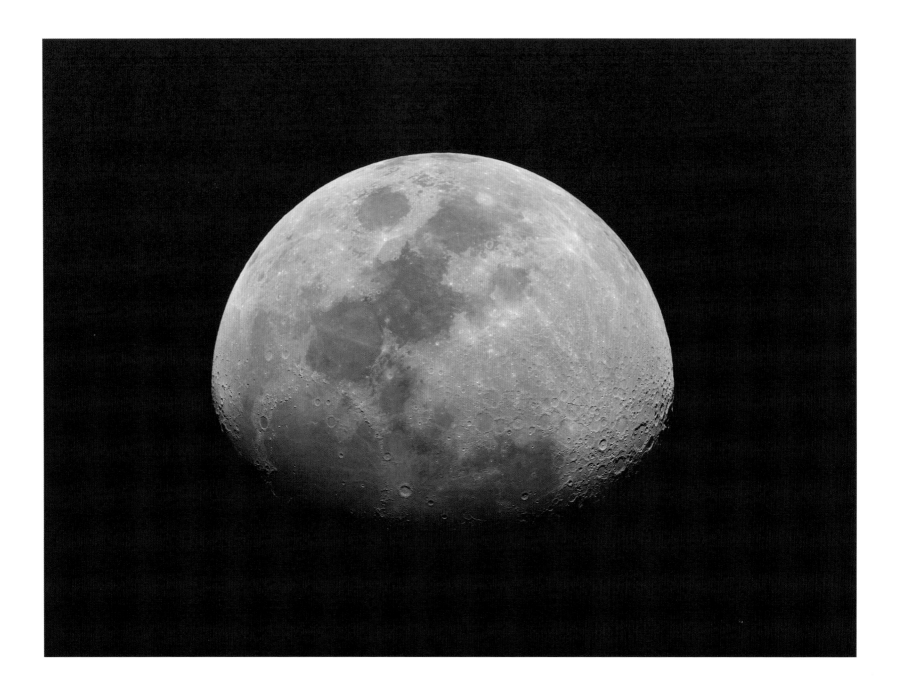

MICHAEL O'CONNELL (Ireland)

WINNER

Blue Sky Moon
[15 April 2008]

MICHAEL O'CONNELL: I have been interested in astronomy since growing up as a child on our small farm in the west of Ireland. I distinctly remember seeing Venus high in the winter sky and my fascination at this brilliant white diamond set against a jet black sky is an experience I will never forget! This image reminds me of mankind's voyage to the Moon four decades ago. Those astronauts devoted their lives to the interests of expanding the scientific knowledge and limits of humanity.

BACKGROUND: The dark areas that can be seen clearly on the Moon's surface in this photograph are vast plains of solidified lava. These are known as lunar seas (*maria*) because they were once believed to be filled with water. Unusually, the Moon is shown here during the day, through the Earth's dark blue sky, giving it the appearance of rising mysteriously from shadow.

Canon 400D DSLR camera; TEC140 refractor

"It is a simple idea yet beautifully executed and processed. It is a great image to have as a reminder of the Apollo landings."

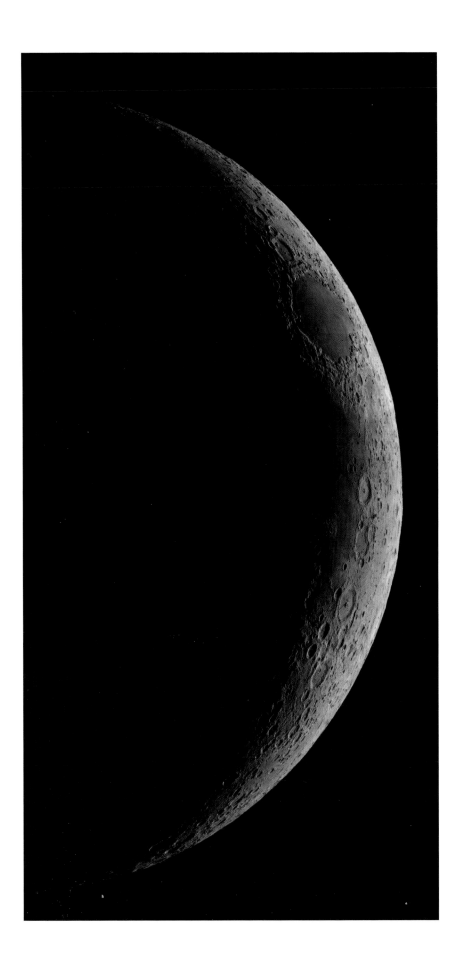

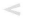

NICK SMITH *(UK)*

RUNNER-UP

3.1 Day-old Moon
[28 April 2009]

NICK SMITH: I have been interested in astronomy since about the age of eight or nine. My interest in astrophotography was fuelled by the 'webcam revolution'. The use of these cheap devices along with modern digital image processing has enabled amateurs to produce amazing results from relatively modest equipment. This shot was taken against a darkening sky, while the Moon was at a relatively low altitude. I was very lucky that the conditions remained good enough to complete the shot and I am very happy with the result.

BACKGROUND: One half of the Moon is always illuminated by the Sun. However, the Moon's appearance in the sky changes depending on its position in orbit around the Earth and the Earth's position in orbit around the Sun. This photograph shows the Moon three days after a 'New Moon', when it is almost on the same side of the Earth as the Sun and only a small portion of the illuminated half can be seen. The oblique angle of the sunlight on this part of the Moon casts long shadows and throws the surface features into sharp relief.

Lumenera Infinity 2-1M CCD camera; Celestron C14 14-inch Schmidt-Cassegrain with red filter

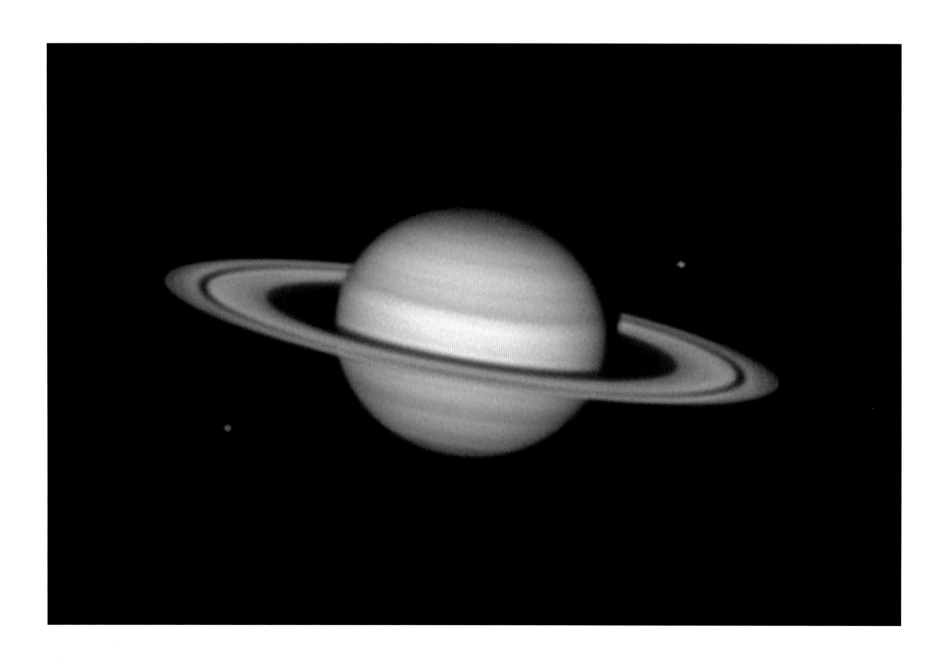

Λ

ETHAN ALLEN *(USA)* *HIGHLY COMMENDED*

Saturn
[*21 March 2008*]

ETHAN ALLEN: Astrophotography is a natural offshoot of my lifelong photography passion. Light and optics have always fascinated me. When I discovered all of the amazing things to photograph floating over my head, there was no turning back! For this photograph I was finishing up a Mars imaging session when by chance, conditions dramatically improved and Saturn was well placed in the sky for this image.

BACKGROUND: Saturn is the second largest planet in the Solar System. This image shows clearly the bands of coloured cloud that surround the planet, and its famous rings made up of ice and dust particles. Saturn also has over sixty moons or satellites and two of the largest, Tethys (bottom left) and Dione (top right), can clearly be seen here orbiting the planet. Both moons are just over 1000 km in diameter, which is about one third of the size of the Earth's Moon.

Lumenera Skynyx2-0M CCD camera; 305mm Orion Newtonian reflector with RGB filters

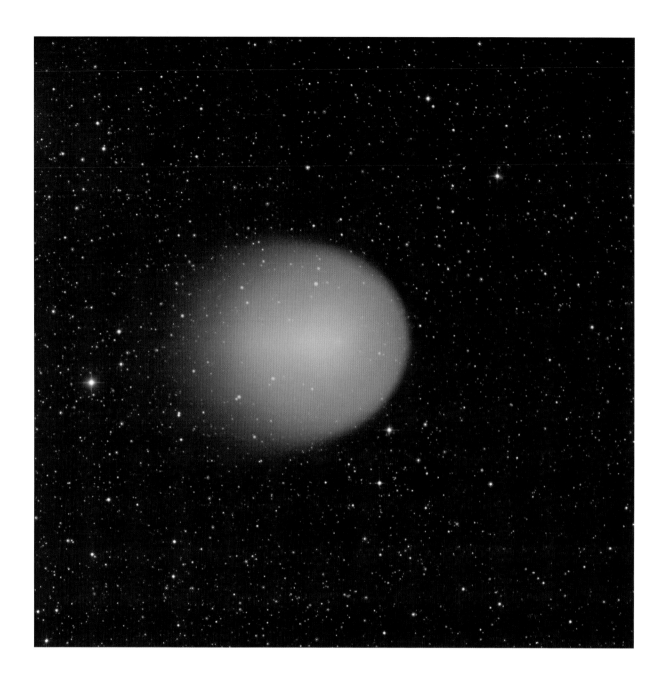

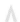

NICK HOWES *(UK)* *HIGHLY COMMENDED*

Comet Holmes
[18 February 2009]

NICK HOWES: This image was taken with friends and neighbours in the garden, watching with binoculars as the laptop was providing a close-up view via my scope and camera. A nine-year-old-boy, whose grandparents live next door, looking in awe at the sky just reminded me of how I must have looked and felt at that age; and yet, over thirty years on, I still feel the same way.

BACKGROUND: The nucleus of a comet is a 'dirty snowball' just a few kilometres across and made of ice, rock and frozen gases. As the comet's orbit approaches the Sun, solar radiation heats the nucleus, evaporating the surface ices to produce a vast halo of gas and dust which streams off to form the distinctive tail. Comet Holmes (17P/Holmes) has an orbit between Mars and Jupiter and can be seen about every seven years as a very faint object in the sky.

Atik 314L monochrome CCD camera; Orion ED80 refractor with RGB filters

NICK SMITH *(UK)*

Clavius-Moretus Mosaic
[28 April 2009]

NICK SMITH: The inspiration and motivation to take this picture stems from a long-held fascination with the Moon. It would have been nice to fill in the gaps on either side of the *Clavius-Moretus* mosaic, but unfortunately the good visibility conditions were fairly fleeting that morning, so I did not get the opportunity. This is very typical of imaging in the UK!

BACKGROUND: The Moon's many craters have been formed by the impact of meteorites, asteroids and comets, and range in size from a few centimetres to hundreds of kilometres across. With no atmosphere or weather to wear them away, the craters can remain unchanged for billions of years. This composite image, made up of two individual photographs, recalls the landscape seen by *Apollo 11* as it approached the Moon's surface over 40 years ago.

Lumenera Infinity 2-1M CCD camera; Celestron C11 11-inch Schmidt-Cassegrain, 2.5x Powermate with red filter

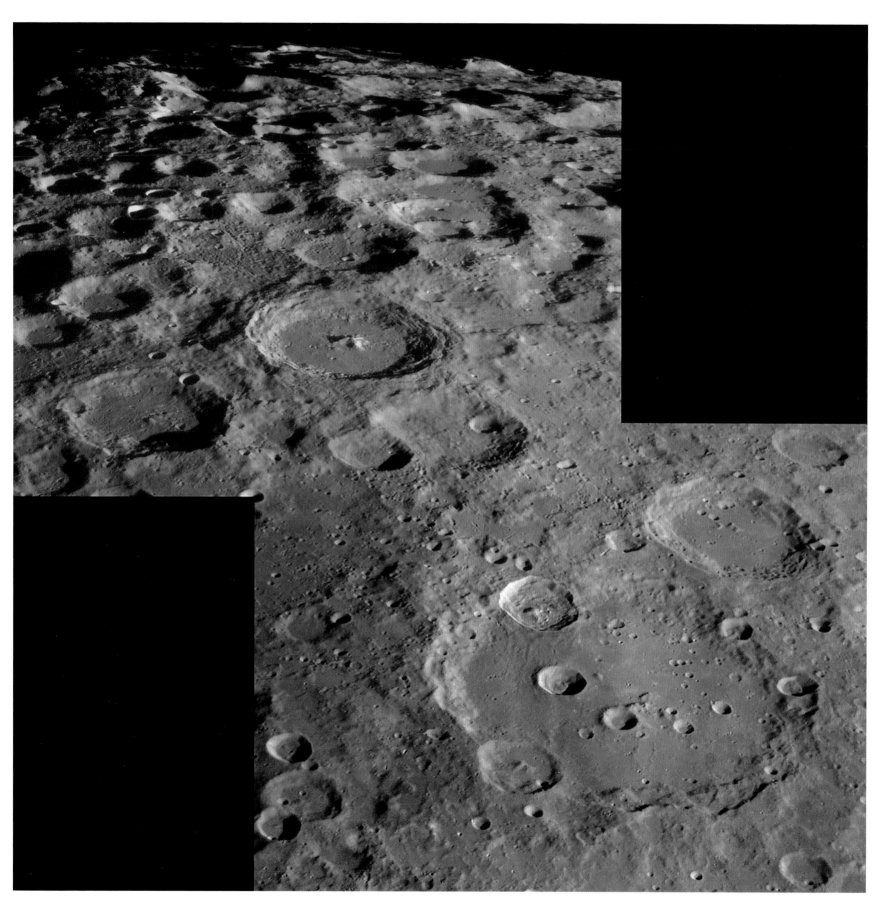

MARTIN PUGH (UK/Australia)

Horsehead Nebula (IC 434)
[*16 March 2009*]

MARTIN PUGH: An extremely popular imaging target, it was an absolute 'must do' for me. My objective was to produce a high-quality, high-resolution image, blending in Hydrogen-Alpha data to enhance the nebulosity. With this image, I really wanted to capture the delicate gas jets behind the Horsehead and kept only the very best data. If I could change anything about this photograph I would expand the frame to include the Flame Nebula and the Great Orion Nebula to create a superlative wide-field vista of this region.

My brother-in-law pulled a dusty old 3-inch refractor out of a closet in early 1999. This represented my first real look through a telescope and from then on I was completely hooked.

BACKGROUND: The Horsehead Nebula is a dark cloud of dust and gas, which from Earth appears to resemble the shape of a horse's head. The gas, dust and other materials condense to form dense knots, which will eventually become stars and planets. New stars have already formed inside part of the dust cloud, as can be seen on the bottom left. The nebula is silhouetted against a background of glowing hydrogen gas, with its characteristic reddish colour, and this exquisite image shows the delicate veils and ripples in the structure of the gas cloud. First identified in 1888, the nebula is located in the star constellation Orion and is about 1500 light years from Earth.

SBIG STL11000 CCD camera guided with adaptive optics; 12.5-inch RC Optical Systems Ritchey-Chrétien telescope; Software Bisque Paramount ME mount; 19 hours of exposures

OVERALL WINNER 2009

"The Horsehead Nebula is one of the most photographed objects in the sky, but this is one of the best images of it I've ever seen. Thirty years ago it would have taken hours of effort on a large professional telescope to make an image like this, so it really shows how far astronomy has come – a fitting way to celebrate the International Year of Astronomy in 2009".

MAREK KUKULA

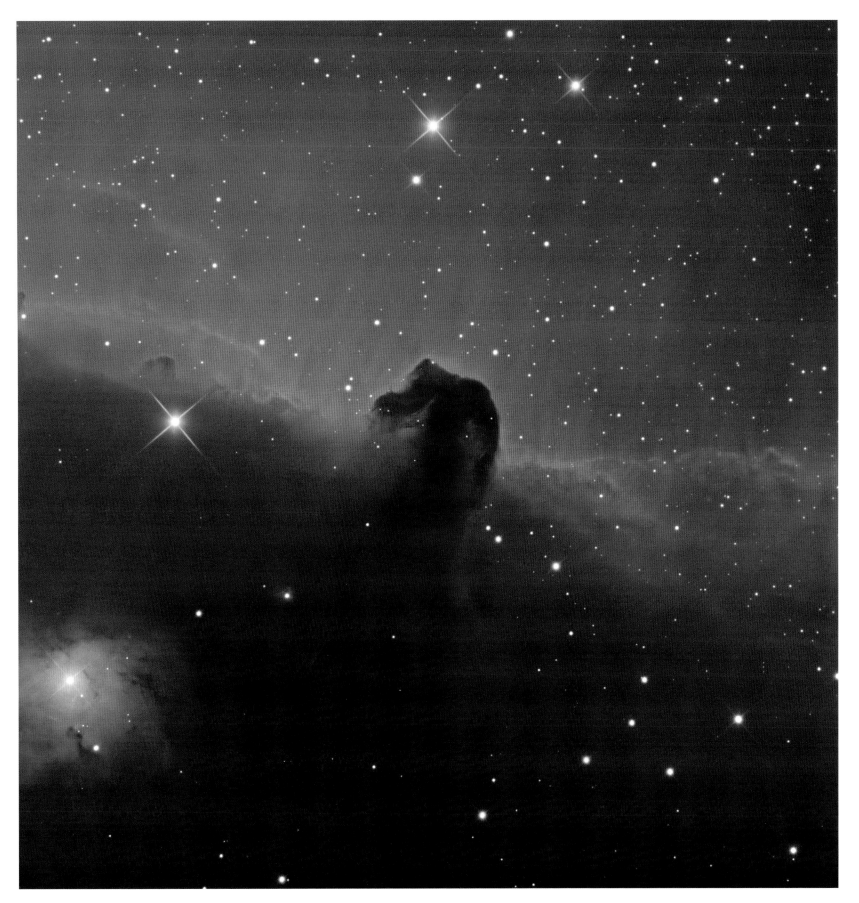

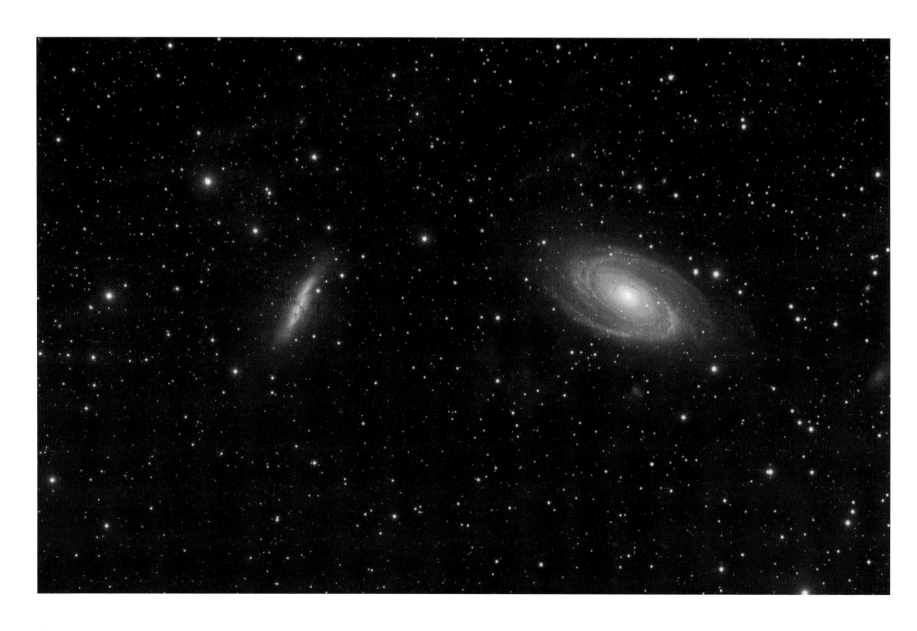

EDWARD HENRY (USA) *RUNNER-UP*

Galaxies M81 and M82
[11 *February 2009*]

EDWARD HENRY: I got interested in astronomy at an early age and was about ten when I put two lenses together and saw what they did. I quickly learned that what I would like to do is take pictures, but knew that I wouldn't enjoy the way it had to be done then with film and manual guiding. As an older adult, when I saw the technology being created with computers and CCD cameras, I got back into it heavily and built my own observatory.

BACKGROUND: This composition shows two galaxies millions of light years away, each consisting of billions of stars. The galaxy on the right is a two-armed spiral galaxy, much like our own. The pink colour, enhanced by the photographer's filter, is hydrogen. The galaxy on the left is also a spiral, but is seen edge on. A spray of hydrogen is coming from its centre, forced out by a huge burst of star formation.

SBIG ST4000 colour CCD camera and SBIG ST10 XME CCD camera; TMB 130mm refractor, 10-inch Meade telescope and a Meade RCX400 12-inch telescope; two-part mosaic, 20 hours worth of exposure each

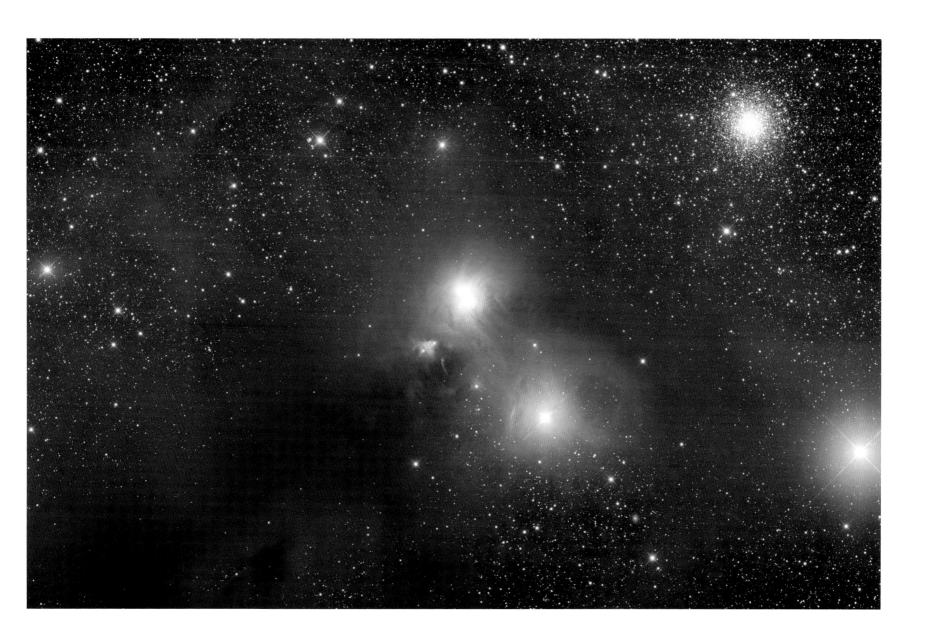

MARTIN PUGH *(UK/Australia)* *HIGHLY COMMENDED*

Galactic Dust in Corona Australis
[16 March 2009]

MARTIN PUGH: This beautiful region of Corona Australis is packed with reflection, dark and variable nebulae, globular clusters and distant galaxies. It was a great challenge to image the entire region at high resolution.

BACKGROUND: Two blue-reflection nebulae, clouds of dust scattering the light of nearby stars, dominate this photograph. They are associated with young stars, not more than a few million years old. A much older globular cluster of thousands of stars can be seen at the top right.

SBIG STL11000 CCD camera guided with adaptive optics; 12.5-inch RC Optical Systems Ritchey-Chrétien telescope; Software Bisque Paramount ME mount; 40 hours worth of exposures

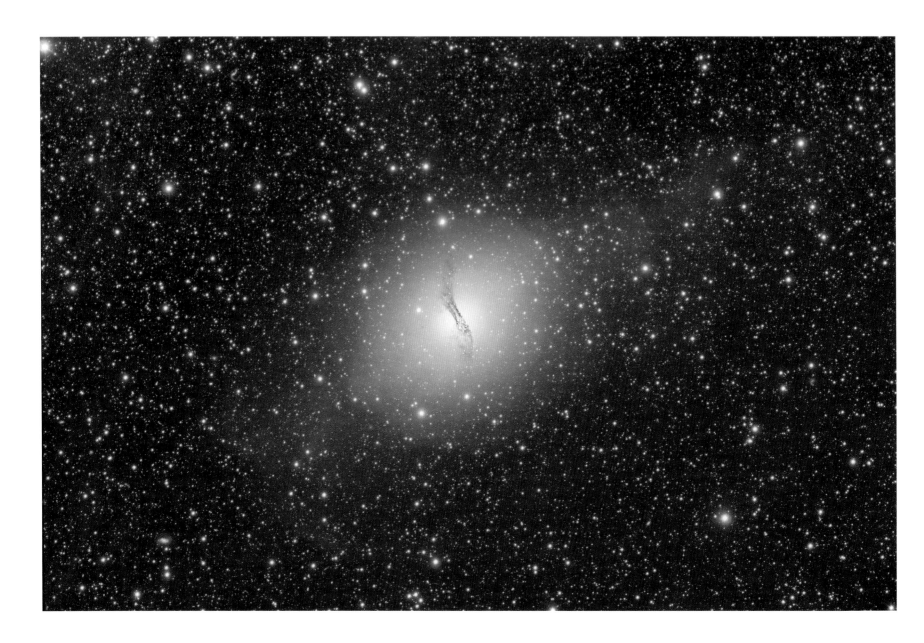

MICHAEL SIDONIO *(Australia)* *HIGHLY COMMENDED*

Centaurus A: Ultra-Deep Field
[*8 May 2009*]

MICHAEL SIDONIO: Inspired by a challenge from Dr David Malin, I pointed my telescope and camera at this wonderful galaxy for three consecutive clear nights to see what was really there! This deep image reveals an enormous galaxy covering an area of sky several times larger than the full moon and the whole field is covered in ultra faint Milky Way dust.

BACKGROUND: All the stars seen in the foreground of this image are from our own Milky Way, with the Centaurus A galaxy in the centre, millions of light years beyond. At some time in the past Centaurus A has merged with another smaller galaxy and the debris from this collision forms the rusty brown band of dust across its middle.

Finger Lakes Instrumentation ProLine 11002 CCD camera; Astro-Physics StarFire 152mm EDF refractor; 19.5 hours worth of exposures

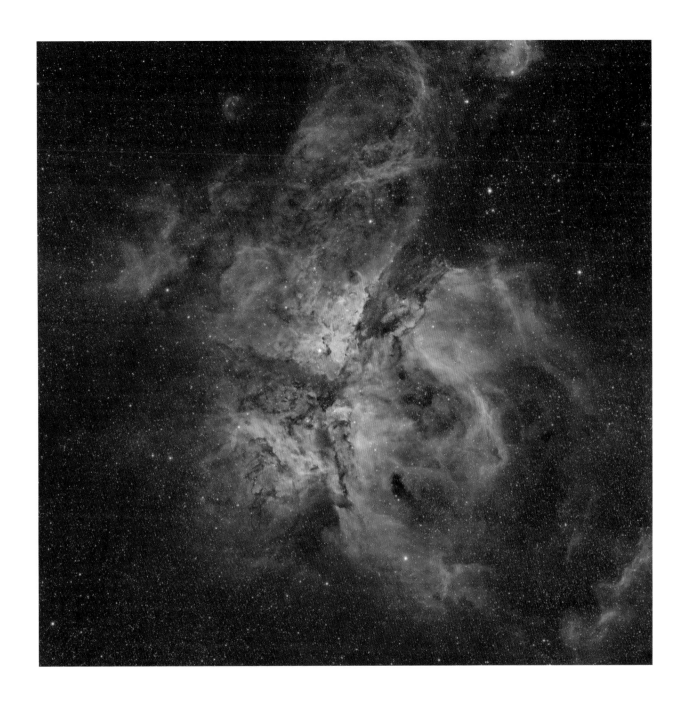

THOMAS DAVIS *(USA)* *HIGHLY COMMENDED*

Eta Carina Nebula
[*1 March 2009*]

THOMAS DAVIS: I had a telescope when I was young but whenever I looked through it I was somewhat disappointed by what I saw. None of the objects looked like the images in books. Therefore I started imaging, first on film and then CCD. Imaging allows me to see the wonders of the heavens in detail and colour. This image shows the massive star-forming region through narrowband filters, the so-called 'Hubble Palette'.

BACKGROUND: This photograph shows part of a vast nebula, or cloud of dust and gas, from which a new generation of stars is condensing. In the centre, a group of bright young stars has already ignited, burning off the surrounding gas and dust to form an enormous void in the heart of the nebula. The Eta Carina Nebula lies at an estimated distance of between 6500 and 10,000 light years away.

FLI Proline CCD camera; Astro-Physics 155mm EDF refractor; sulphur II, hydrogen alpha, and oxygen II filters; 13.5 hours worth of exposures

PAUL SMITH *(Ireland)*, AGED 14　　　　　　　　　　*WINNER*

Occultation of Venus
[1 December 2008]

PAUL SMITH: It was amazing to see Venus disappearing and then reappearing from behind the Moon! I just had to get a photo to remember it by.

BACKGROUND: An occultation occurs when one planet or moon appears to move in front of another, temporarily hiding it from view. The word comes from 'occult', which means 'hidden'. In this photograph the Moon has passed in front of Venus, only for the planet to reappear several hours later. Like the Moon, Venus goes through a set of phases as it moves around the Sun. Here Venus is almost full, while the Moon is still in a crescent phase.

Canon 400D DLSR camera; Celestron C8-N 8-inch reflector; ISO 200; 1/80-second exposure

"This is a very striking image. The photographer has just caught this in a perfect balance just after Venus has reappeared from behind the Moon. It feels like you are hovering in front of the image."

DAN HOLDSWORTH

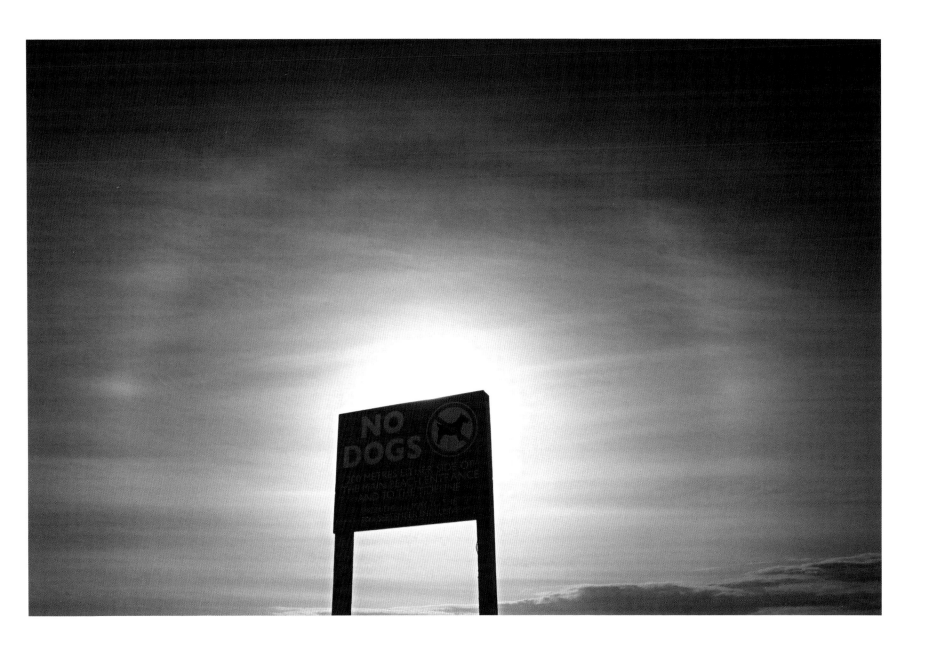

SARAH GILLIGAN *(UK)*, **AGED 11** *RUNNER-UP*

No Dogs on Beach
[*3 May 2009*]

SARAH GILLIGAN: I needed something to hide the bright Sun, so the 'No Dogs on Beach' sign was the best thing, but we did see the two Sun Dogs or *parhelia* which means 'beside the Sun'.

BACKGROUND: 'Sun Dogs' is the name given to the patches of refracted light which can appear to either side of the Sun on the rare occasions when it shines through clouds of ice crystals high in Earth's atmosphere. Here they can be seen just above the level of the 'No Dogs' sign, on the right and left of the halo surrounding the Sun.

Canon 450D DSLR camera; 18–55mm lens

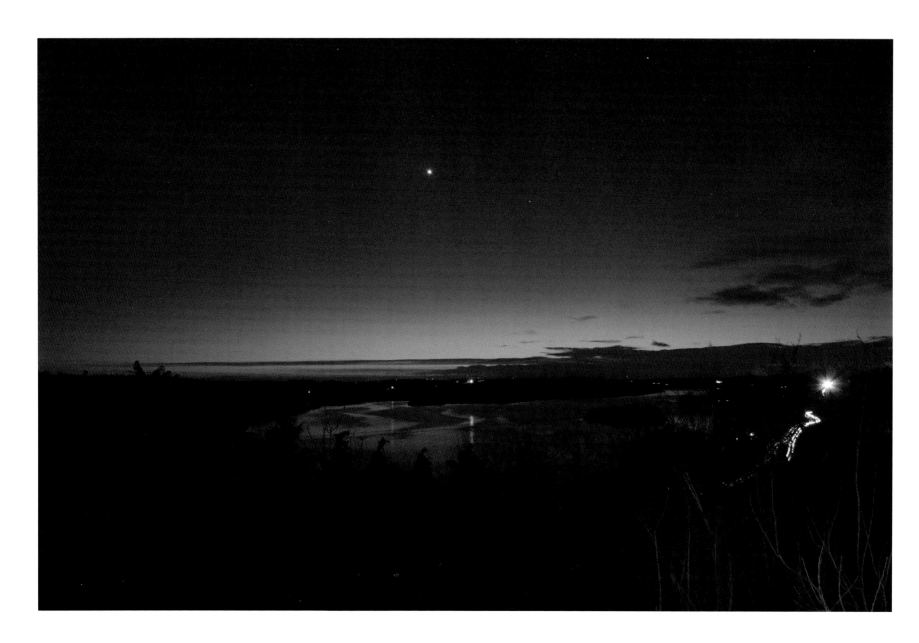

PAUL SMITH *(Ireland),* AGED 14 *HIGHLY COMMENDED*

Venus
[March 2009]

PAUL SMITH: Venus is a fantastic sight against the blue twilight sky.

BACKGROUND: The planet Venus is often the brightest thing to be seen in the sky, and can be spotted at sunrise and sunset. It is often mistaken for a UFO!

Canon 400D DSLR camera, 18mm lens at f/5; ISO 400; 30-second exposure

BEN FERNANDO *(UK)*, **AGED 15** *HIGHLY COMMENDED*

Mercury and the Crescent Moon
[26 April 2009]

BEN FERNANDO: With Mercury and a day-old crescent Moon being challenging objects to see, I decided to try and photograph them together. I liked the result – simple, yet interesting and elegant.

BACKGROUND: Mercury, the tiny planet closest to the Sun, is quite difficult to see in the sky because it is usually hidden by the Sun's glare. However, it is sometimes visible just before sunrise or after sunset, leading the Ancient Greeks to give it two separate names: Apollo and Hermes.

Canon PowerShot SX10 IS digital camera; ISO 80; 0.8-second exposure

JATHIN PREMJITH *(India)*, AGED 13 *HIGHLY COMMENDED*

Full Moon
[8 July 2009]

JATHIN PREMJITH: A full Moon is always fascinating but an 'almost full Moon' is more fascinating because of the prominence of some of the craters. After all, craters on the Moon give 'life' to the whole picture. To create this effect the photo was taken the next day after a full Moon. This retains the 'almost' sphere.

BACKGROUND: Here, the features of the Moon can be seen very clearly. The 'rays' towards the lower portion of the image are the spray of debris from an ancient crater, formed by the impact of a large object billions of years ago.

Canon EOS 50D DSLR camera; 18–55mm lens; ISO 400

ASTRONOMY ✶ PHOTOGRAPHER
OF THE YEAR

earth and space

our solar system

deep space

best newcomer

people and space

young astronomy photographer of the year

Blazing Bristlecone
[*14 August 2009*]

TOM LOWE: If I could change anything about this photo, it would be the artificial lighting! The light on that tree occurred accidentally because I had my headlamp and possibly a camping lantern on while I was taking a series of test shots! The artificial light is too frontal for me and not evenly distributed, but in the end the light did in fact show the amazing patterns in the tree's wood.

The reason these trees inspire me so much, aside from their obvious and striking beauty, is their age. Many of them were standing while Genghis Khan marauded across the plains of Asia. Being a timelapse photographer, it's natural for me to attempt to picture our world from the point of view of these ancient trees. Seasons and weather would barely register as events over a lifetime of several thousand years. The lives of humans and other animals would appear simply as momentary flashes.

BACKGROUND: The gnarled branches of an ancient tree align with a view of our Milky Way galaxy. The Milky Way is a flat, disc-like structure of stars, gas and dust measuring more than 100,000 light years across. Our Sun lies within the disc, about two-thirds of the way out from the centre, so we see the Milky Way as a bright band encircling the sky.

This view is looking towards the centre of our galaxy, 26,000 light years away, where dark clouds of dust blot out the light of more distant stars. What appears to be an artificial satellite orbiting the Earth makes a faint streak of light across the centre of the image.

Canon EOS 5D Mark II DSLR camera; Canon EF 16–35mm lens at 16mm

OVERALL WINNER 2010

"I like the way the tree follows the Milky Way and the definition is very good."

SIR PATRICK MOORE

"I think this beautiful picture perfectly captures the spirit of Astronomy Photographer of the Year, linking the awe-inspiring vista of the night sky with life here on Earth. The bristlecone pines in the foreground can live as long as five thousand years. But they are babies compared to the starlight shining behind them, some of which began its journey towards us almost 30,000 years ago."

MAREK KUKULA

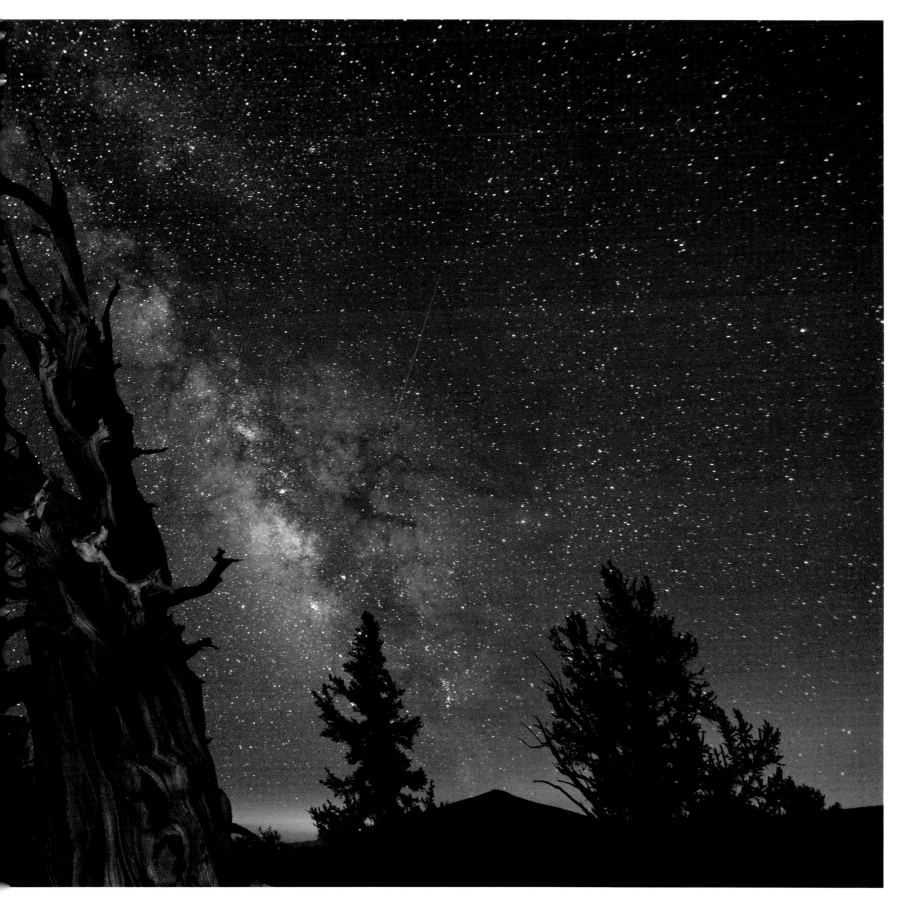

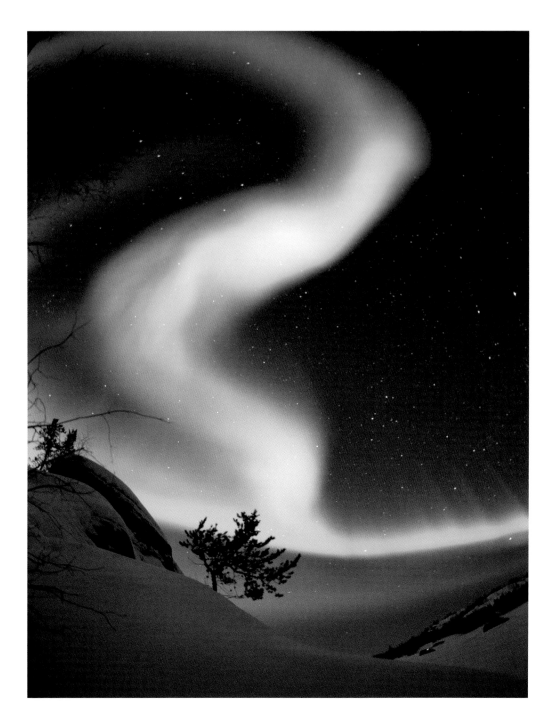

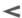

DAVE BROSHA *(Canada)* *RUNNER-UP*

Whisper of the Wind
[3 April 2010]

DAVE BROSHA: I photographed this on a bitterly cold night along the shores of Vee Lake, just outside Yellowknife, Northwest Territories … I wanted a composition that tied the land below into the grander display above, and when I saw the shape of this aurora on my viewfinder, which looked so gentle – like a soft wind was blowing it – I knew I had something special.

BACKGROUND: The aurorae, or Northern and Southern Lights, are caused by the interaction between the Earth's atmosphere and a stream of particles from the Sun known as the solar wind. The Earth's magnetic field funnels these particles down over the planet's poles giving rise to glowing curtains of coloured light. These are best seen in the night sky near to the North and South Poles.

Canon EOS 5D Mark II DSLR camera; Sigma 15mm fisheye lens on a static tripod

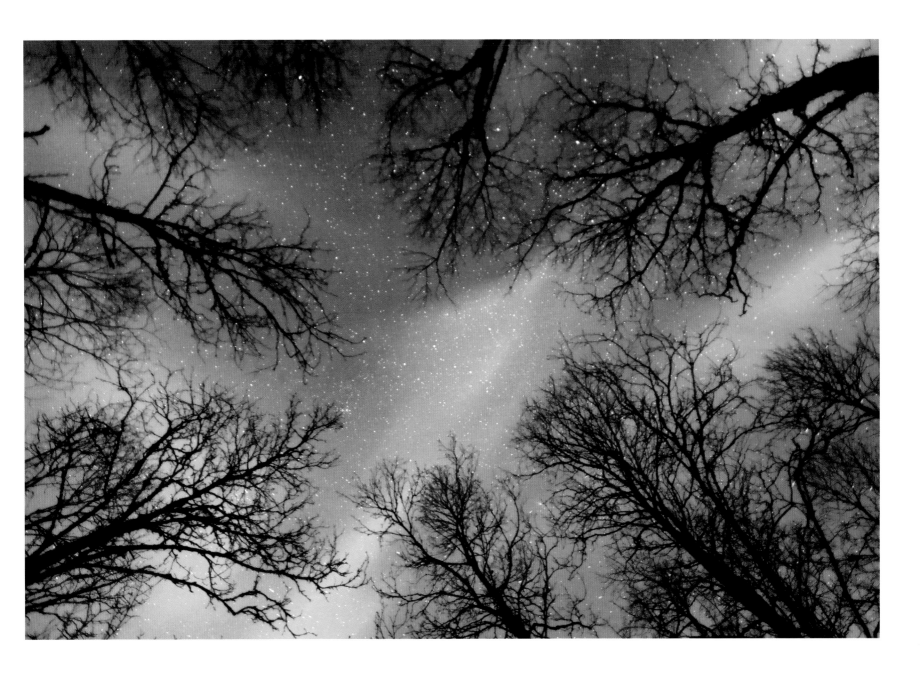

∧

FREDRIK BROMS *(Sweden)* *HIGHLY COMMENDED*

Surrounded by Space
[*22 October 2009*]

FREDRIK BROMS: Ever since my grandfather took me out as a child and showed me the wonders of the night sky, I have been deeply interested and fascinated by astronomy. Even though I unfortunately lost my guide and greatest source for inspiration too early, my fascination continued to grow deeper. In this picture, from the forest floor, I wanted to capture some of the magic feeling of being completely surrounded both by our own Earth and the vast space beyond.

BACKGROUND: The Northern Lights flicker above the bare branches of this winter forest in Kvaløya, Norway. Framed by the treetops, bright stars form the familiar 'W'-shape of the constellation Cassiopeia.

Nikon D3 DSLR camera; AF Nikkor 20mm lens

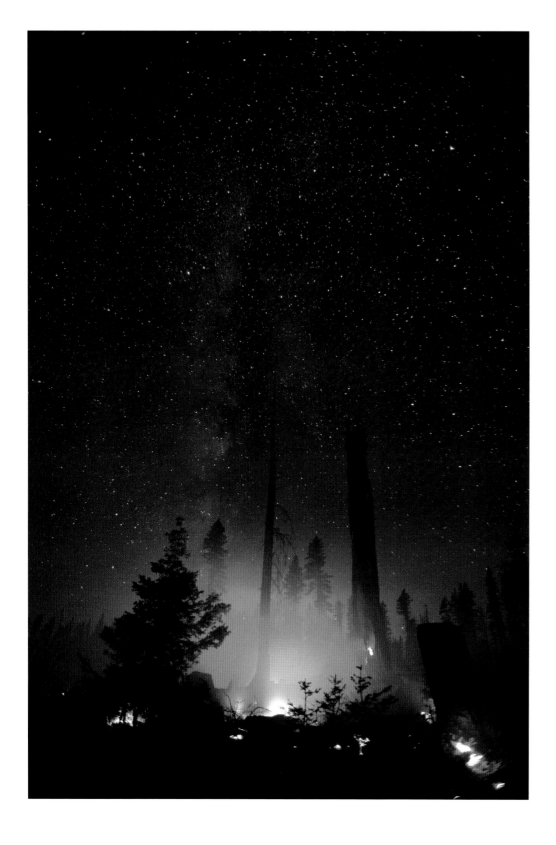

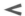

Primal Wonder
[*11 September 2009*]

LARRY ANDREASEN: The beauty of the Milky Way as backdrop to a forest fire on Yakima Nation Lands, on Mount Adams in Washington State, makes me think of a people long ago huddled around a campfire pondering the mysteries of the timeless skies in wonder.

BACKGROUND: What appears to be smoke rising from this controlled fire in a North American forest is in fact our galaxy, the Milky Way, a vast disc of stars, gas and dust. Looking out from this disc, we see a few thousand stars which are relatively close to Earth. Looking along the disc, at the 'smoke' in this photograph, we see hundreds of billions of stars and clouds of dust and gas which are spread throughout the Galaxy.

Nikon D3 DSLR camera; 20–35mm lens at 20mm

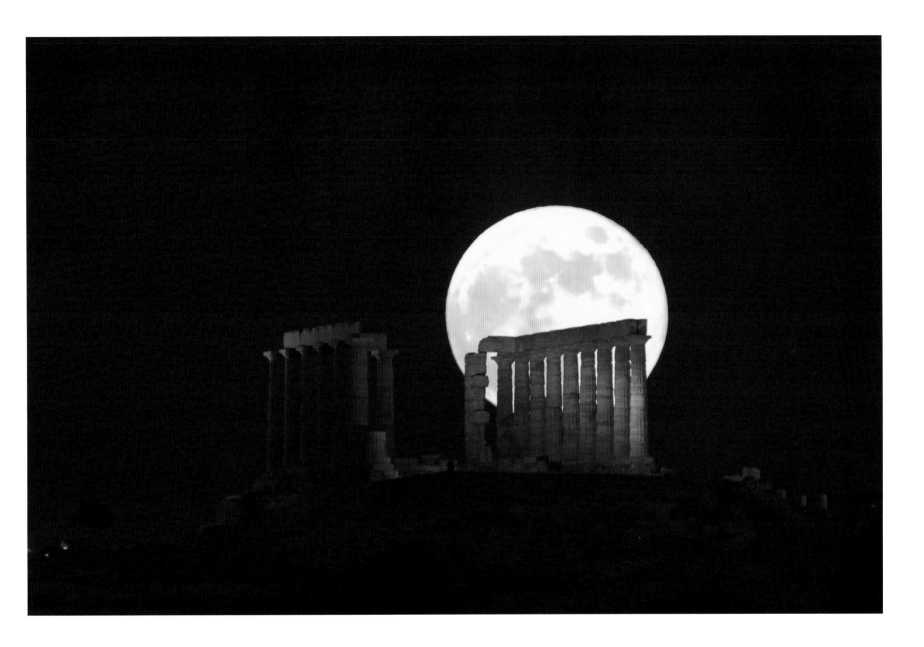

Λ

ANTHONY AYIOMAMITIS (*Greece*) *HIGHLY COMMENDED*

Solstice Full Moon over Sounion
[*26 June 2010*]

ANTHONY AYIOMAMITIS: From a very young age I was always fascinated by the aura of Ancient Greece, and the rising full Moon at Sounion was a unique way to freeze a very special and breathtaking moment involving our 4.5-billion-year-old celestial neighbour and the 2500-year-old temple. A lot of work went into preparing for this single-exposure photo since there was absolutely no room for error.

BACKGROUND: At the Summer Solstice, the full moon rises behind the columns of the ruined temple of Poseidon on Cape Sounion, south of Athens. The Moon often appears orange or yellow when close to the horizon, as its light is filtered through the thick layers of the Earth's atmosphere. At these low angles, the Moon can look much larger than usual because our eyes compare it with familiar objects on the skyline.

Takahashi FSQ-106 106mm refractor telescope; Astro-Physics 2x convertible Barlow lens; Canon EOS 5D Mark I DSLR camera

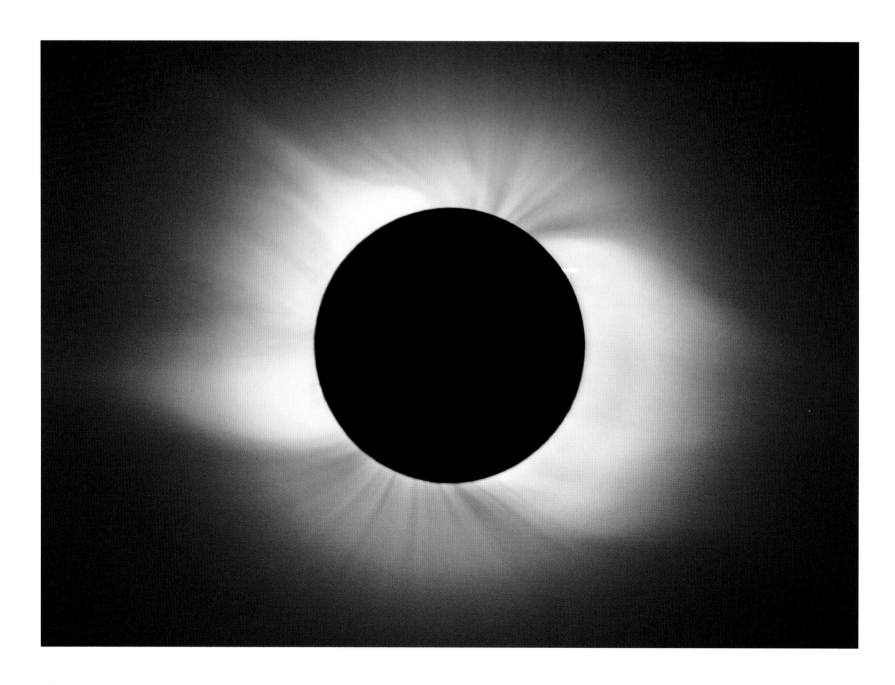

Λ

ANTHONY AYIOMAMITIS (*Greece*) *WINNER*

Siberian Totality
[*1 August 2008*]

ANTHONY AYIOMAMITIS: On eclipse day, the clouds were present everywhere and only one hour before first contact (partial phase) did the skies clear … and they cleared beautifully and with pristine transparency. There was a slight wind, especially at the top of the roof of the Institute of Nuclear Physics, but it was a very small price to pay.

BACKGROUND: During a total solar eclipse, the Moon passes directly in front of the Sun. For a few minutes, with the dazzling light of the solar disc blocked from view, we gain a rare glimpse of the corona, the Sun's outer atmosphere. Powerful magnetic fields warp and shape the super-heated gas of the corona into glowing loops and streamers.

Takahashi FSQ-106 106mm refractor telescope; Celestron CG3 German equatorial mount; Canon EOS 350D XT DSLR camera

"The processing used maintains an exquisite level of detail right across the corona and delivers a view similar to what would be seen with the human eye. This is something that's not easy to do with a camera and the end result completely justifies all the hard work that's gone into producing this beautiful image."

PETE LAWRENCE

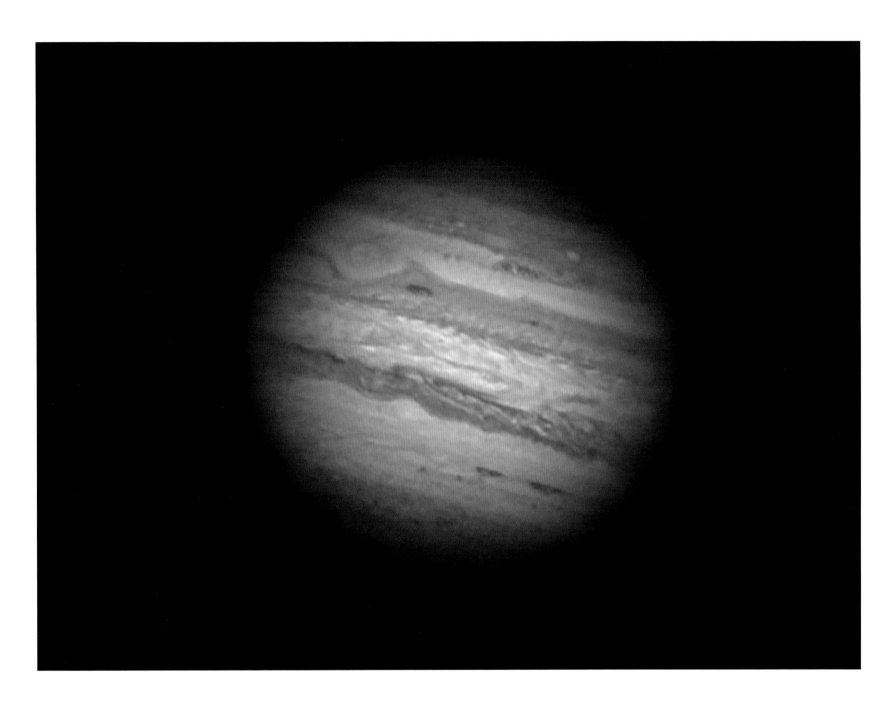

Λ

NICK SMITH *(UK)* *RUNNER-UP*

Jupiter
[15 August 2009]

NICK SMITH: My first telescope was a 50mm Tasco refractor that I had aged ten! It was only about five years ago that I realised it was possible for amateurs to take really high resolution images of the Moon and planets using low-cost consumer webcams.

BACKGROUND: Jupiter is the largest planet in the Solar System. A giant ball of gas with no solid surface, its atmosphere is streaked with colourful bands of cloud. This image was taken just after a large asteroid plunged into Jupiter's atmosphere, exploding beneath the clouds. A dark patch near the top of the planet's disc marks the impact.

Celestron C14 14-inch Schmidt-Cassegrain telescope; Tele Vue 1.8x Barlow lens; Lumenera SKYnyx 2-0M CCD camera

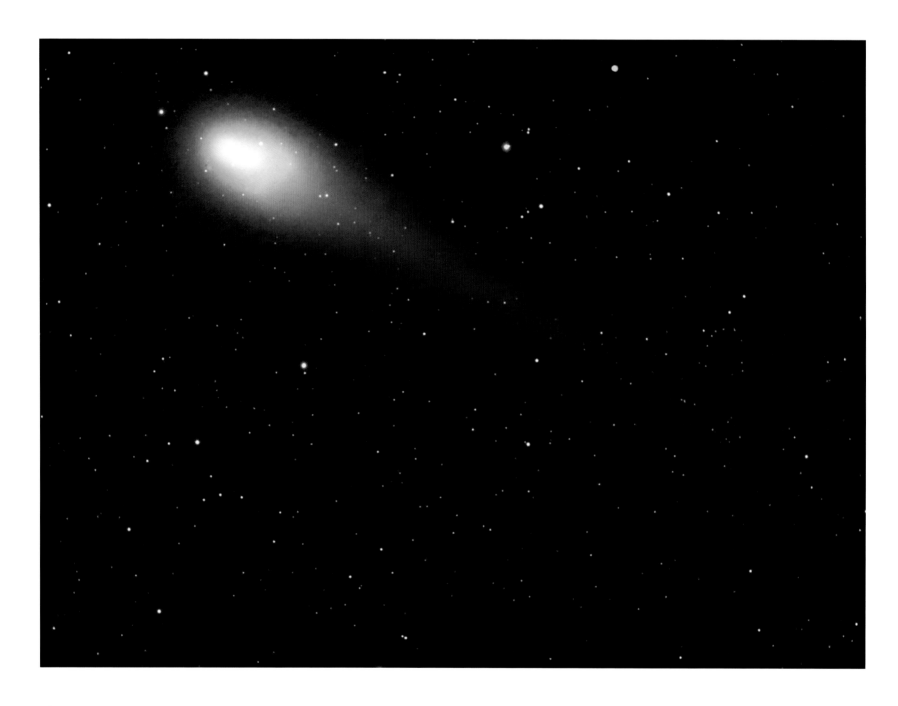

Λ

RICHARD HIGBY *(Australia)* HIGHLY COMMENDED

The Green Visitor – Comet Lulin
[*3 March 2009*]

RICHARD HIGBY: I had read that Comet Lulin was approaching our solar system. This speeding dirty snowball would not revisit us during our lifetime! This was all that was needed to rush home on a number of occasions praying for a break in the clouds and weather to capture the green visitor from our backyard in North Sydney, Australia.

BACKGROUND: Comets are visitors from the frozen edges of the Solar System. A comet's nucleus is a chunk of ice and rock just a few kilometres across. As it passes close to the Sun, ice on the surface evaporates. This streams off into space to produce the comet's spectacular tail of dust and gas, millions of kilometres long.

Wiliam Optics Megrez 90mm doublet apochromatic refractor; Takahashi EM200 equatorial mount; SBIG ST-2000MXC CCD camera

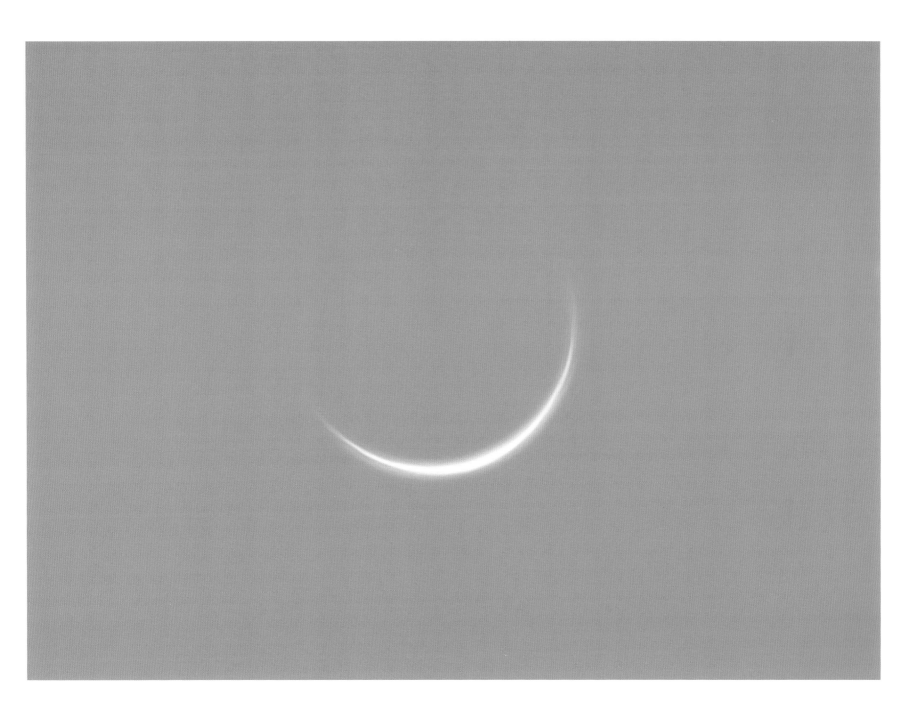

Λ

LORENZO COMOLLI *(Italy)* *HIGHLY COMMENDED*

The Crescent Venus
[*22 March 2009*]

LORENZO COMOLLI: The Sun was very near and it was very hard to be sure not to burn the imaging camera!

BACKGROUND: As it moves around the Sun, our neighbouring planet, Venus, appears to go through a series of phases from crescent to full, just like the Moon. These phases can only be seen through a telescope or binoculars. They were first observed by the Italian astronomer Galileo Galilei around 400 years ago. His observations proved that Venus must orbit the Sun, showing that not everything in the Universe goes around the Earth.

30cm Newtonian reflector with Barlow lens and a modified Philips Vesta Pro webcam with a monochrome sensor

NICK SMITH (UK)

Sinus Iridum
[*26 January 2010*]

NICK SMITH: The *Sinus Iridum* shot was taken from my back garden in Oxford in the UK. It is an area of the Moon that I often return to in the hope of capturing a few more of the illusive 'craterlets' that litter the floor of the bay.

BACKGROUND: *Sinus Iridum*, or the 'Bay of Rainbows' lies on the edge of the Moon's 'Sea of Rains' (*Mare Imbrium*). The smooth floor of the bay is filled with dark lava, which solidified billions of years ago and is surrounded by rugged mountains. These highlands are older than the lava plains and are therefore more heavily scarred by craters – the relics of ancient meteorite impacts.

Celestron C14 14-inch Schmidt-Cassegrain telescope; Tele Vue 1.8x Barlow lens; Lumenera Infinity 2-1M CCD camera

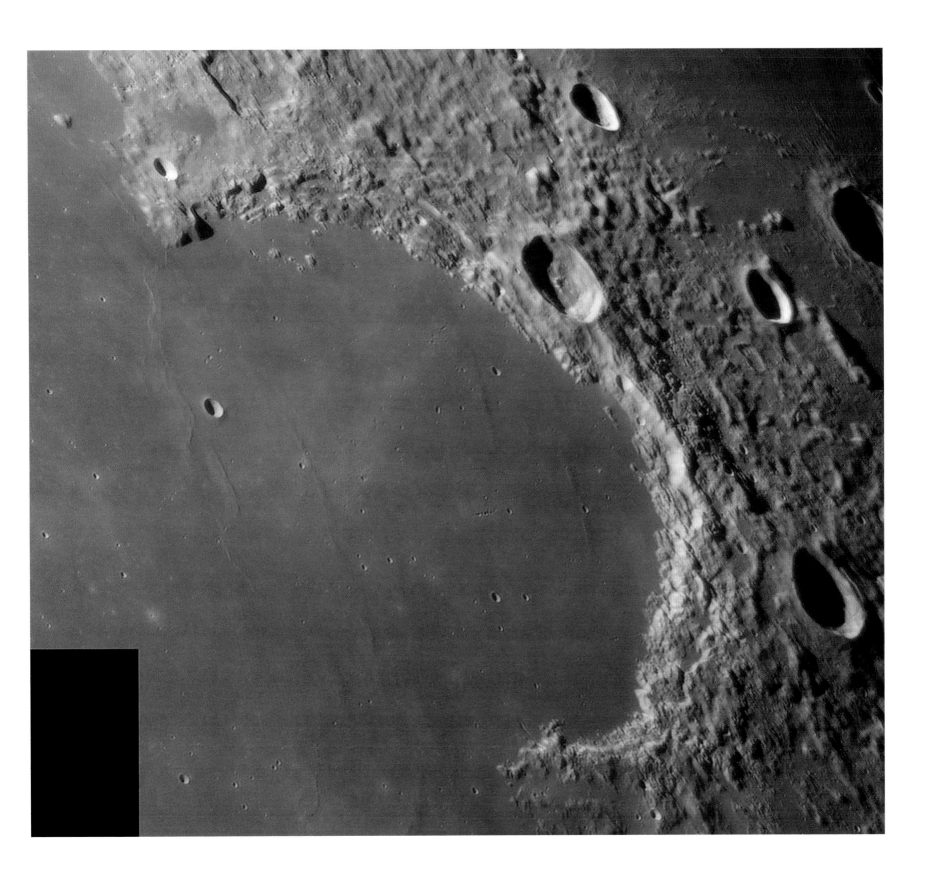

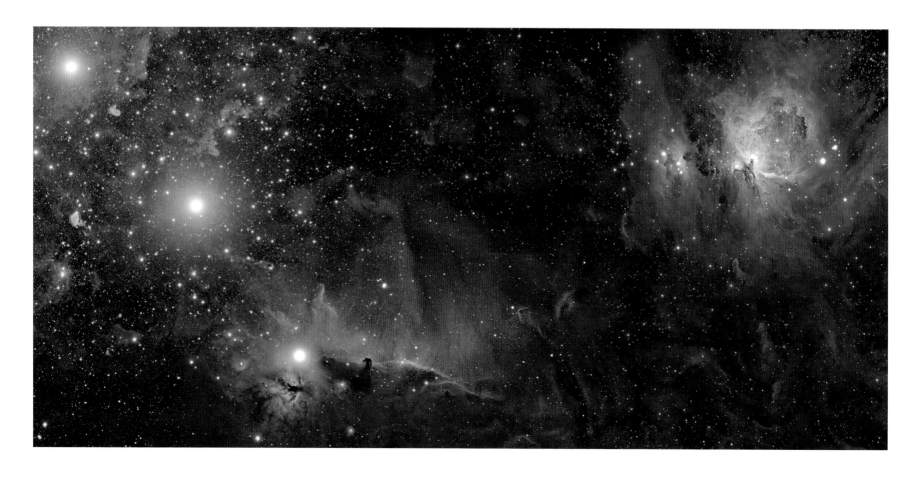

ROGELIO BERNAL ANDREO (USA) *WINNER*

Orion Deep Wide Field
[*January–September 2009*]

ROGELIO BERNAL ANDREO: I love this image for several reasons. One, because it includes a feature easily recognizable even from light-polluted skies (Orion's belt), so anyone can 'place' this image in the sky. Another reason is because the composition resembles a complex and beautiful stellar landscape, rather than just an object placed in the middle of the frame.

BACKGROUND: The three bright stars of Orion's Belt, on the left of this image, are a familiar sight in the winter sky. Here, however, a long exposure reveals an epic vista of dust and gas clouds which are too faint to be seen by the naked eye. This is an immense region of space hundreds of light years across. It contains several well-known astronomical sights, including the Horsehead Nebula (bottom centre) and the Orion Nebula (top right).

Takahashi FSQ 106 EDX 106mm refractor with 0.7x focal reducer; Takahashi EM-400 equatorial mount; SBIG STL11000 CCD camera

"This is a truly superb image which reveals an amazing amount of dark dust permeating the space in the direction of Orion's belt and down to his sword. The way the faint detail between the Orion Nebula and Horsehead Nebula has been brought out is nothing short of astonishing. This alien skyscape really captivates my imagination and I could look at it for hours on end!"

PETE LAWRENCE

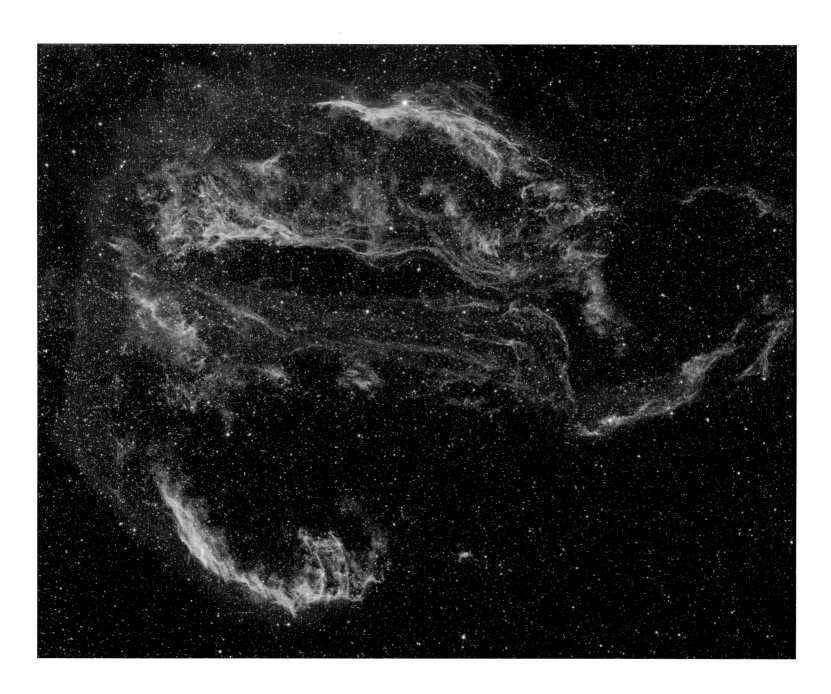

Λ

MARTIN PUGH *(UK/Australia)* *RUNNER-UP*

The Veil Nebula in Cygnus
[July–August 2009]

MARTIN PUGH: I was struck by the way the blues and reds intermingle throughout this image, without manipulation. Rotated 90 degrees clockwise, the Veil Nebula transforms into an intergalactic jellyfish.

BACKGROUND: The Veil Nebula is the aftermath of a supernova explosion, the violent death of a star many times more massive than the Sun. Thousands of years later, the debris from the blast is still spreading out through space, in the form of this glowing cloud of gas. Explosions like this are the source of many of the chemical elements from which planets, and even life, have formed.

Takahashi FSQ 106N 106mm apochromatic refractor; Software Bisque Paramount ME mount; SBIG STL11000M CCD camera

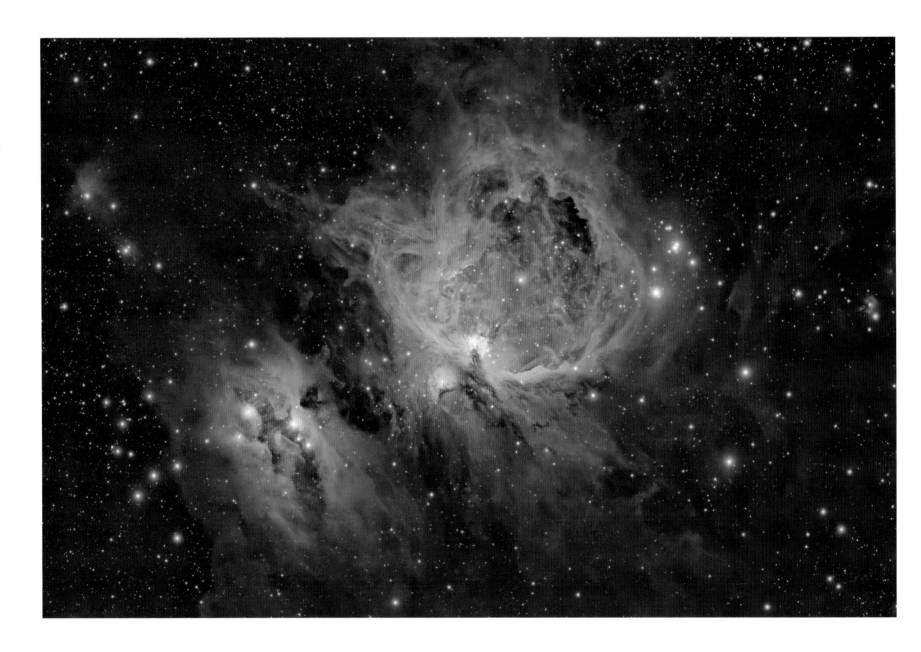

Λ

MARCUS DAVIES *(Australia)* *HIGHLY COMMENDED*

The Sword and the Rose (Orion's Sword and M42)
[10 January 2010]

MARCUS DAVIES: Apart from its sheer beauty and astronomical significance, I imaged this object because it's quite difficult to capture properly. My goal was to render the complex colours as vividly and as faithfully as possible.

BACKGROUND: This cloud of dark dust and glowing gas in the Sword of Orion is the M42 nebula, a stellar nursery where new stars are being born. M42 is visible to the naked eye but a telescope reveals the full beauty of this giant star factory. The fierce radiation from newly-formed stars peels back the layers of gas, like a giant flower unfurling its petals.

Takahashi TOA-150 150mm refractor; Takahashi EM-400 equatorial mount; SBIG STL11000M CCD camera

∧

EDDIE TRIMARCHI *(Australia)* *HIGHLY COMMENDED*

The Trifid Nebula (M20)
[*17 June 2009*]

EDDIE TRIMARCHI: I have imaged this particular nebula every year over the last ten years, with various telescopes and lenses. It's a beautiful object at any scale and particularly so up-close.

BACKGROUND: This glowing cloud of gas takes its name from the dark lanes of dust which appear to divide it into three. The pink glow comes from hydrogen atoms which have been energized by the stars at the centre of the nebula. To the left of the image, a neighbouring cloud of dust reflects the blue light of the central stars.

16-inch Richey-Chretien telescope; Apogee Alta U9000 CCD camera

EDWARD HENRY (USA)

The Andromeda Galaxy (M31)
[1 March 2009]

EDWARD HENRY: I like the way this came out. If I were going to do anything differently, I might bring out those red areas a little more ... and, of course, more exposure time is always good.

BACKGROUND: Andromeda is one of the closest galaxies to our own Milky Way. Even so, the light from Andromeda takes 2.5 million years to reach us, so we see this galaxy as it appeared in the distant past. Like the Milky Way, Andromeda contains hundreds of billions of stars, as well as dust and gas swirling in its spiral arms. Seen from Andromeda, our own galaxy would probably look very similar to this.

TMB 152mm refractor; SBIG STL11000M CCD camera

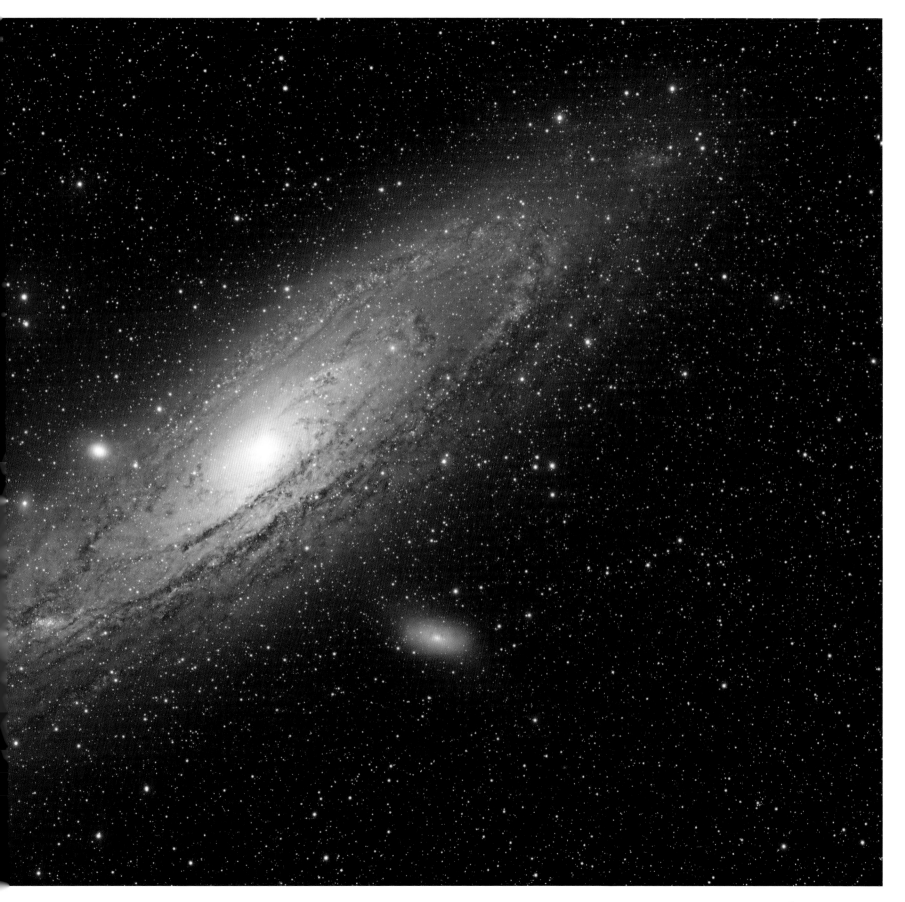

KEN MACKINTOSH (UK)

The Whirlpool Galaxy (M51)
[16–17 April 2010]

KEN MACKINTOSH: I have been interested in astronomy since I was very young and took it as an option at university. My interest was very much rekindled recently when I realised (just casually browsing through flickr, in fact) how much more accessible the photography side of the hobby had become, and what good results could be achieved at not such a great cost or effort.

BACKGROUND: Galaxies are vast collections of hundreds of billions of stars, gas and dust bound together by gravity. M51, or the Whirlpool, is a classic example of a spiral galaxy with swirling patterns of newly formed stars lacing gracefully through its disc. A smaller, rounder galaxy is seen towards the top of this image. It is slowly colliding with its larger neighbour.

Maxvision 127mm apochromatic refractor; EQ6 mount; modified Canon EOS 450D DSLR camera

"This is a lovely image of the Whirlpool Galaxy and its companion galaxy (NGC 5195). I particularly like the detail that has been captured in the faint dust lanes that can be seen silhouetted against the Whirlpool's bright spiral arms."

WILL GATOR

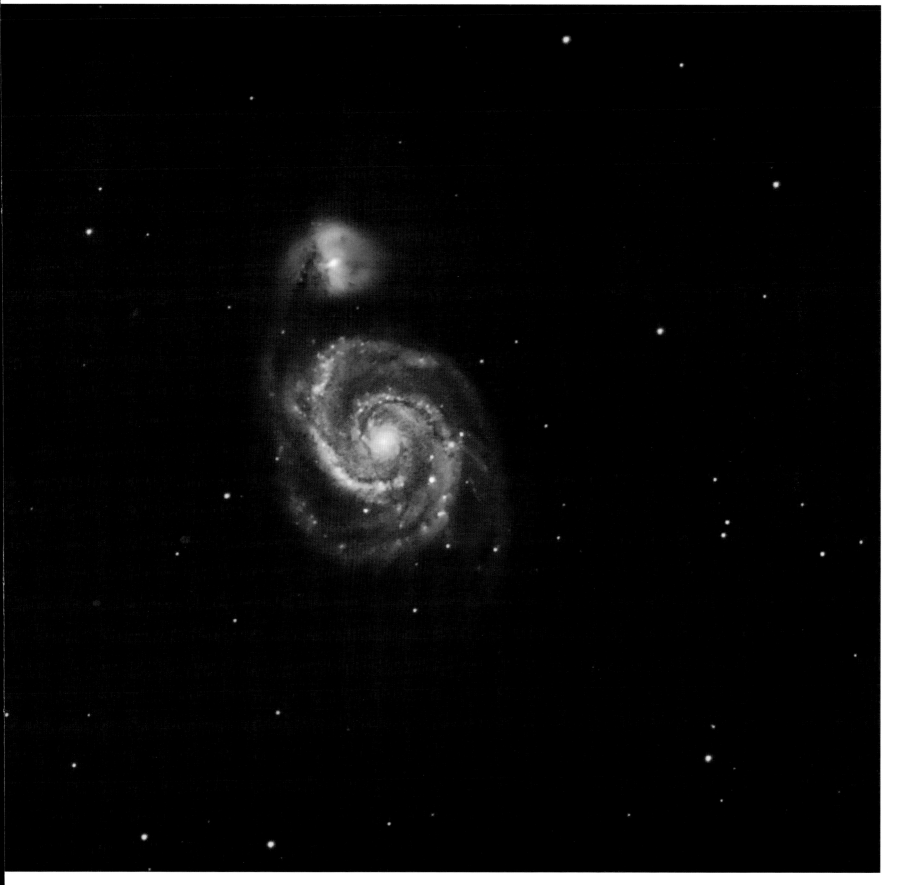

STEVEN CHRISTENSON (USA) *WINNER*

Photon Worshippers
[23 December 2009]

STEVEN CHRISTENSON: Astronomy and astronomical phenomena have been a hobby for my entire life. Nothing is quite so awe-inspiring to me as being in a dark night sky and watching a meteor shower or a lunar eclipse – or just seeing the majesty of the Milky Way reaching from horizon to horizon.

BACKGROUND: For a few days each year, the setting Sun shines directly through the archway of a large rock formation at Pfeiffer Beach in Big Sur, California. This event has become very popular with photographers. Alignments of the Sun with natural and man-made structures have been significant to people for thousands of years.

Canon EOS 50D DSLR camera; Canon 10–22mm lens at 10mm; Manfrotto tripod

"It's a rare event – it happens only once a year and the photographer has taken full advantage – the composition is fabulous."

SIR PATRICK MOORE

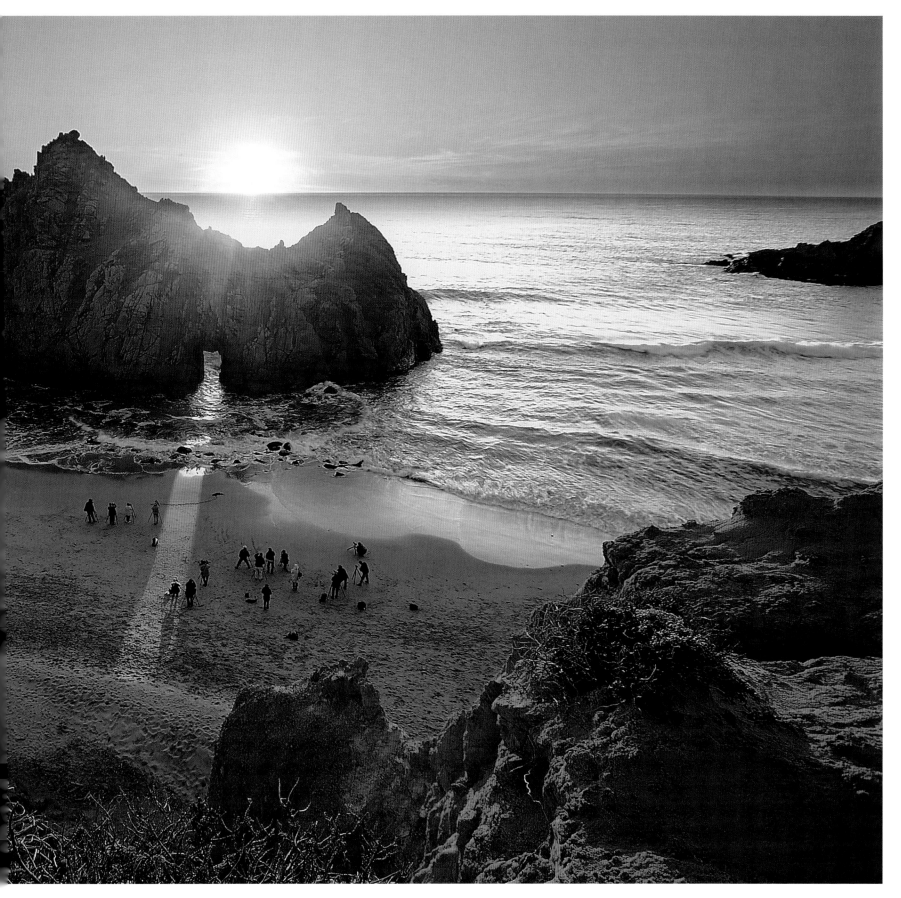

DHRUV ARVIND PARANJPYE *(India)*, AGED 14 *WINNER*

A Perfect Circle
[15 January 2010]

DHRUV ARVIND PARANJPYE: My father got me a telescope and a digital camera, and the annular eclipse was a perfect opportunity to test my skills. The photograph was clicked from the southernmost tip of the Indian Peninsula, Kanyakumari.

BACKGROUND: An annular eclipse occurs when the Moon is too far from the Earth to cover the Sun's disc completely, as it would during a total solar eclipse. Seen here through a layer of cloud, a bright ring appears as the uncovered part of the Sun shines around the edges of the Moon.

Nikon E3700 digital camera

"I loved how the perfect geometry of the eclipsed Sun contrasts with the chaotic shapes of the clouds. By using the clouds as a filter, Paranjpye has been able to reproduce wonderful, contrasting colours."

REBEKAH HIGGITT

Λ

LAURENT V. JOLI-COEUR *(Canada)*, AGED 13 *RUNNER-UP*

Solar Halo
[*17 October 2009*]

LAURENT V. JOLI-COEUR: I was in my family's car on our way to New York City when I saw a beautiful solar halo through the roof. I happened to have my mother's camera in my hands so I tried my best to capture the beautiful scene in all its glory. My parents were not happy when I opened my window (on the highway) to take the picture. My mother was afraid that I would break her camera!

BACKGROUND: From time to time, unusual weather conditions produce spectacular lighting effects in the Earth's atmosphere. In this photo, sunlight is reflecting from tiny ice crystals in very high clouds, giving rise to a colourful solar halo. Two vapour trails from passing aircraft cast shadows on the higher clouds above due to the low angle of the Sun.

Canon Digital Rebel DSLR camera; Canon EF-S 18–55mm lens

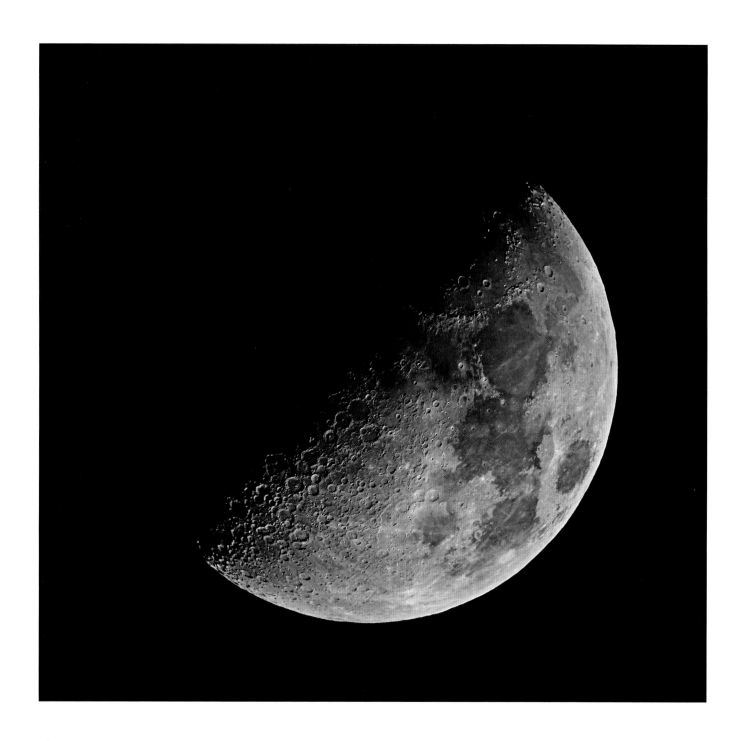

Λ

JATHIN PREMJITH *(India)*, **AGED 14** *HIGHLY COMMENDED*

Half-Moon Terminator
[*23 March 2010*]

JATHIN PREMJITH: A half moon is always fascinating to look at. In this photo, the line of sunrise or sunset (terminator) on the Moon reveals some of the important craters such as Archimedes, Ptolemaeus and Alphonsus casting their shadows. Part of the mountain range Montes Apenninus can also be seen clearly.

BACKGROUND: The lunar landscape is littered with craters formed by the impact of asteroids and comets over billions of years. They are easiest to see close to the terminator, the boundary between the sunlit and dark sides of the Moon. Here, the terminator marks lunar sunrise and elongated shadows make the craters stand out in sharp relief.

Celestron CPC 800 8-inch Schmidt-Cassegrain telescope; Canon EOS 7D DSLR camera

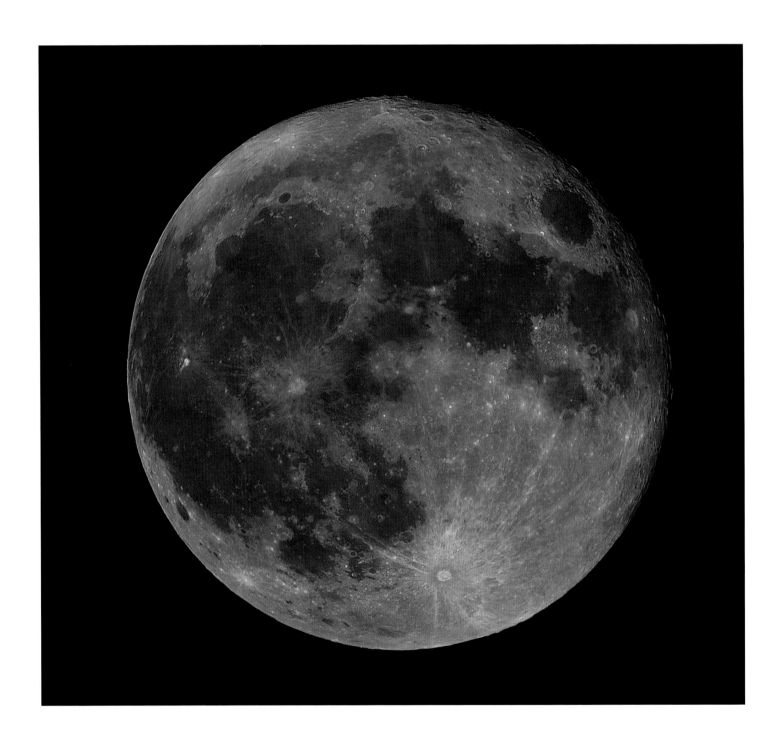

Λ

DANIEL MORTIMER *(UK)*, **AGED 15** *HIGHLY COMMENDED*

A Detailed Full Moon
[*30 January 2010*]

DANIEL MORTIMER: The Moon has always been one of my favourite targets and I had imaged it at most of its phases before, but I had never bothered to image a full Moon because of the lack of detail. So, the inspiration was simple – to see how much detail I could get out of a full Moon.

BACKGROUND: The dark areas on the Moon's surface are vast plains of solidified lava called lunar 'seas' or *maria*. The 'rays' towards the lower portion of this image are the spray of debris from an ancient crater, formed billions of years ago by the impact of a large asteroid or comet.

Sky-Watcher Skyliner 200P 8-inch Dobsonian telescope; Philips SPC900NC webcam

Λ

ELIAS JORDAN *(USA)*, AGED 15 *HIGHLY COMMENDED*

The Pelican Nebula Up-Close
[22 June 2010]

ELIAS JORDAN: I took the photo during my 'Astrocation' (Astronomy Vacation) in New Mexico. Astronomy is just a science that excites the minds of everyone! After seeing the majestic rings on Saturn, I was hooked! Luckily, I was encouraged by my parents to continue to advance my knowledge in the subject, and thanks to their support, I was able to combine two of my favourite hobbies, photography and astronomy.

BACKGROUND: The Pelican Nebula is part of a huge cloud of gas and dust in which new stars are forming. Hydrogen gas heated by young stars glows pink, while dense clouds of dark dust stand out against the lighter background. A very bright star can be seen towards the bottom of the image.

Takahashi FRC-300 300mm Ritchey-Chretien Cassegrain telescope; Software Bisque Paramount ME mount; SBIG STL11000M CCD camera

201

1

ASTRONOMY ✦ PHOTOGRAPHER
OF THE YEAR

earth and space

our solar system

deep space

best newcomer

people and space

robotic scope

young astronomy photographer of the year

>

TUNÇ TEZEL *(Turkey)*

Galactic Paradise
[11 July 2010]

TUNÇ TEZEL: When I travelled to see the total solar eclipse of 11 July 2010, I stayed in Oneroa village on the west coast of Mangaia, Cook Islands. This is how the sky looked from a relatively open area just outside Oneroa village.

BACKGROUND: Forming a dramatic backdrop to a tropical skyline, the Milky Way galaxy contains hundreds of billions of stars in a disc-like structure. Our Sun lies within the disc, about two-thirds of the way out from the centre, so we see it as a bright band encircling the sky. This southern hemisphere view highlights dark clouds of dust that aboriginal Australian astronomers called the 'Emu in the Sky'

Hutech modified Canon 5D DSLR camera; 24mm lens

"This beautiful image has a truly magical feel to it. I love how the rich star fields of the Milky Way appear to follow the line of the horizon. Look closely and you'll see many pink nebulae nestled within our galaxy's spiral arms."
WILL GATER

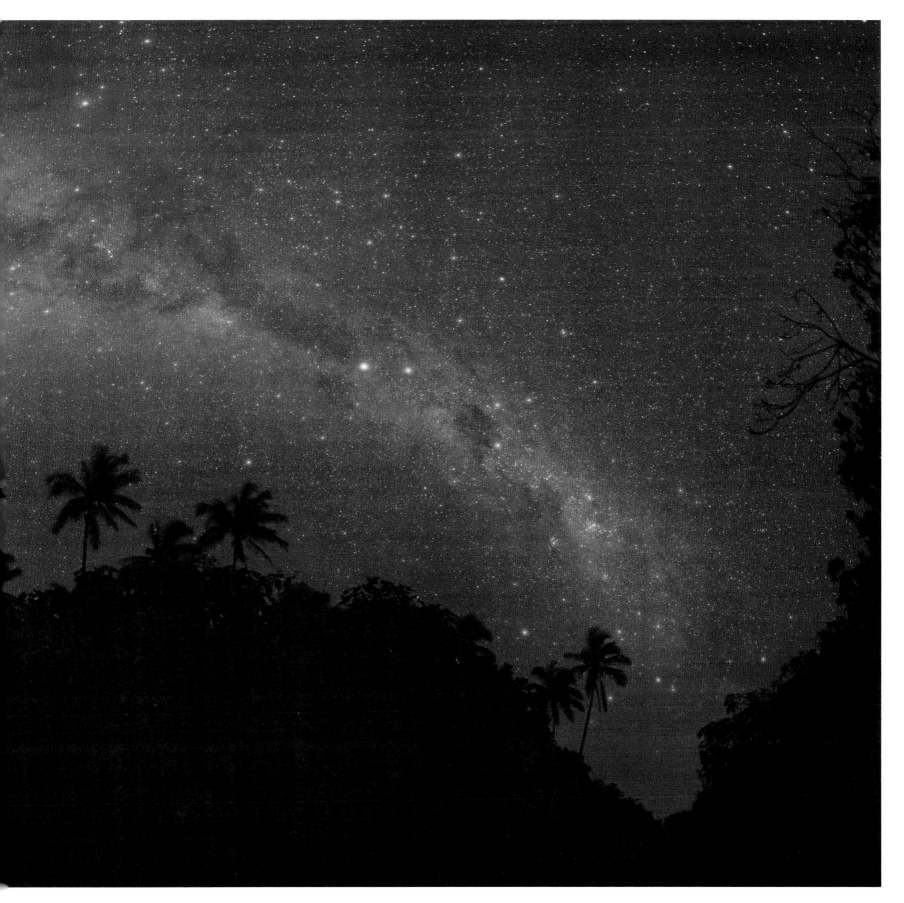

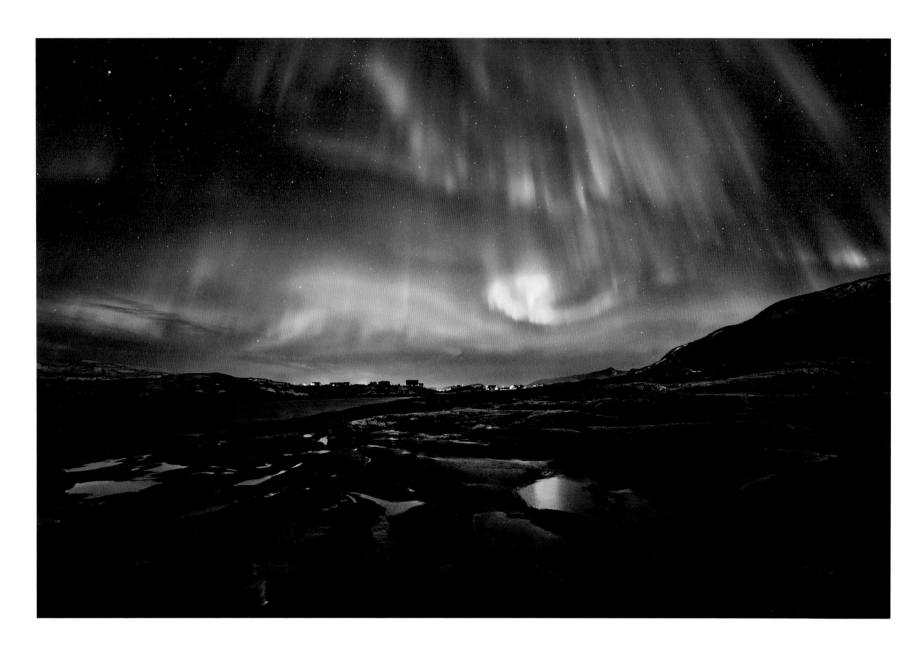

OLE C. SALOMONSEN (Norway) *RUNNER-UP*

Divine Presence
[*11 March 2011*]

OLE C. SALOMONSEN: I love watching the aurorae dancing over my head, surrounded by stars, and sometimes the Moon and even shooting stars. It really puts things into perspective when you're standing there, and you realize how small you are in this endless universe we are living in.

BACKGROUND: The aurorae, or Northern and Southern Lights, are caused by the interaction between the Earth's atmosphere and a stream of particles from the Sun known as the solar wind. The Earth's magnetic field funnels these particles down over the planet's poles giving rise to the glowing curtains of coloured light. These are best seen in the night sky near to the North and South Poles.

Canon 5D Mark II DSLR camera; Nikon 14–24mm lens at 20mm

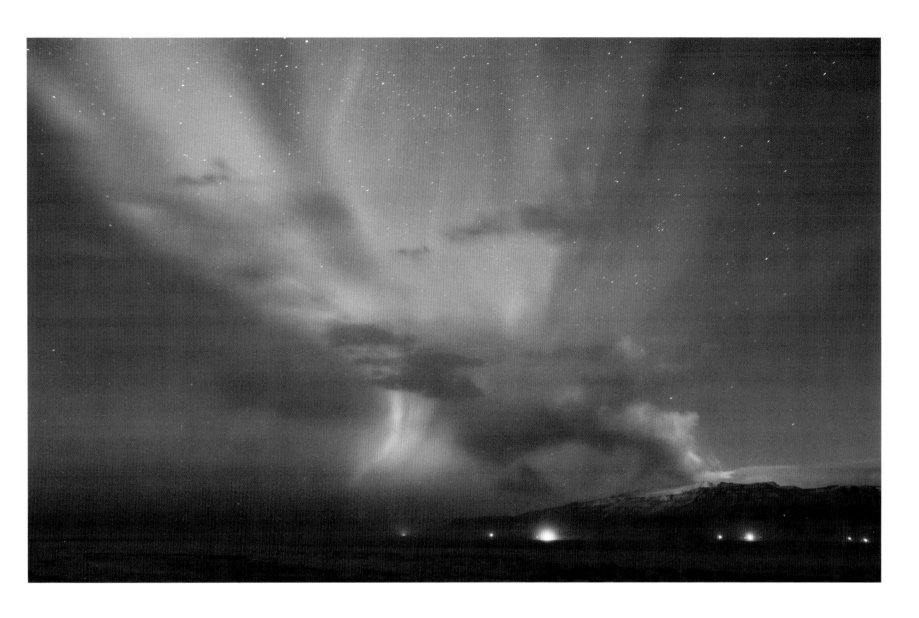

∧

ÖRVAR ATLI ÞORGEIRSSON *(Iceland)* HIGHLY COMMENDED

Volcanic Aurora
[*24 April 2010*]

ÖRVAR ATLI ÞORGEIRSSON: I have always wanted to shoot the aurora with an erupting volcano. This night shooting the Eyjafjallajökull volcano, at the very end of the aurora season, luck was with me.

BACKGROUND: A shimmering aurora, resulting from magnetic activity on the Sun, provides a spectacular background to a dramatic volcanic eruption on Earth. A dark cloud of ash at ground level can be seen to the left in this photograph, while there is bright red lava at the mouth of the volcano. The eruption caused substantial disruption to international travel in the spring of 2010.

Canon 5D Mark II DSLR camera; Canon EF 16–35mm lens at 30mm

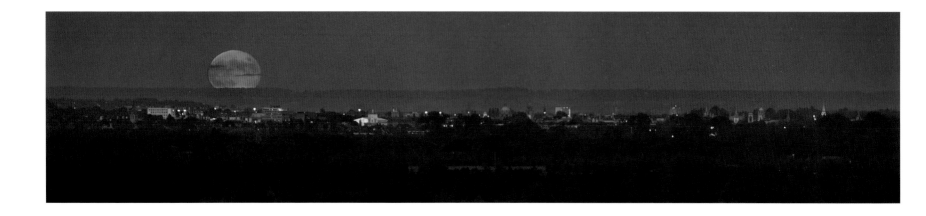

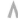

ANDREW STEELE *(UK)* *HIGHLY COMMENDED*

Red Moon rising over Oxford
[16 June 2011]

ANDREW STEELE: After the lunar eclipse of 15 June was obscured by a thick blanket of cloud, I was determined to make the best of my careful planning, regardless. The following night, I went up the same hill from which I'd planned to photograph the eclipsed Moon behind Oxford, and captured this shot.

BACKGROUND: The Moon often appears coloured when close to the horizon, as its light is filtered through the thick layers of the Earth's atmosphere. In this image, made up of three overlapping photographs, an incredibly red full Moon rises over low clouds in the early evening. At these low angles, the Moon can look much larger than usual because our eyes compare it with familiar objects on the skyline.

Nikon D90 camera; 70–200mm lens and TC-17E II teleconverter

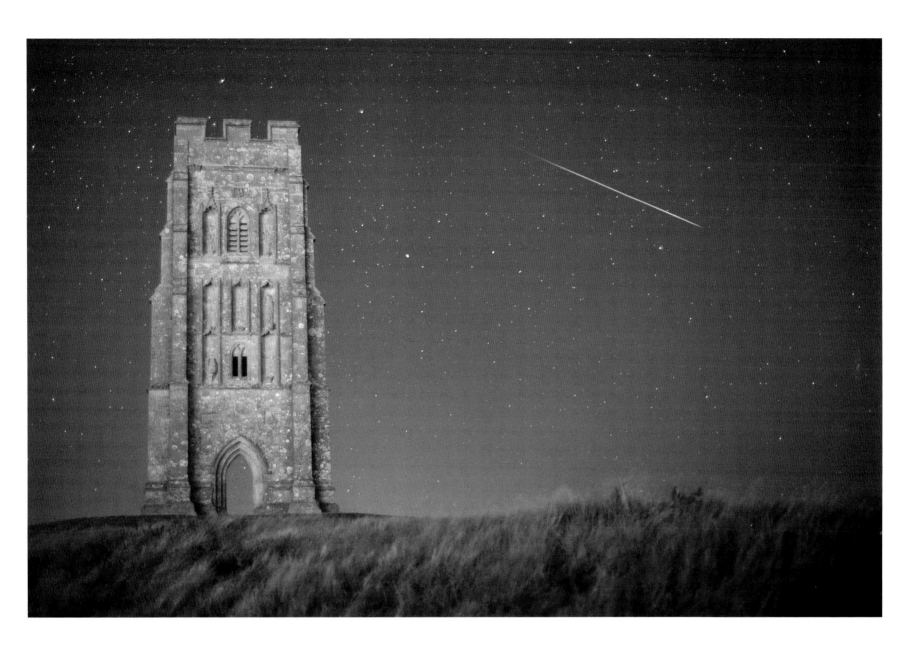

Λ

MIKE KEMPSEY (*UK*) *HIGHLY COMMENDED*

Meteor at Midnight, Glastonbury Tor
[*12 August 2010*]

MIKE KEMPSEY: My interest in astrophotography stems from being both an incurable night owl and an incurable landscape photographer. I have a long-standing acquaintance with the Moon, and it has assisted me with my night photography on many occasions, but until last year, Perseus and its radiant display had escaped my camera's gaze.

BACKGROUND: During the Perseid meteor shower, which peaks each year in August, hundreds of meteors – often called shooting stars – can be seen in a single night. Meteor showers occur when the Earth passes through trails of debris left by comets. Small fragments of comet dust leave a bright and sometimes colourful streak as they heat up while passing through the Earth's atmosphere. This photograph captures one momentary flash beside the 15th-century St Michael's Tower.

Canon 5D Mark II DSLR camera; Carl Zeiss 50mm Planar T* lens

DAMIAN PEACH *(UK)*

Jupiter with Io and Ganymede, September 2010
[*12 September 2010*]

DAMIAN PEACH: This photograph was taken as part of a long series of images taken over a three-week period from the island of Barbados in the Caribbean – a location where the atmospheric clarity is frequently excellent, allowing very clear and detailed photographs of the planets to be obtained.

I've been interested in astronomy since the age of ten and have specialized in photographing the planets for the last fourteen years. I'm very happy with the photo and wouldn't really change any aspect of it.

BACKGROUND: Jupiter is the largest planet in the Solar System. It is a giant ball of gas with no solid surface, streaked with colourful bands of clouds and dotted with huge oval storms.

In addition to the swirling clouds and storms in Jupiter's upper atmosphere, surface features of two of the planet's largest moons can be seen in this remarkably detailed montage. Io, to the lower left, is the closest to Jupiter. The most geologically active object in the Solar System, its red-orange hue comes from sulphurous lava flows. Ganymede, the largest moon in the Solar System, is composed of rock and water ice. The planet and its moons have been photographed separately, then brought together to form this composite image.

Celestron 356mm Schmidt-Cassegrain telescope (C14); Point Grey Research Flea3 CCD camera

OVERALL WINNER 2011

"This is a truly incredible image of the planet Jupiter. Damian has even managed to capture detail on two of Jupiter's moons! It's truly astonishing to think that this was taken from the ground by an amateur astronomer using his own equipment."

PETE LAWRENCE

"There were so many beautiful images this year but this one really stood out for me. It looks like a Hubble picture. The detail in Jupiter's clouds and storms is incredible, and the photographer has also managed to capture two of the planet's moons. An amazing image."

MAREK KUKULA

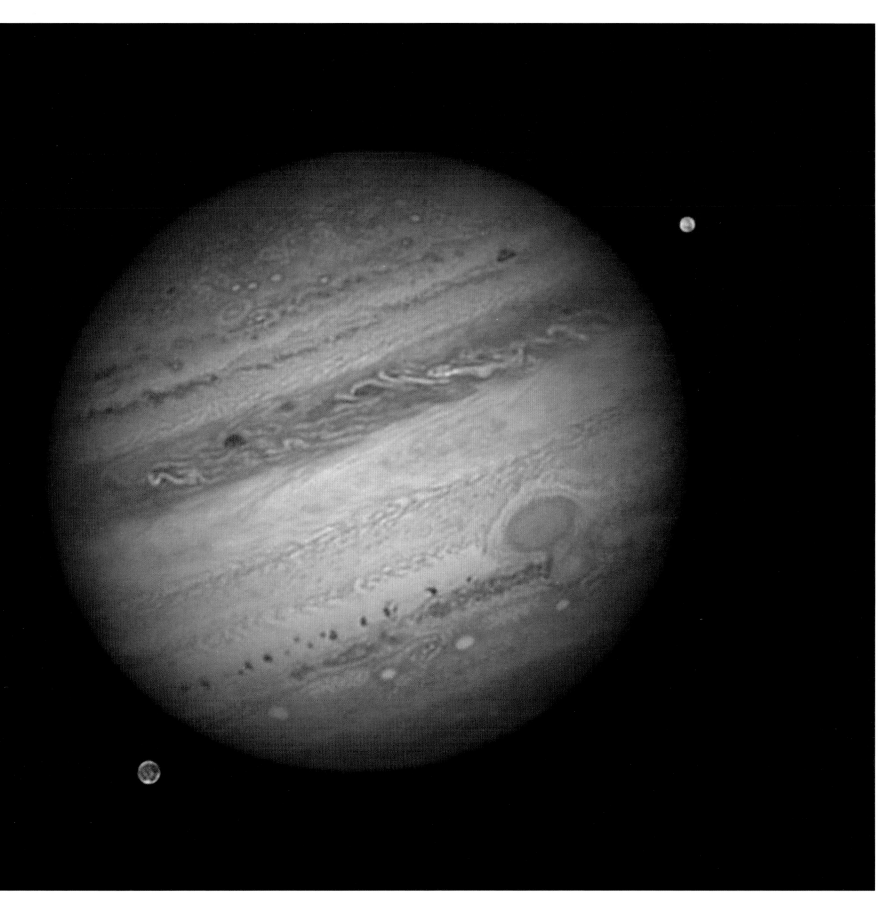

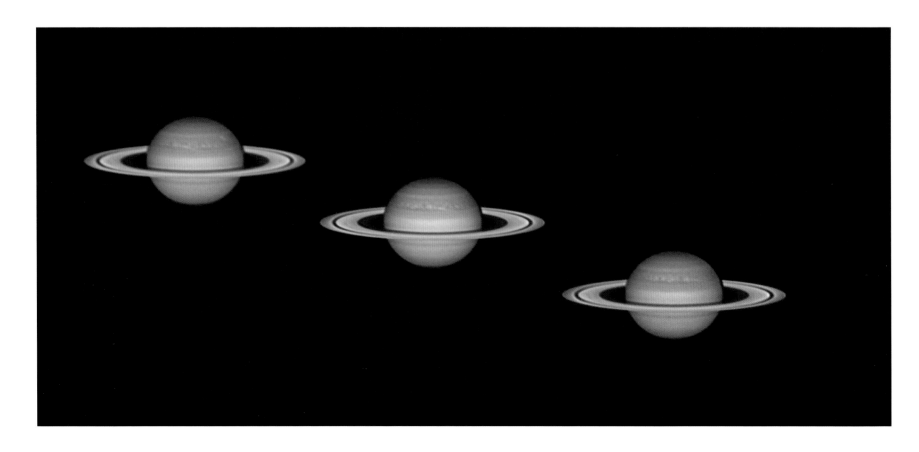

PAUL HAESE *(Australia)* *RUNNER-UP*

Dragon Storm
[*29 March 2011*]

PAUL HAESE: This is the best image set I have obtained of Saturn. In the southern hemisphere we have been waiting a while for Saturn to climb high enough so we can get great detailed images.

BACKGROUND: Saturn, the second largest planet in the Solar System, is best known for its brilliant rings. These rings are made up of countless ice and dust particles orbiting the planet in intricate patterns, some of which can be seen in this series of photographs. Taken about forty minutes apart, these images show the progress of a huge storm, called the Dragon Storm, moving in Saturn's upper atmosphere as the planet rotates.

Peltier cooled Celestron 356mm Schmidt-Cassegrain telescope (C14); PGR Flea3 CCD camera

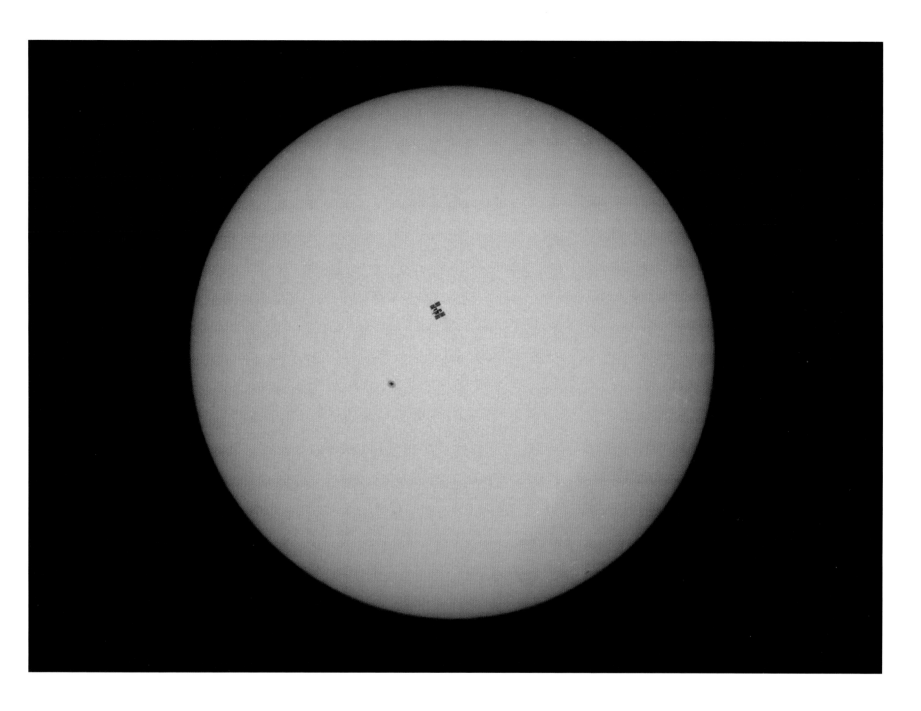

Λ

DANI CAXETE *(Spain)* *HIGHLY COMMENDED*

ISS and Endeavour Crossing the Sun
[*21 May 2011*]

DANI CAXETE: My dream was to immortalize the ISS (International Space Station) with the space shuttle *Endeavour* despite my novice-level knowledge and my humble equipment. I am very proud of the results achieved.

BACKGROUND: A perfectly timed photograph captures a silhouette of the International Space Station and docked space shuttle *Endeavour* as they passed in front of the Sun in less than half a second. Features of the Sun's photosphere – or visible layer – can also be seen, including a grainy texture resulting from the bubbling motion of gas at 6000 degrees Celsius. A dark spot to the left of the ISS is a sun spot, containing cooler gas, which is caused by intense magnetic activity.

Celestron 127mm Schmidt-Cassegrain telescope (C5); Nikon D7000 camera

Λ

GEORGE TARSOUDIS (Greece) HIGHLY COMMENDED

Crater Petavius
[8 February 2011]

GEORGE TARSOUDIS: I started astrophotography accidentally in 2005 in my town, Alexandroupolis, in the northeast of Greece. I like to take lunar and planetary photos at high resolution. The Crater Petavius is perhaps one of the strangest craters on the Moon that I have noticed since I started shooting the Moon.

BACKGROUND: The Moon's many craters have been formed by meteorites, asteroids and comets which have crashed into the lunar surface over billions of years. Craters can range in size from a few centimetres to hundreds of kilometres. The large crater to the lower right of this photograph is almost 200 kilometres wide and over three kilometres deep. It has a central peak reaching nearly two kilometres from the crater floor.

250mm (10-inch) Newtonian reflector telescope; Unibrain Fire-I 785 camera

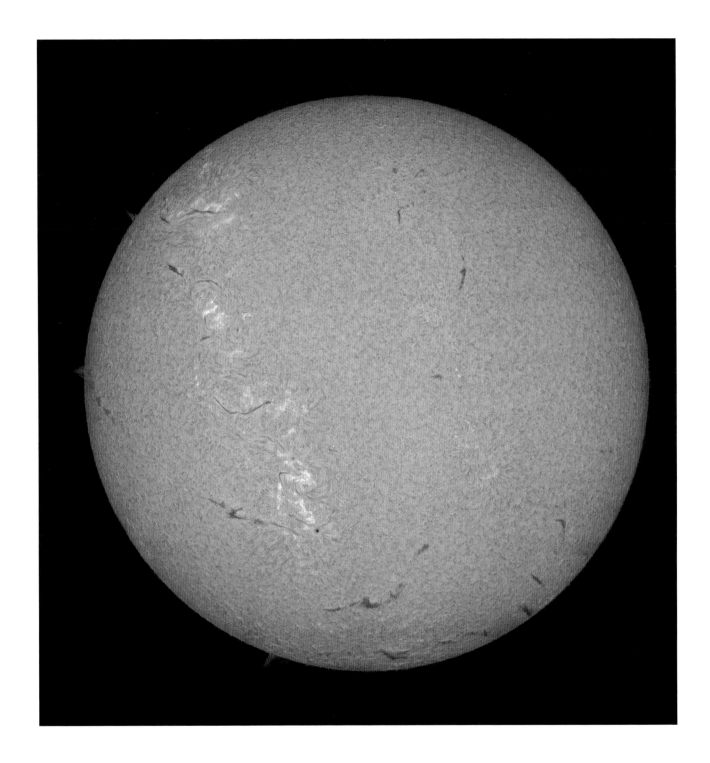

PETER WARD *(Australia)*

HIGHLY COMMENDED

May 7th Hydrogen-Alpha Sun
[*7 May 2011*]

PETER WARD: The dynamics of the solar chromosphere change on a daily basis. I enjoy documenting these features, which unlike the majority of astronomical subjects can literally change in minutes.

BACKGROUND: This image shows details of the Sun's chromosphere, a thin layer of the Sun's atmosphere. It was taken through a filter which isolates red light emitted by very hot hydrogen gas. The chromosphere contains gas with temperatures of up to 20,000 degrees Celsius. Dense tubes of cooler gas can be seen as dark filaments across the disc of the Sun or bright red prominences emerging at its edge.

Astro-Physics EDF155 refractor telescope; Coronado 90mm H-alpha filter; SkyNyx 2-2 planetary camera

MARCO LORENZI (Italy)

Vela Supernova Remnant
[*5 February 2011*]

MARCO LORENZI: I've always been inspired by supernova remnants, in particular by their reach and their different compositions. After all, several of the building bricks of life are created during these apocalyptic events.

BACKGROUND: This intricate structure is the aftermath of a supernova explosion, the violent death of a star many times more massive than the Sun. It took place over 10,000 years ago. Seen against stars and gas in the disc of our Milky Way, this expanding shell of debris and heated gas now covers an area of the sky which is twenty times wider than the disc of the full Moon.

Pentax 67 DEIF 300mm (12-inch) telescope; FLI Proline 16803 CCD camera

"This is a lovely picture of the Vela Supernova Remnant, so far as I know not quite the same as anything else in the sky. This splendid picture shows the details clearly. Such a pity we weren't there to see the supernova go off!"

SIR PATRICK MOORE

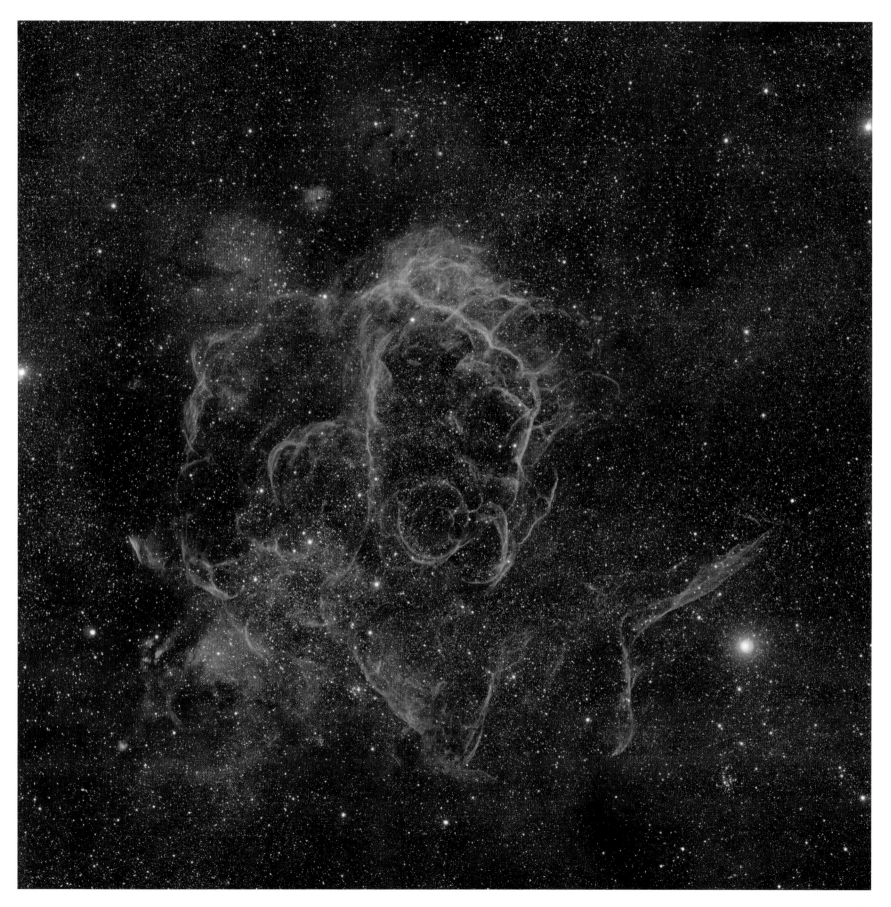

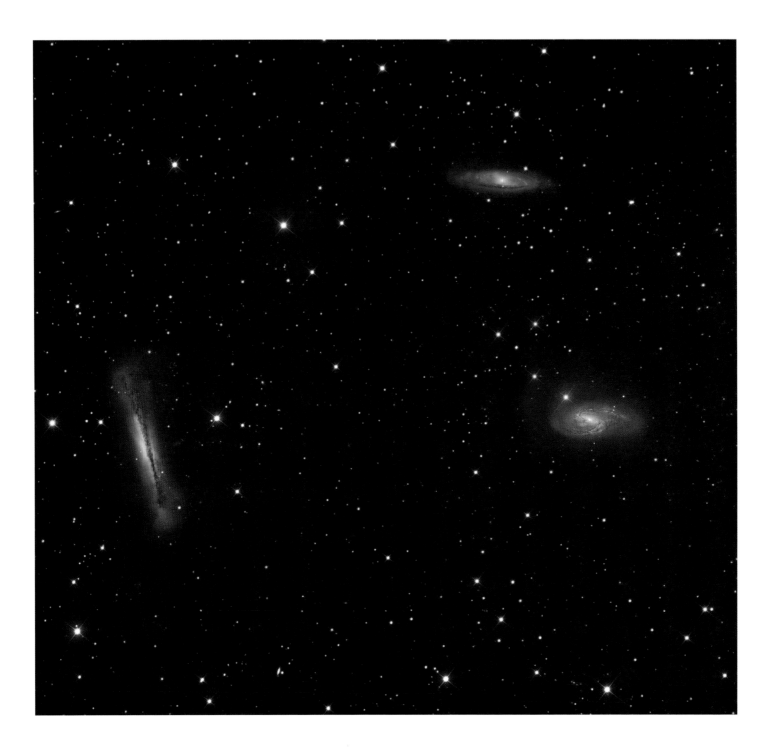

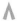

EDWARD HENRY *(USA)* *RUNNER-UP*

Leo Triplet
[*4 April 2011*]

EDWARD HENRY: I decided to create this image because I wanted a high-resolution shot of what is normally a low-resolution, wide-field image. This required a composite image, layering data from two different scopes, which gave me the desired effect.

BACKGROUND: The Leo Triplet is a group of three spiral galaxies located thirty-five million light years away. Like our own Milky Way, they are disc-like galaxies. They contain billions of stars with bright knots of gas and dark dusty lanes, which trace spiral patterns where new stars are formed. The galaxy on the left is seen edge-on, as we view our own galaxy.

356mm (14-inch) F10 Schmidt-Cassegrain telescope and TMB 130mm telescopes; STL 4020 camera

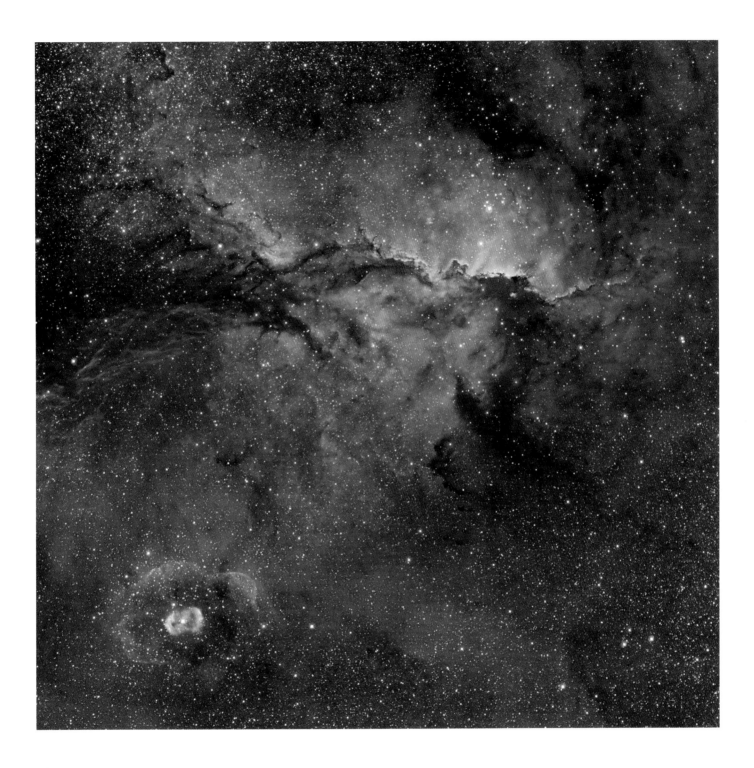

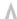

MICHAEL SIDONIO *(Australia)* *HIGHLY COMMENDED*

Fighting Dragons of Ara (NGC 6188 and 6164)
[*22 May 2011*]

MICHAEL SIDONIO: I wanted to showcase this beautiful piece of Ara in a fresh, new way that would highlight the amazing structures and also reveal the rarely imaged faint expanding shell around NGC 6164.

BACKGROUND: Powerful emissions of light and matter from hot, young stars are able to heat up and shape the clouds of gas and dust from which they form. The 'dragons' in this photograph have been shaped by the recent birth of stars much bigger and brighter than our Sun. One such star can be seen to the lower left of the image within two shells of glowing gas.

Orion Optics 300mm (12-inch) F3.8 corrected Newtonian astrograph telescope; FLI ProLine 16803 camera

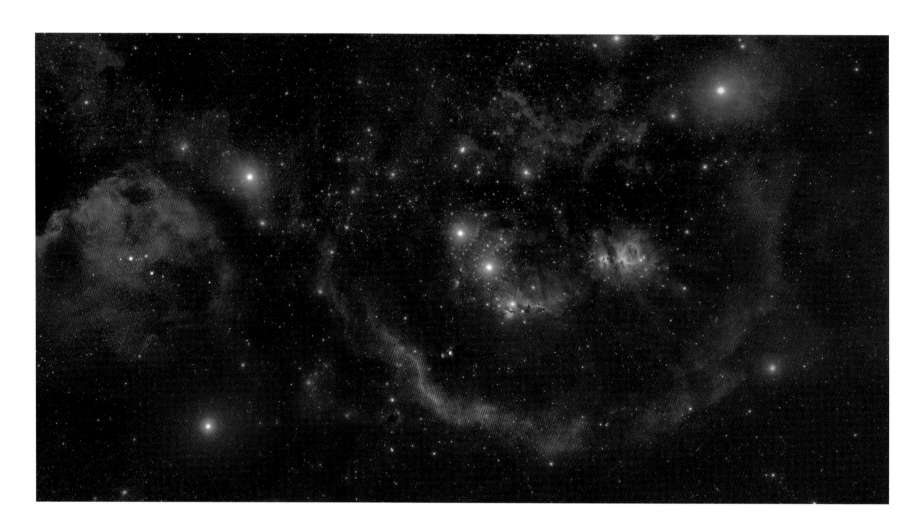

∧

ROGELIO BERNAL ANDREO *(USA)* *HIGHLY COMMENDED*

Orion, Head to Toe
[13 July 2011]

ROGELIO BERNAL ANDREO: What moved me to embrace this ambitious project was the fact that I wanted to see all of the wonders of Orion in one colour frame at a resolution higher than what was already available.

BACKGROUND: This image places the bright stars of a familiar constellation within a skyscape of fainter stars, gas and dust, which is invisible to the naked eye. Orion the Hunter, one of the most prominent winter constellations in the northern hemisphere, is laid out from left to right in this photograph. A huge cloud of gas and dust in which new stars are forming lies below the three stars of Orion's belt, while bright red and blue supergiant stars mark his armpit and foot.

Takahashi FSQ 106 telescope; SBIG STL 11000M CCD camera

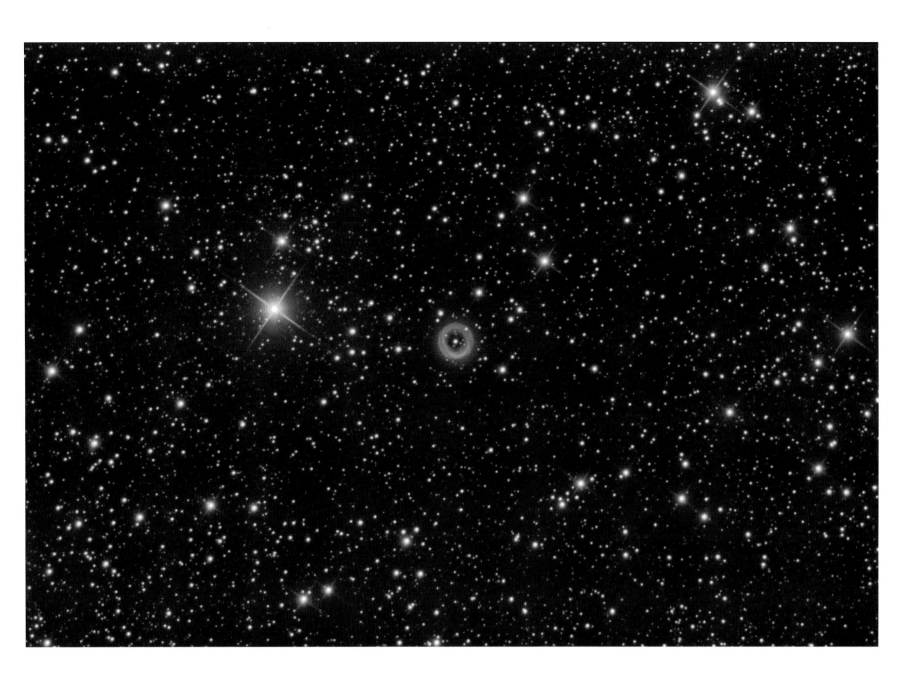

STEVE CROUCH *(Australia)*　　　*HIGHLY COMMENDED*

Planetary Nebula Shapley 1
[*28 May 2011*]

STEVE CROUCH: I've always been interested in imaging obscure objects. Shapley 1 is best known from the David Malin image of it and I wanted to try and do one at least as good. I was surprised at how well it came out which shows how much imaging technology has advanced since David took his shot in the 1980s.

BACKGROUND: When viewed through a small telescope, planetary nebulae like Shapley 1 resemble nearby planets in our solar system. They are, in fact, distant regions of hot, glowing gas ejected by stars as they run out of fuel at the end of their lives. The colours visible in the ring are caused by the temperature and chemical composition of the material this star has returned to its environment.

12.5-inch RCOS Ritchey Chretien telescope; SBIG STL 6303E CCD camera

HARLEY GRADY (USA)

Zodiacal Light on the Farm
[*25 February 2011*]

HARLEY GRADY: Growing up far away from the city lights, I was always fascinated with the night sky. When I began college I had the opportunity to take some astronomy classes. I soon began to combine my love of photography with astronomy and began documenting the night sky.

BACKGROUND: The faint glow reaching into the sky from the horizon to the right of the barn in this scene is known as zodiacal light. Visible only in extremely dark skies, it results from sunlight reflecting off dust particles in our solar system.

Canon 5D Mark II DSLR camera; 16–35mm lens

"I love the calm of this image but there's a lot going on, from the gentle glow of zodiacal light, to the starlit night sky and even a couple of satellites. A memorable shot!"

CHRIS LINTOTT

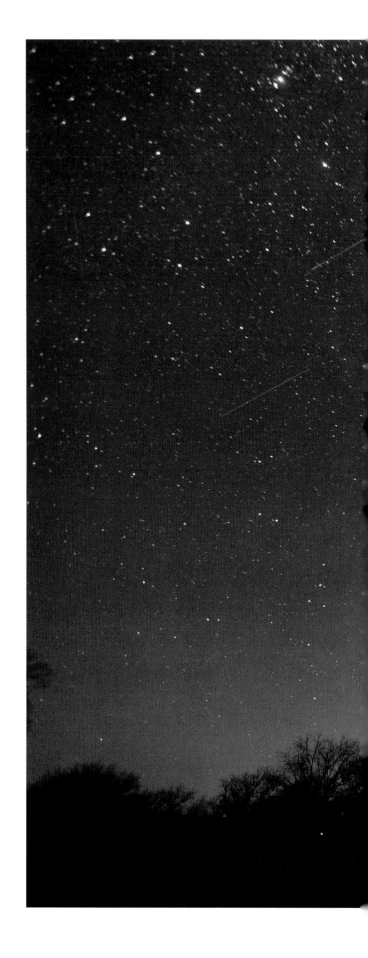

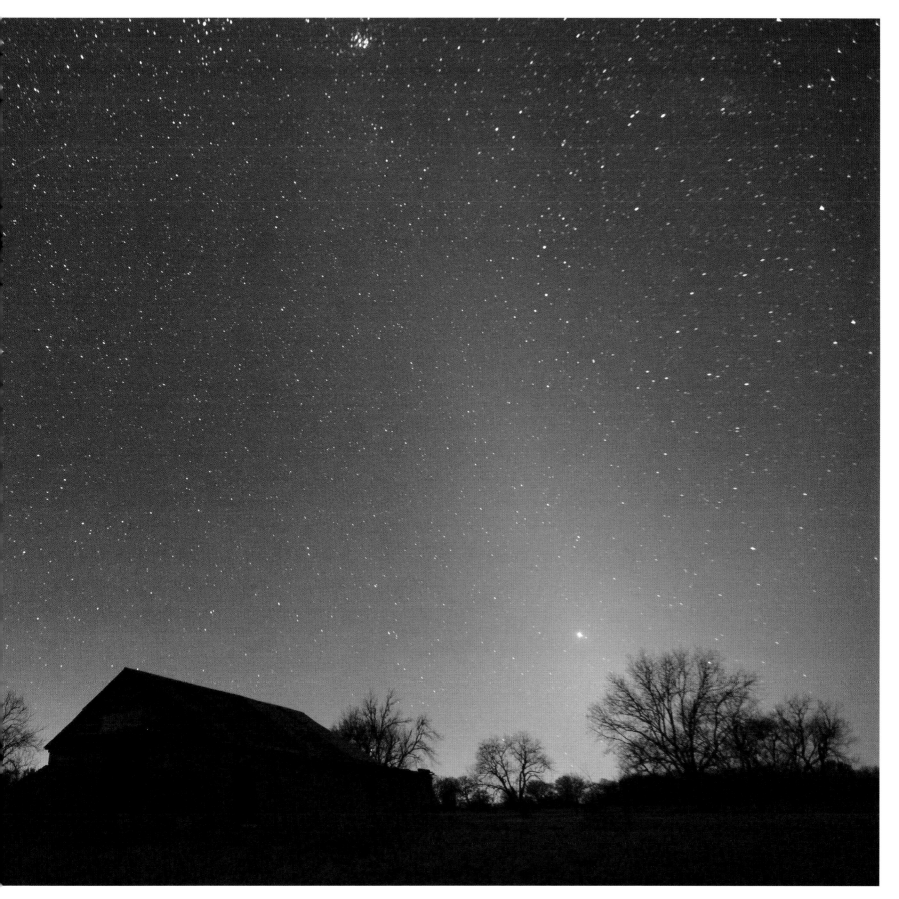

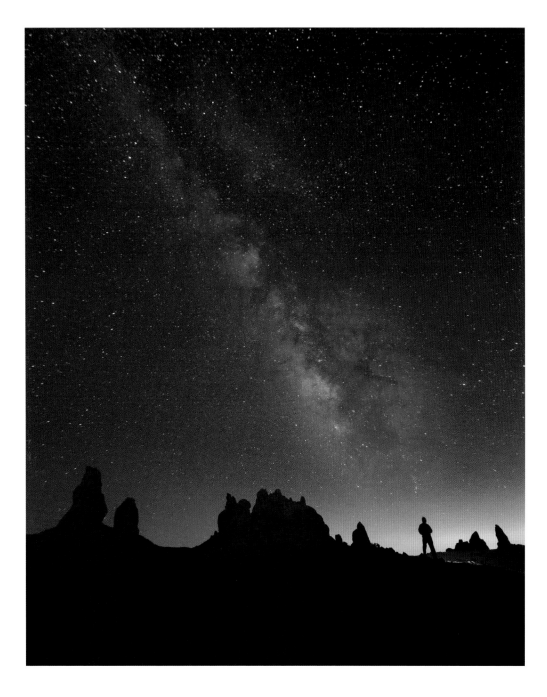

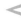

JEFFREY SULLIVAN (USA) *WINNER*

Stargazing
[30 June 2011]

JEFFREY SULLIVAN: This is a self-portrait under the Milky Way. I was having too much fun pursuing the Milky Way and star-trail photos to sleep, but after catching sunrise I eventually caught a couple of hours of sleep.

BACKGROUND: In remote locations, dark skies make it possible to see thousands of stars using just your eyes. When the sky is lit by the Sun, Moon or artificial lights on Earth, it blocks the view of all but the brightest stars.

Canon 5D Mark II DSLR camera; 525 separate exposures

"Jeffrey Sullivan's image is striking in its grandeur, showing off both the Milky Way and the spectacular scenery on the ground. It puts humankind in perspective, reminding us how small a part of the Universe we are, and how much of it is inhospitable to humankind."

GRAHAM SOUTHORN

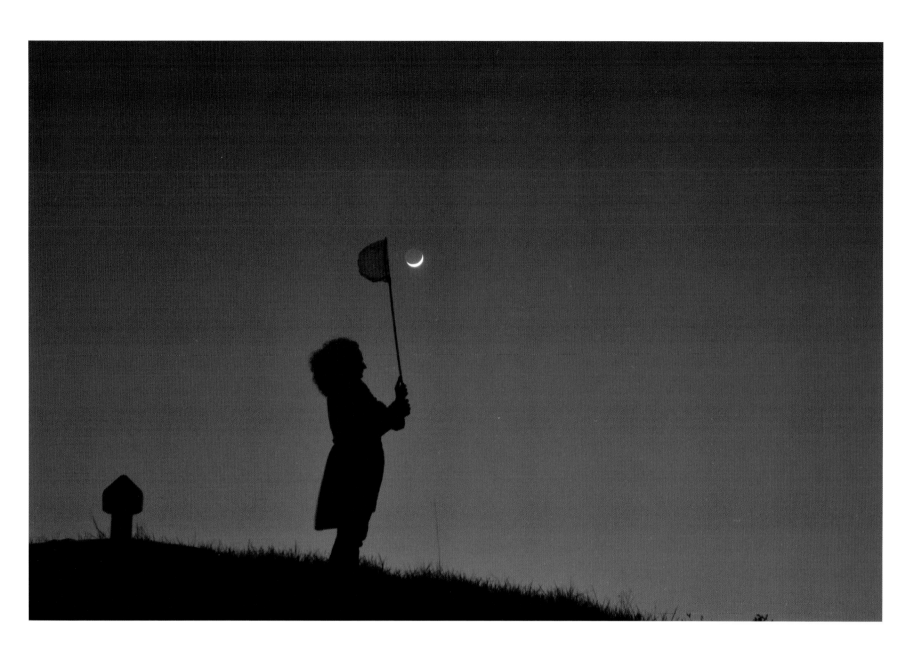

JEAN-BAPTISTE FELDMANN *(France)*　　　*RUNNER-UP*

Hunting Moon
[*6 April 2011*]

JEAN-BAPTISTE FELDMANN: I have made images of astronomical environments for over thirty years. If I had to redo this picture, I think I would ask a child to hold the net; the image would probably be even more poetic.

BACKGROUND: A playful silhouette places an Earth-bound Moon-catcher in pursuit of the waxing crescent Moon in the early evening sky. The bright crescent is the part of the Moon lit directly by the Sun. The rest of the face of the Moon is also visible, although much fainter, owing to reflected light from the Earth, known as earthshine.

Nikon D3100 digital camera; Samyang 18–55mm lens

MARCO LORENZI *(Italy)*

Shell Galaxies (NGC 474 and NGC 467)
[5 February 2011]

MARCO LORENZI: These galaxies have been on my 'to-do' list for a very long time, since I saw a professional image of NGC 474 long ago showing its complex structure, like ripples in a pond.

BACKGROUND: In the upper left of this photograph, faint billowing shapes can be seen in the outer regions of an elliptical galaxy. Elliptical galaxies, which can contain up to a trillion stars, are typically smooth and shaped like a rugby ball. The delicate, wispy sheets seen in this galaxy may result from its gravitational interaction with the nearby spiral galaxy to the right.

RCOS 14.5-inch f/9 telescope; APOGEE U16 CCD camera

"It's the vast variety of objects in this scene – nearby stars and distant galaxies of different shapes, colours and sizes – that makes this unusual image such a beautiful and intriguing window on the Universe for me."

OLIVIA JOHNSON

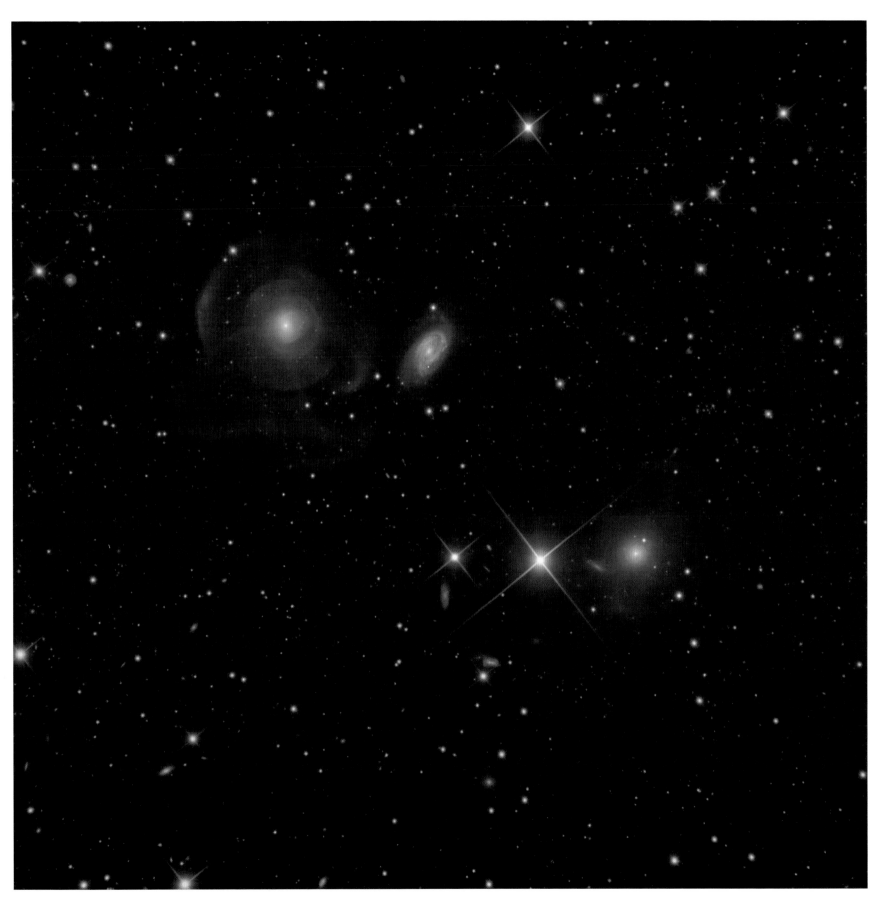

JATHIN PREMJITH *(India)*, AGED 15 *WINNER*

Lunar Eclipse and Occultation
[15 June 2011]

JATHIN PREMJITH: I was always fascinated by the coppery-red colour of the Moon during the total lunar eclipse. Also, it was interesting to note that not all lunar eclipses are the same, as the colour can change from light red to dark red depending on the position of the Moon and the amount of dust or pollution in the atmosphere at that time.

BACKGROUND: A lunar eclipse is a brief alignment of the Sun, Earth and Moon which places the Moon in the Earth's shadow. Here, the Moon is a red colour because it is lit by sunlight which has been filtered through the Earth's atmosphere. The photograph skilfully captures a second fleeting astronomical event, the moment a star appears from behind the orbiting Moon.

Celestron CPC800 203.3mm (8-inch) Schmidt-Cassegrain telescope; Canon 5D Mark II DSLR camera

"The judges are always hugely impressed by the quality of the Young Astronomer entries. For me, this is one of the most striking images in the competition. The colour of the eclipsed moon, reflecting the red of sunsets all over Earth, is both delicately beautiful and truly majestic. The photographer has also captured just the right moment, with a bright but tiny star close to occultation."

REBEKAH HIGGITT

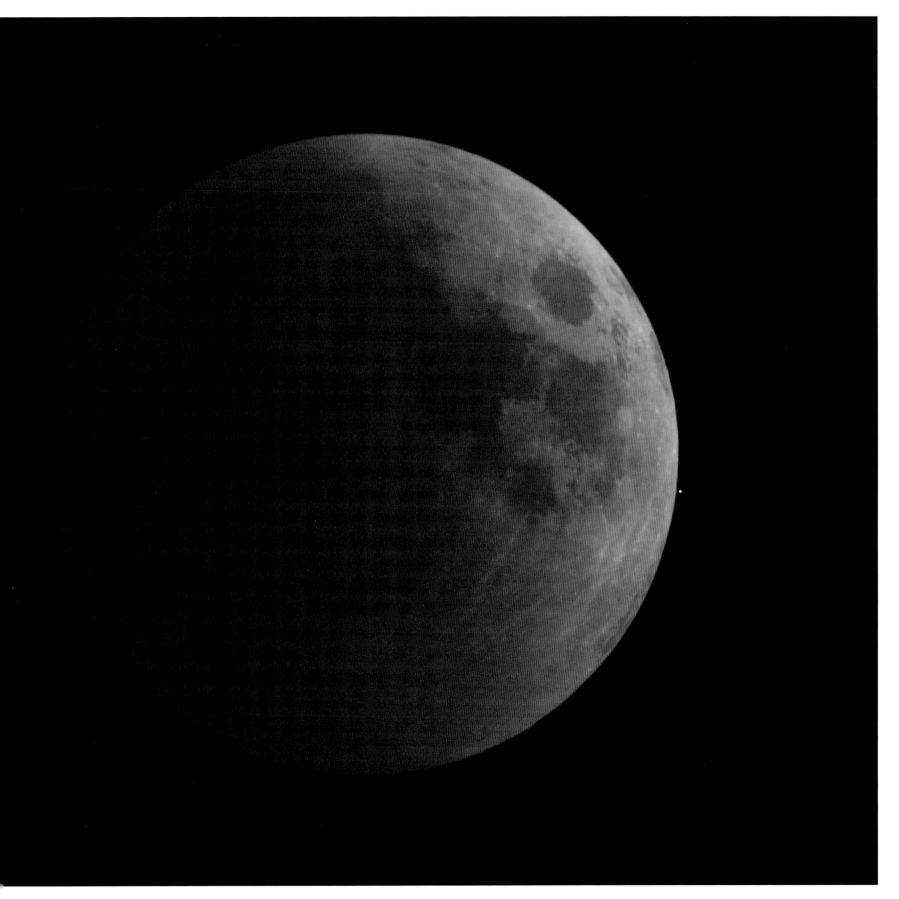

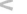

Starry Night Sky

[30 June 2011]

NICOLE SULLIVAN: The way the stars move around the North Star fascinates me, so I took the picture to show everyone just how cool it really is.

BACKGROUND: Most stars, like the Sun, appear to move across the sky from east to west as the Earth spins on its axis every twenty-four hours. This long-exposure photograph captures the apparent motion of the stars that seem to circle the area in the sky over the Earth's North Pole close to the Pole Star.

Canon 40D DSLR camera

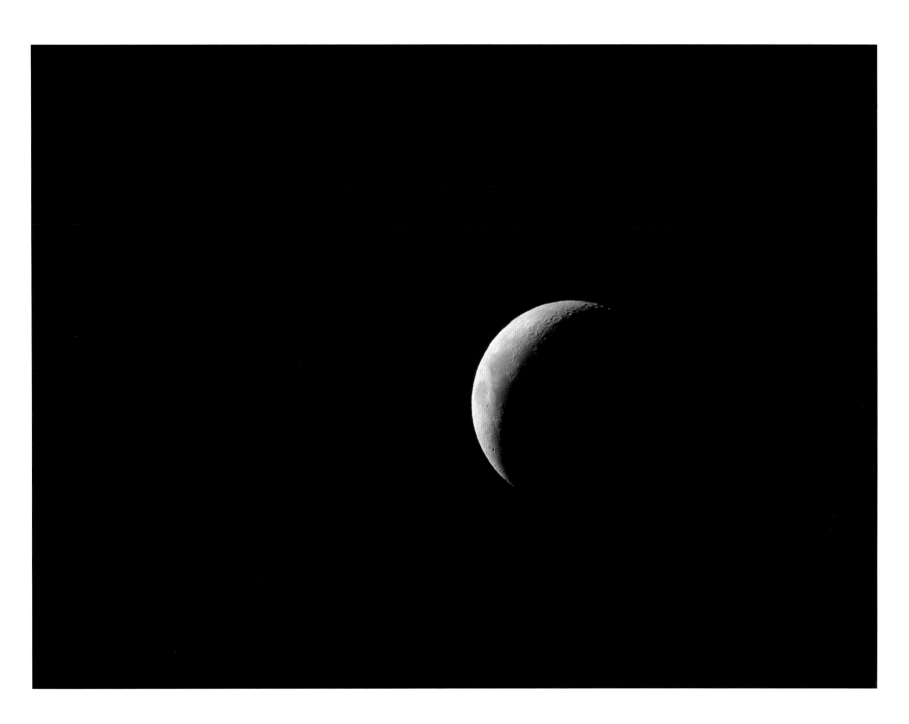

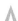

PETER PIHLMANN PEDERSEN *(UK)*, **AGED 15** *HIGHLY COMMENDED*

Lonely Moon
[*9 March 2011*]

PETER PIHLMANN PEDERSEN: I took this photo because I have had an interest in astronomy since a course in astronomy was offered in my school for GCSE. Since then, astronomy has been one my best hobbies.

BACKGROUND: Like the Earth, one half of the Moon is always lit by the Sun. It is the relative positions of the Earth, Moon and Sun that determine how much of this illuminated side we see from the Earth. Here a crescent moon displays a sliver of the Moon's sunny side.

Skywatcher 114mm (4.5-inch) Newtonian reflector telescope; FinePix J250 compact digital camera

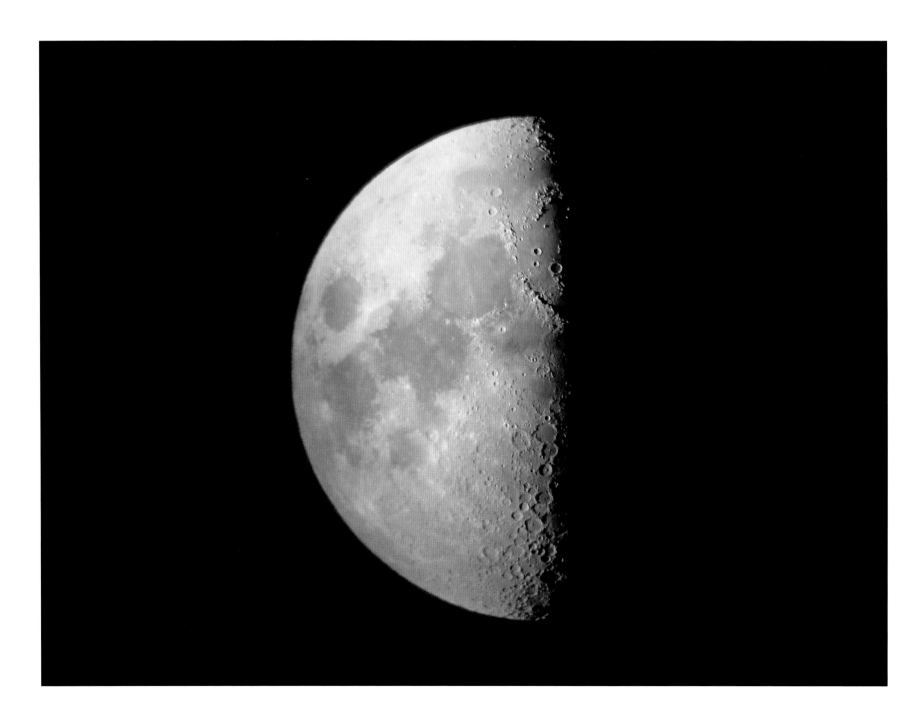

Λ

TOM CHITSON *(UK)*, AGED 15 *HIGHLY COMMENDED*

First-Quarter Moon
[*8 July 2011*]

TOM CHITSON: Last year at school, I had the opportunity to do a GCSE in astronomy. Our teacher for astronomy was very enthusiastic and got everyone in the class interested in the subject. From the first day of getting my telescope, I have been taking photos of the Moon, Saturn and Jupiter, all by just pointing a camera through the eyepiece of the telescope.

BACKGROUND: The features on the Moon that are easiest to see are close to the terminator, the boundary between the sunlit and dark sides. In this photograph, the craters and rugged mountain ranges stand out in sharp relief close to the terminator. The smooth, dark areas are lunar *maria* or 'seas', filled with dark lava which solidified billions of years ago.

Celestron Nexstar 4SE 102mm (4-inch) Maksutov-Cassegrain telescope; Sony Cybershot W210 compact digital camera

JESSICA CATERSON (UK), AGED 15 *HIGHLY COMMENDED*

Winter's Moon
[*18 December 2010*]

JESSICA CATERSON: I got into astrophotography through a friend, who saw a programme about taking pictures of stars, and I had a go and thought it was cool. So I started taking interest in adding astronomy to my pictures where I could. Astronomy has always interested me and I enjoyed learning about it in science at school. By discovering the photography aspect I have appreciated it more and more.

BACKGROUND: While the Moon is most evident in the night sky, it is visible during the daytime for much of its monthly orbit around the Earth. This nearly full Moon, called a waxing gibbous Moon, is rising in the east in a wintry afternoon sky.

Nikon D5000 DSLR camera; 18–55mm lens

ASTRONOMY ✦ PHOTOGRAPHER
OF THE YEAR

earth and space

our solar system

deep space

best newcomer

people and space

robotic scope

young astronomy photographer of the year

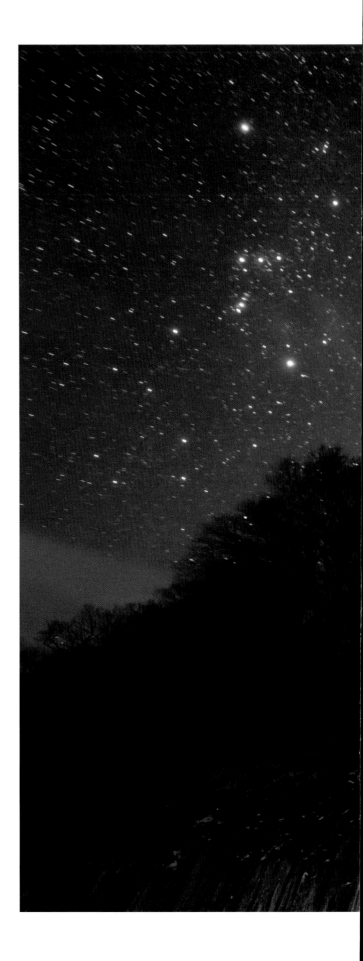

MASAHIRO MIYASAKA (Japan) *WINNER*

Star Icefall
[*8 January 2011*]

MASAHIRO MIYASAKA: The stars fell from the heavens.
The stars transformed themselves into an icicle.
Stars sleep eternally here.

BACKGROUND: Orion, Taurus and the Pleiades form the backdrop to this eerie frozen landscape. Though the stars appear to gleam with a cold, frosty light, bright-blue stars like the Pleiades can be as hot as 30,000 degrees Celsius. Cooler orange stars such as Betelgeuse and Aldebaran are still a scorching 3500 degrees Celsius.

Canon 5D Mark II camera; Samyang 14mm f/2.8 IF ED MC Aspherical lens; ISO 5000

"This image grabs you from the word go – the lines of ice naturally draw your eyes skyward towards the rich star fields above. I find there's a great visual balance here between the Earth and the sky and for me, this makes it a perfect picture for the category."

PETE LAWRENCE

"One of my favourite images of the competition. Dark, moody with a great angle. It looks like fine art."

MELANIE GRANT

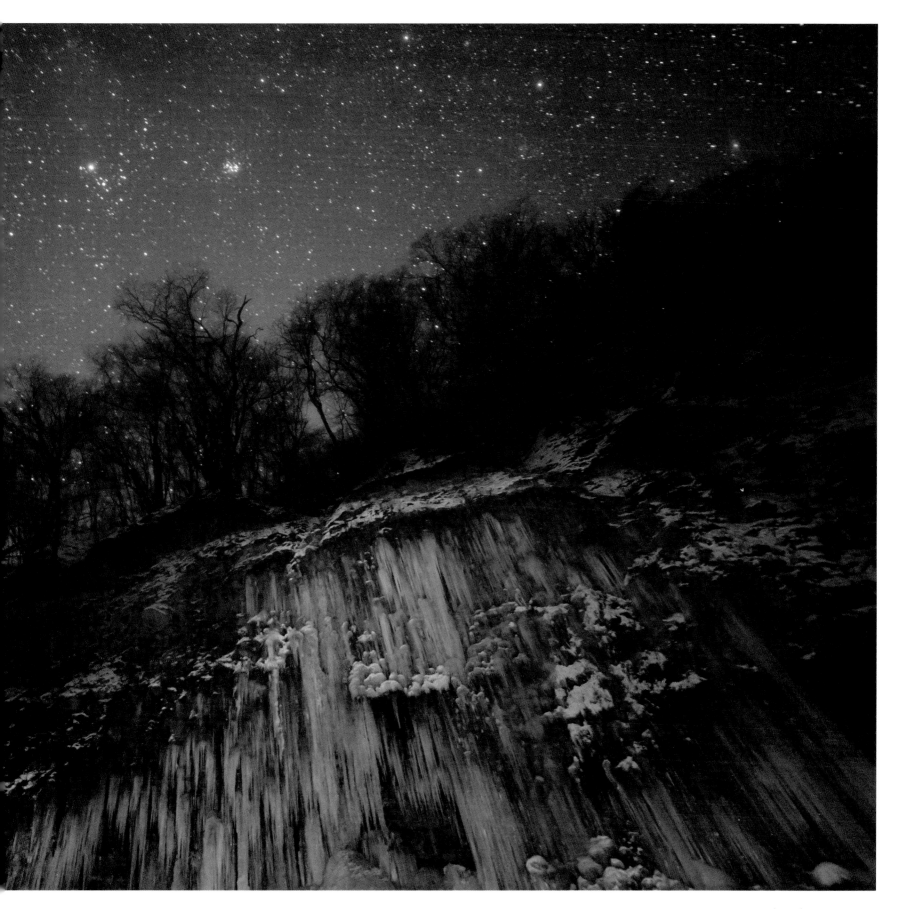

ARILD HEITMANN *(Norway)* *RUNNER-UP*

Green World
[*22 January 2012*]

ARILD HEITMANN: This is a special shot for me since it captures the intense feeling of standing deep in the mountains, far away from light pollution, watching the finest light show on the planet!

BACKGROUND: The shimmering curtains of the *aurora borealis* trace the shifting patterns of the Earth's magnetic field. The eerie green light in this image comes from oxygen atoms high in the atmosphere, which have been energized by subatomic particles from the solar wind.

Canon 5D camera; 16–35mm f/2.8 lens at 16 mm; ISO 1600; 23-second exposure

"In this image, the curves and folds in the Earth's magnetic field lines are beautifully depicted by a sky full of green aurora. There's a great balance here between the frozen landscape and the spectacle above. I particularly like the perspective of the trees as they appear to diminish in size from right to left combined with the aurora becoming less detailed from top to bottom as the elements of the display increase in distance from the camera. For me, this is a great and pleasing composition."

PETE LAWRENCE

"This wonderful image really gives a sense of what it's like to stand under a display of the Northern Lights. I love the tranquillity of the shot and the way the glow of the aurora casts a soft green light over the snowy landscape."

WILL GATER

"This wonderfully eerie image brings a new twist to the aurora borealis. I like the softness of the snow and the wildness of the trees."

MELANIE GRANT

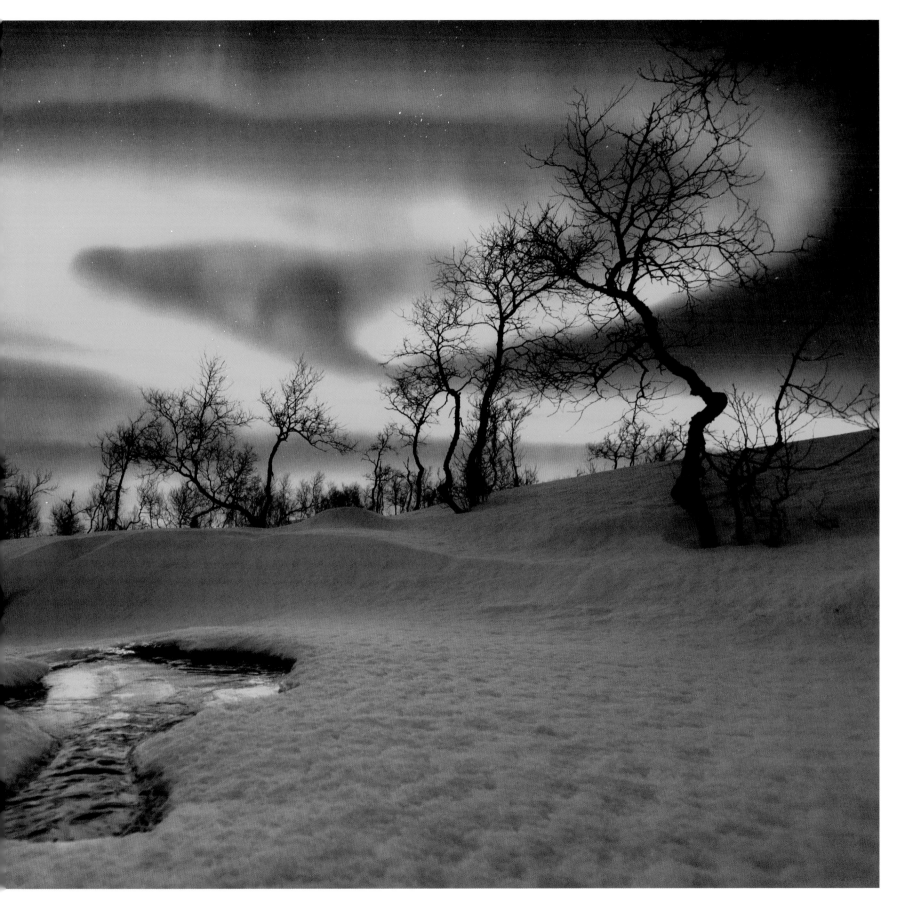

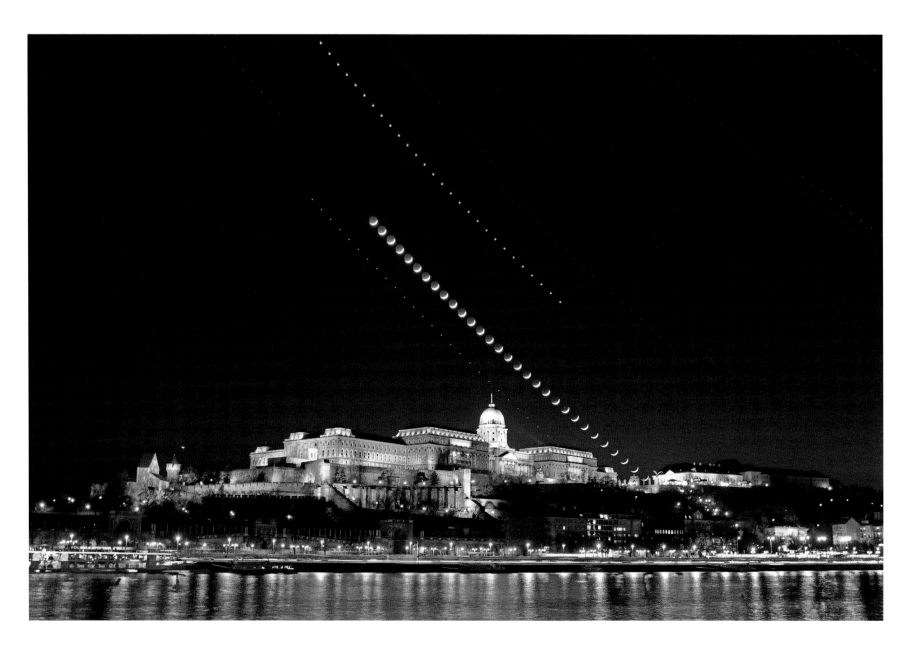

Λ

TAMAS LADANYI *(Hungary)*

Moon and Planets over Budapest
[*26 March 2012*]

TAMAS LADANYI: The conjunction of the Moon, Jupiter and Venus over Budapest, Hungary. A sequence of photos made this multi-exposure image and shows the Moon and planets gliding to the western horizon as the evening proceeded. Photographed here is the Buda Castle, a prominent icon of the Budapest World Heritage Site.

BACKGROUND: A series of regularly timed exposures captures the paths of Venus, the Moon and Jupiter as they set over the historic Buda Castle. Despite the light pollution of a major city, bright objects like these are still clearly visible even to the naked eye.

Canon 600D camera; Canon 16–35mm f/2.8 lens at 23mm; ISO 1600; 1/2-second exposure

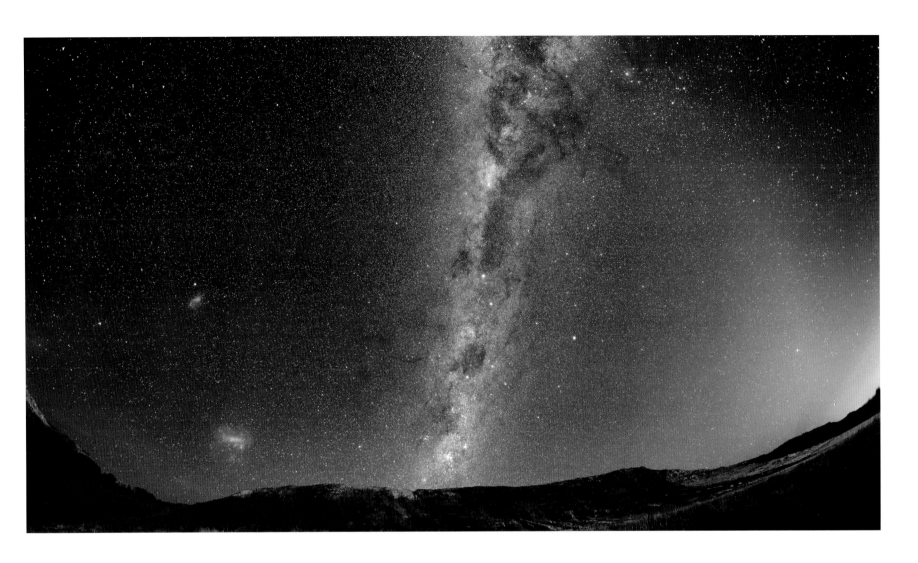

Λ

LUIS ARGERICH (*Argentina*)

Sources of Light
[*28 August 2011*]

LUIS ARGERICH: The Milky Way, the Magellanic Clouds and zodiacal light in a battle to illuminate the sky over the ancient hills of the Tandilia System.

BACKGROUND: As the title suggests, three different sources of light can be seen in this image. On the left are the most distant: two fuzzy patches of starlight which make up our companion galaxies, the Large and Small Magellanic Clouds. In the centre are the billions of stars which form our own Milky Way galaxy. On the right, closest of all, is the zodiacal light: a haze of sunlight reflected by tiny particles of dust within our solar system.

Canon 5D Mark II camera; Sigma 15 mm f/4 Fisheye lens; ISO 3200

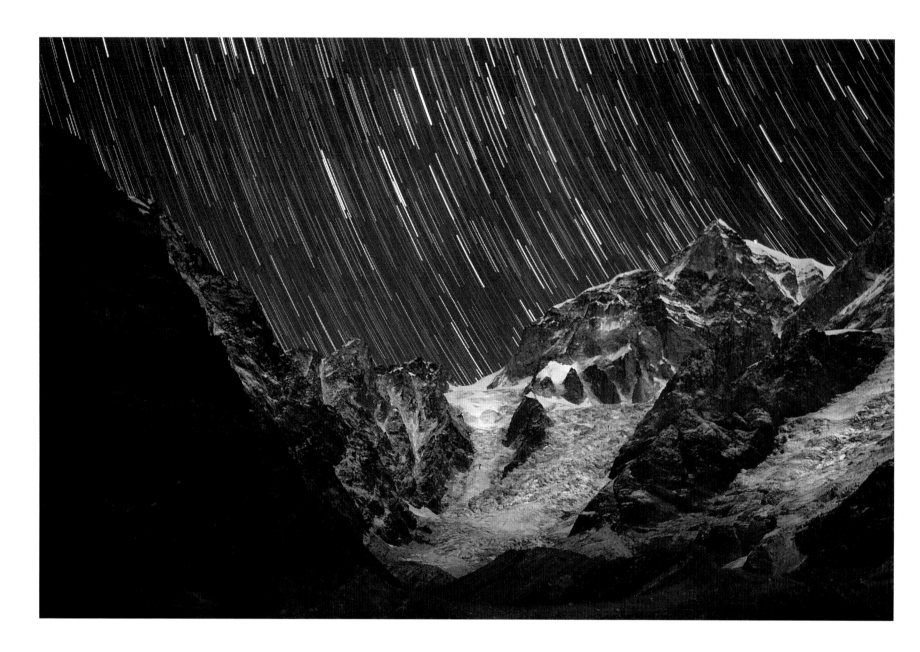

ATISH AMAN (India)

Star Trails over Moonlit Himalayas
[10 October 2011]

ATISH AMAN: Kedarnath is located near the source of the River Mandakini at an altitude of 3580 metres above sea level. This photo was taken from a hilltop 3700 metres above sea level, about two kilometres away from the village.

BACKGROUND: The mighty Himalaya mountains were forced up from our planet's crust by immense tectonic processes millions of years ago. They form a suitably dramatic foreground for the slow turning of the Earth, shown by the star trails in this long exposure photograph.

Nikon D80 camera; 50mm f/1.8 lens

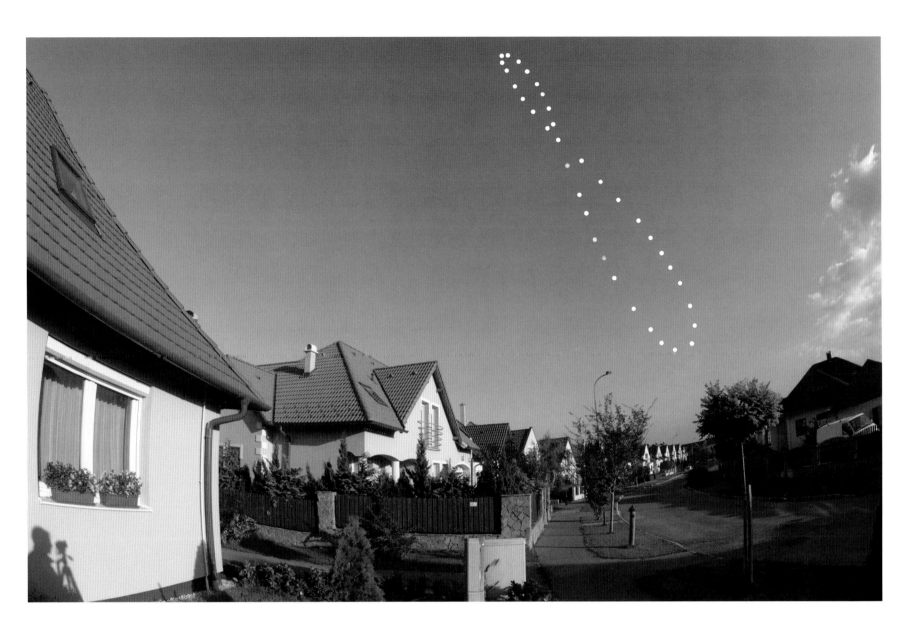

Λ

TAMAS LADANYI (*Hungary*)

Analemma over Hungary
[*9 October 2010*]

TAMAS LADANYI: This analemma shows the Sun's apparent motion observed from a fixed position on the Earth... Pictured in the foreground of this composite image is my house and neighbourhood in Veszprem, Hungary. The foreground image was made without a solar filter, in October, during the late afternoon when the Sun was on the other side of the sky, causing my shadow to appear on the wall.

BACKGROUND: An analemma is the apparent path traced out by an astronomical object in the sky as the Earth moves around its orbit. This clever and painstaking picture is composed of exposures of the Sun taken at the same time on thirty-five different days during one year. It clearly shows how the Earth's tilted axis and orbital motion cause the relative position of the Sun to alter, giving rise to seasonal changes in day length and temperature.

Canon 500D camera; Sigma 10mm f/2.8 lens

MASAHIRO MIYASAKA *(Japan)*

Christmas Stars Diamond
[*5 December 2010*]

MASAHIRO MIYASAKA: Last Christmas I climbed to an altitude of 3000 metres in the Japanese Alps to photograph the stars behind the beautiful Mount Kiso-Komagatake in Nagano. The light on the left comes from a resort hotel.

BACKGROUND: This breathtaking view of the night sky above snow-covered Japanese mountains includes the misty band of the Milky Way. The familiar stars of Orion rise above the peaks to the left of the picture. From left to right the stars Sirius, Betelgeuse and Capella are particularly prominent.

Canon 5D Mark II camera; Sigma 15mm f/2.8 EX DG Fisheye lens; ISO 5000; 33-second exposure

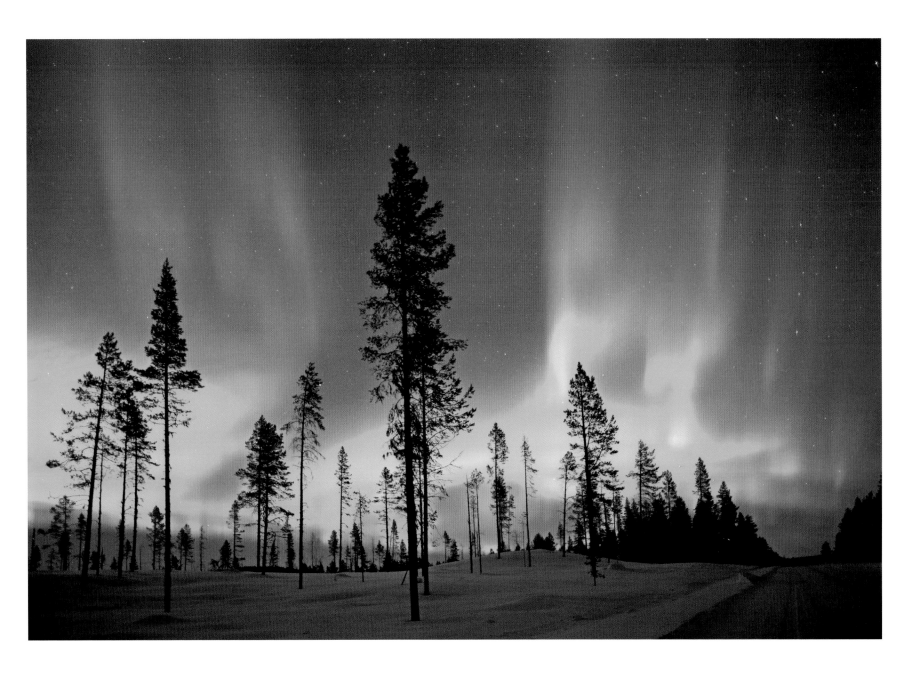

ANTONY SPENCER (*UK*)

Kiruna Aurora
[*5 March 2011*]

ANTONY SPENCER: I was forced inland from the coast at Tromsø due to the cloud and made a six-hour drive through the mountains and tundra to Kiruna where the forecast was better. I arrived with a small amount of daylight remaining and drove around scouting a decent location to photograph any aurorae. I couldn't believe my luck when I found these trees, just perfect. That night, even though no major aurorae were predicted, I witnessed a beautiful display for about an hour or so. I just loved the way the curtains of aurora danced between the pine trees here.

BACKGROUND: The *aurora borealis* shimmers over this northern landscape. Like all life on Earth, the trees on the ground are shielded from dangerous particles of the solar wind by our planet's magnetic field. The particles which manage to penetrate this magnetic barrier are absorbed by the atmosphere, creating these colourful light shows.

Canon 5D Mark II camera; 24mm f/1.4 lens; ISO 800; 8-second exposure

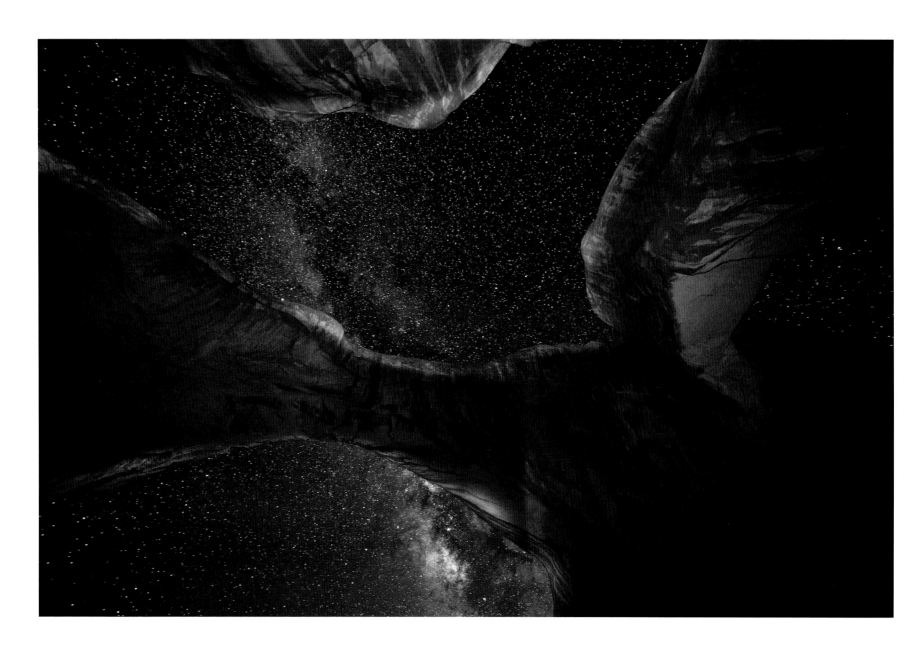

∧

BRAD GOLDPAINT (USA)

Galileo's Muse
[5 May 2011]

BRAD GOLDPAINT: This image offers a surprising view, and captures the imagination of anyone who dreams of unlocking the secrets of nature. A breakthrough idea can come from where we least expect it. Using his internal rhythms of imagination, Galileo found insight within humanistic roots of modern science, even when confronted by his own limitations.

BACKGROUND: The span of this natural rock arch echoes the even vaster (and much older) span of the Milky Way, which arches across the sky above it. Our galaxy is a vast disc of stars, dust and gas but, because our solar system lies within the disc itself, we see the Milky Way as a band of light, stretching right around the sky.

Nikon D700 camera

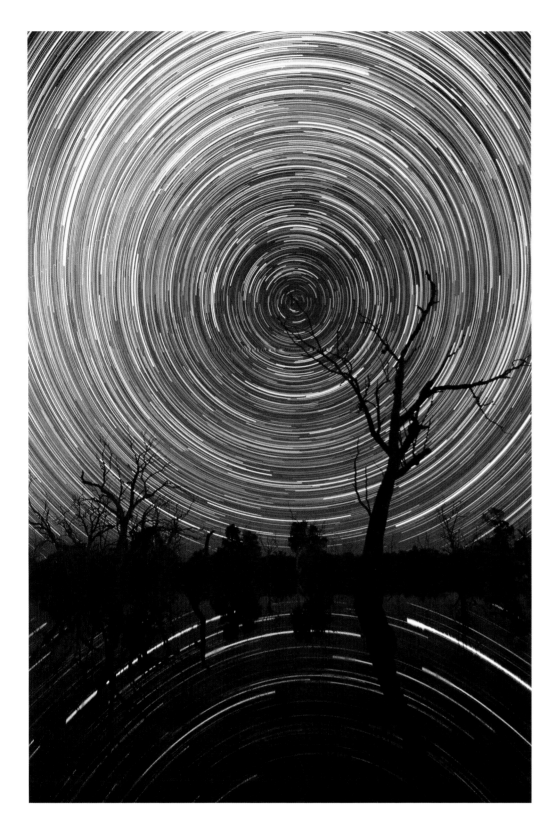

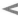

WAYNE ENGLAND (*Australia*)

Concentricity
[*7 May 2011*]

WAYNE ENGLAND: This star trail image is centred on the south celestial pole and reflected in Poocher Swamp near Bordertown, South Australia. The dead tree reaches up like a hand to the sky and the concentric circles give the optical illusion that the sides of the image are curved.

BACKGROUND: A long exposure shows the stars tracing mesmerizing circles around the sky's south pole as the Earth rotates. The mirror-like surface of the water in the foreground reflects the brighter stars.

Nikon D7000 camera; Tokina 12–24mm f/4 lens at 12mm; ISO 3200; 30-second exposure

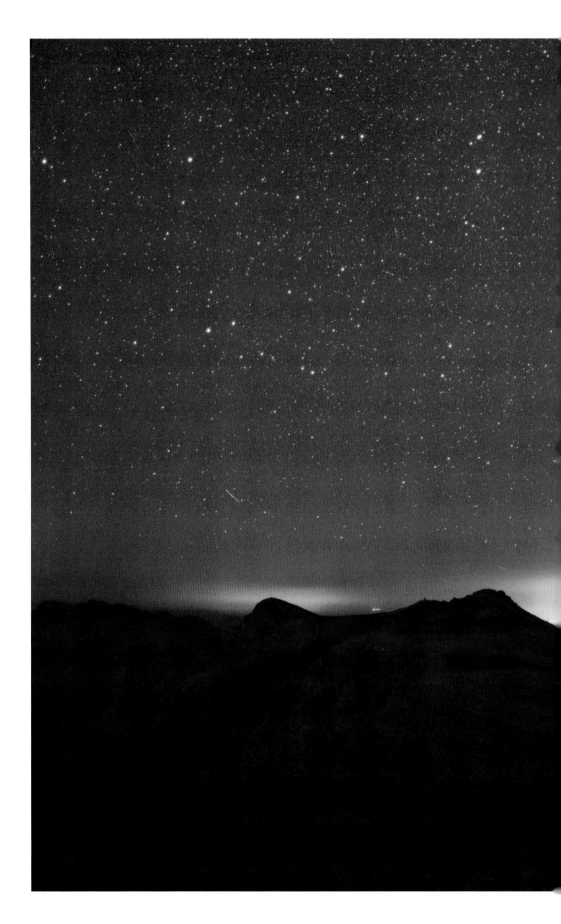

TUNÇ TEZEL *(Turkey)*　　HIGHLY COMMENDED

Sky away from the Lights
[*12 August 2010*]

TUNÇ TEZEL: In the evening of 12 August 2010, I went up to Uludag National Park near my hometown of Bursa, Turkey. My destination was the glacial lakes area and … my first aim was to catch the evening planets and the Moon before they set, and then watch the Perseids as the meteor shower peaked… The lights of towns and villages down below were greatly diffused by the dust, haze and humidity accompanying the heat wave of July–August 2010. Normally, it is either very clear or the lower lands are lost under the clouds all together.

BACKGROUND: The distant lights of towns and villages seem to be embedded into this landscape in Turkey, which has been the site of human civilization for thousands of years. The Milky Way above would have been a familiar sight to even the earliest settlers.

Hutech modified Canon 5D camera; 35mm f/2 lens at f/2.8; ISO 3200; 30-second exposure

"Two beautiful lightscapes compete for your attention here. The beauty and majesty of the star fields close to the centre of our galaxy compete with misty, man-made pockets of encroaching artificial light below."

PETE LAWRENCE

"This wonderfully atmospheric vista over a dark landscape is really put in context by the galaxy arcing over it: though the misty lights appear to stretch miles to a distant horizon, they are dwarfed by the stars and the band of the Milky Way. Tunç Tezel's picture also highlights the impact that man-made lighting is having on a precious natural resource – darkness."

CHRIS BRAMLEY

"Light pollution can be a big problem for astronomers but I like the way this picture makes a virtue of necessity, using the artificial lights to create a rather beautiful contrast with the night sky."

MAREK KUKULA

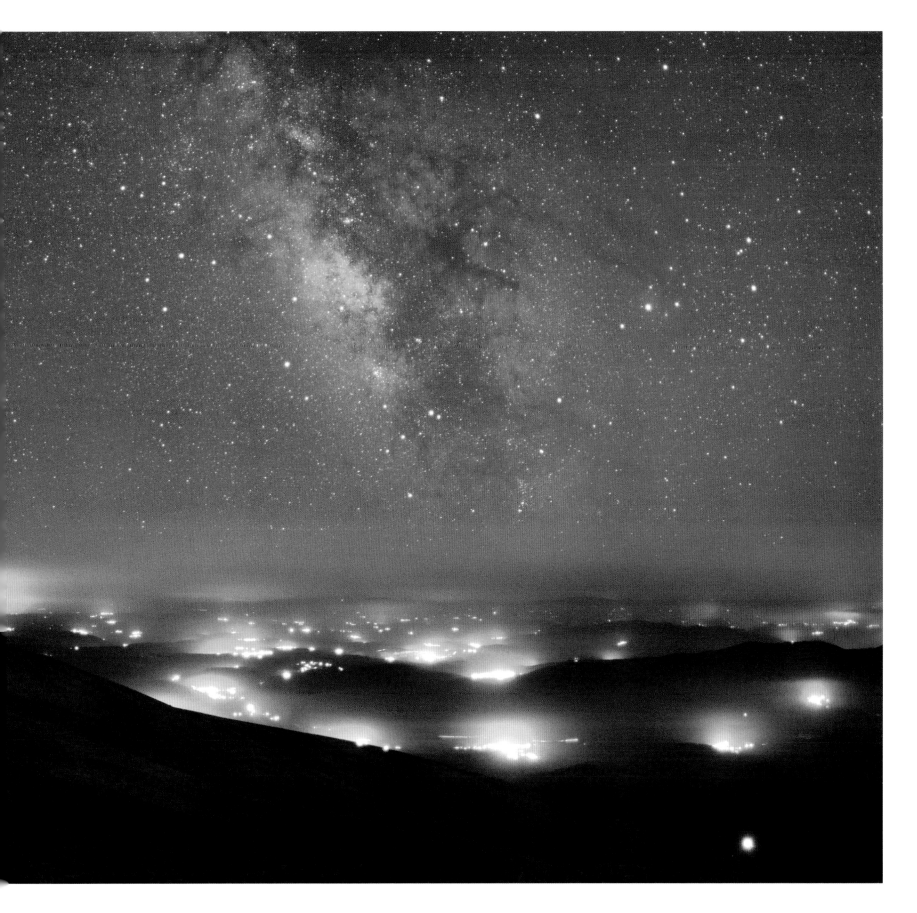

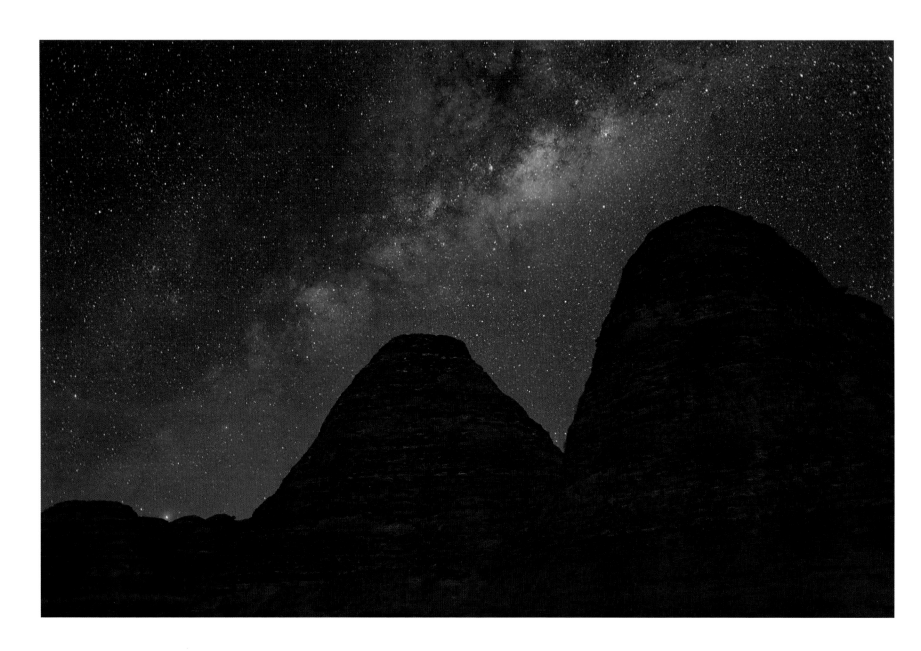

Λ

COLIN LEGG *(Australia)*

Galactic Domes
[1 July 2011]

COLIN LEGG: The image was taken at the Bungle Bungle Range, Purnululu National Park, Western Australia. A crescent Moon lights the landscape and the slope of the domes nicely matches the plane of our Milky Way galaxy.

BACKGROUND: The myriad stars visible in this view of the Milky Way demonstrate the excellent dark skies which can be enjoyed in remote regions. Here in Western Australia, far from the light pollution of towns and cities, the most spectacular night skies can be enjoyed.

Canon 5D Mark II camera

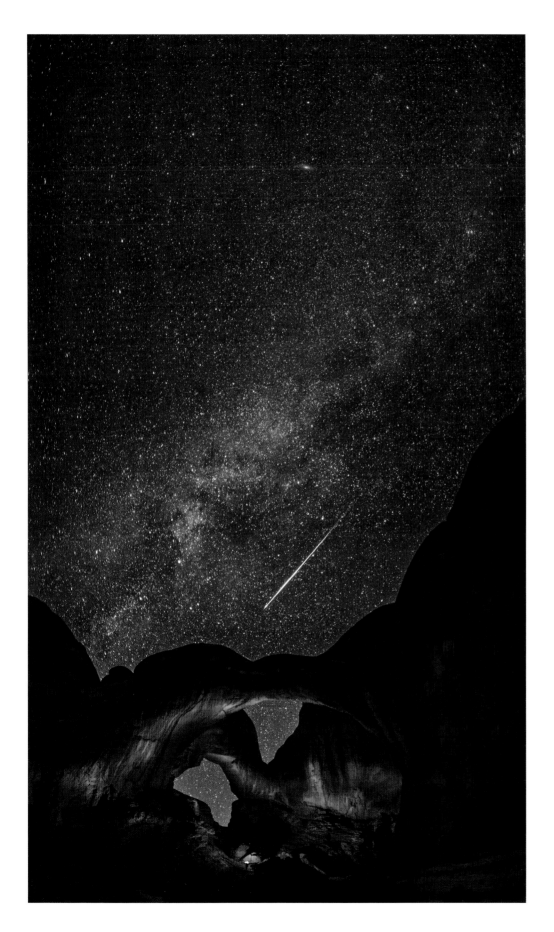

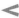

THOMAS O'BRIEN *(USA)*

Double Arch with a Perseid Meteor and the Milky Way
[*22 September 2011*]

THOMAS O'BRIEN: This shot was captured by complete chance really. I was at home in Aspen, Colorado, the night of the Perseid meteor shower ... I knew it was cloudy all around where I lived so I jumped in the car and headed to Moab Utah. Three hours later I arrived in Arches National Park and set up...my camera to do a vertical panoramic. I took one test shot, then took the bottom image of the arches, then the middle image of the arches, and as soon as I opened the shutter for the third shot, the biggest meteor I have ever seen in my life streaked across the sky directly above the arches.

BACKGROUND: A meteor burning up, high in the Earth's atmosphere, punctuates the vastness of the night sky. Catching a bright meteor in a carefully planned shoot like this one is a fine stroke of luck. Down below, the photographer has used an artificial light source to illuminate and emphasize the dramatic rock formations.

Canon 5D Mark II camera; Canon 24mm f/1.4 lens; ISO 3200; 20-second exposure

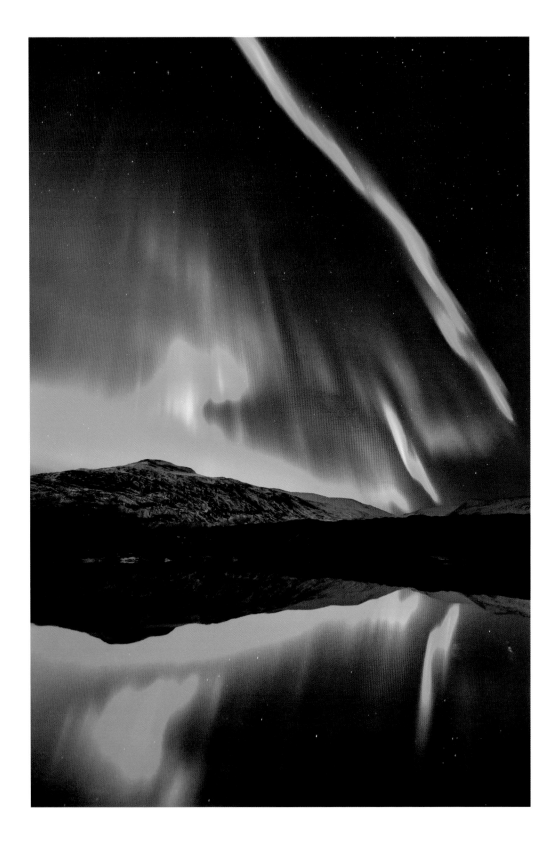

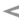

TOMMY ELIASSEN (*Norway*)

Sky Show
[*25 October 2011*]

TOMMY ELIASSEN: This night everything worked out better than I could dream of. I set up the camera near a small lake, pointing south towards the mountain called Høgtuva. I was hoping for the aurora to play along with the composition and after a while it slowly came dancing into the frame. For the first time I could see the bright red colours in the aurora with my own eyes. The outburst lasted for over an hour and it's still the best aurora display I have witnessed.

BACKGROUND: The Earth's magnetic field funnels particles from the solar wind down over the planet's polar regions. More than 80 kilometres above the ground, these particles collide with atoms and molecules of gas in our atmosphere, causing them to glow in the characteristic colours of green and pale red for oxygen, and crimson for nitrogen.

Nikon D700 camera; Nikkor 14–24mm f/2.8 lens at 14mm; ISO 2000; 10–24-second exposure

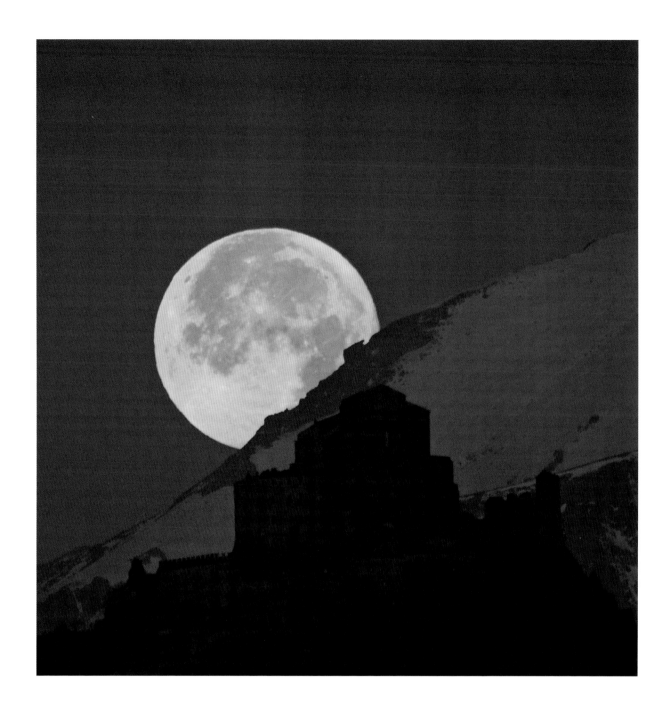

STEFANO DE ROSA (Italy)

Full Moon setting behind the Alps
[11 December 2011]

STEFANO DE ROSA: After careful planning, I went out to capture the post-eclipse 'Full Cold Moon' setting behind the Alps and the *Sacra di San Michele*. This is a religious complex and a symbol of the Piedmont region, in northwest Italy, situated 1000 metres up, on Mount Pirchiriano.

BACKGROUND: Human, geological and astronomical timescales are juxtaposed in this atmospheric photograph. The building in the foreground may be old by our standards, but the mountains in which it stands formed millions of years ago. Behind them, the setting Moon has remained relatively unchanged for billions of years.

Canon 5D Mark II camera; 700mm f/9 lens; ISO 500; 1/125-second exposure

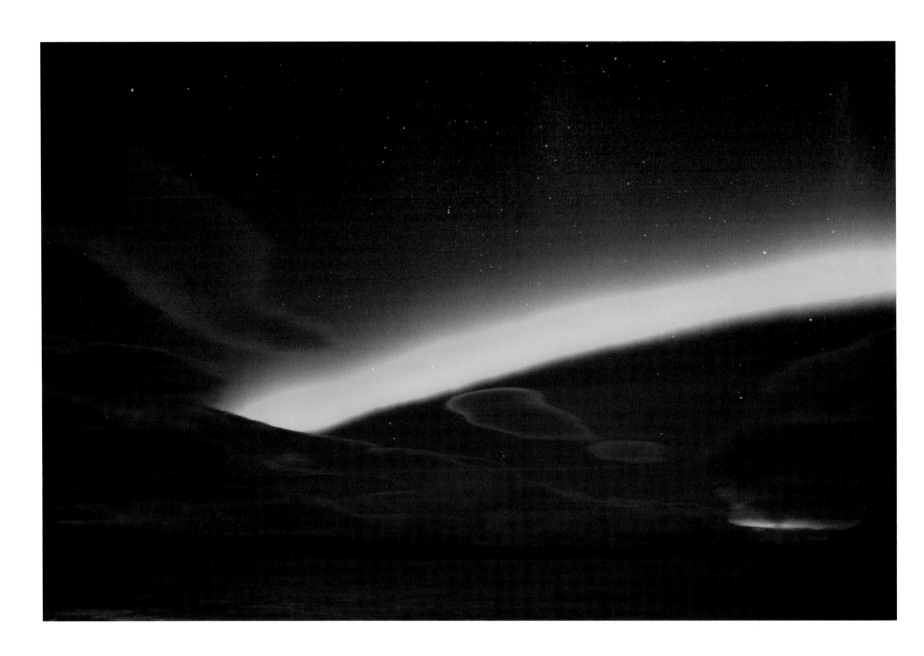

Λ

DEREK SHERWIN *(UK)*

Aurora over Lake Myvatn, Iceland
[*26 February 2012*]

DEREK SHERWIN: I think that the auroral band looks quite striking and the train of clouds extending towards it add to the effect, particularly as their edges have an auroral glow.

BACKGROUND: Like a celestial rainbow, a band of auroral light arches high above the unusual cloud formations in this image. Aurorae can be visible over large distances because they occur at heights of over 80 kilometres from the Earth's surface.

Canon 5D camera; Tamron 28–80mm f/3.5 lens; ISO 800; 25-second exposure

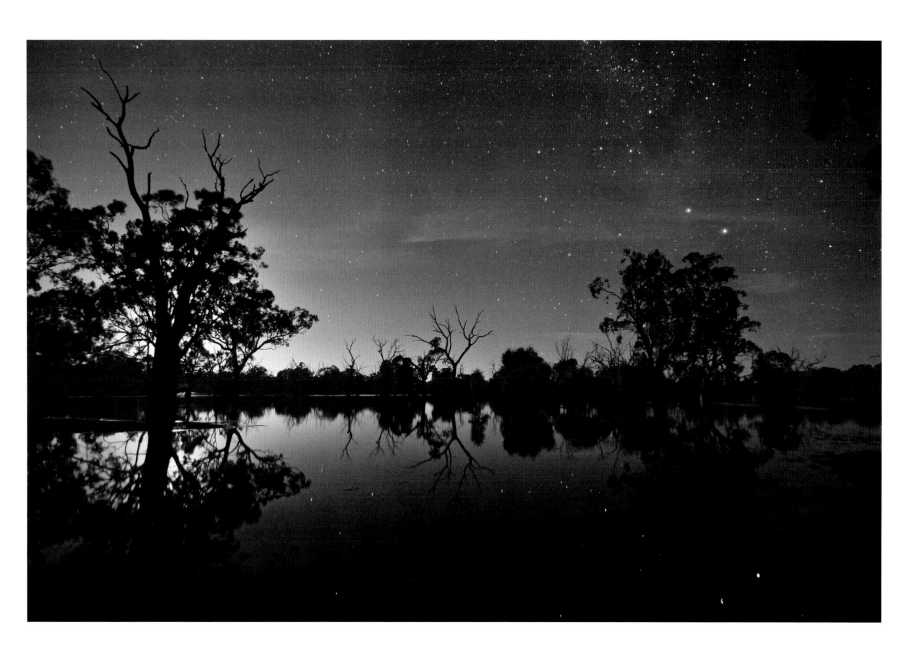

Λ

WAYNE ENGLAND *(Australia)*

Moonrise
[*28 December 2010*]

WAYNE ENGLAND: I like how this photograph connects the foreground scene with the night sky. The rising Moon illuminates a serene Poocher Swamp, near Bordertown, South Australia, while eucalyptus trees are silhouetted against the glow.

BACKGROUND: The amber glow of the rising Moon dominates this tranquil scene. Its light is actually reflected sunlight, and although the full Moon is around 400,000 times fainter than the Sun, it is still the brightest object in the night sky by far.

Nikon D700 camera; Tokina 12–24mm f/4 lens at 17mm; ISO 1600; 30-second exposure

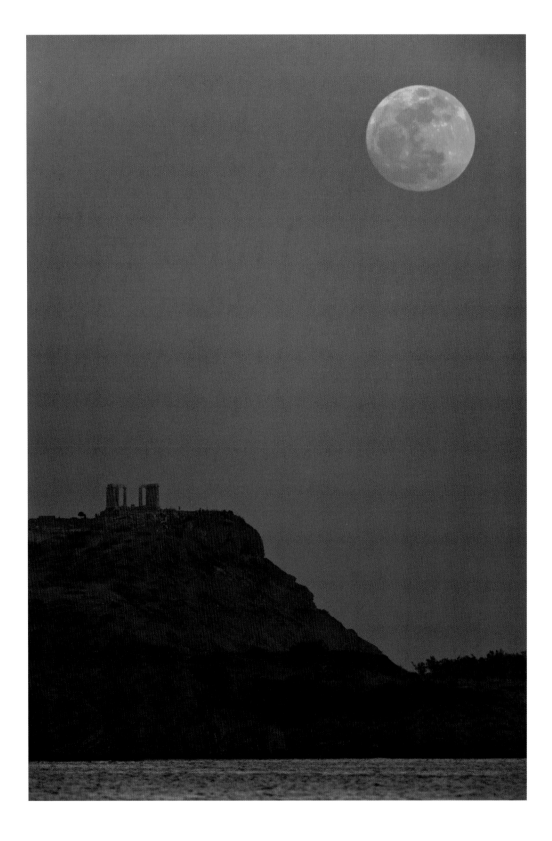

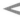

ANTHONY AYIOMAMITIS *(Greece)*

Super-Full Moon 2012 over Cape Sounion
[*5 May 2012*]

ANTHONY AYIOMAMITIS: The full Moon in May 2012 was a little more special this time around, since it coincided with the minimum possible perigee Moon for the year, thus also making the full Moon a super-full Moon. I captured the rising super-full Moon from a distance of just over four kilometres from Cape Sounion and the 2500 year-old Temple of Poseidon. The Sun was setting due west, just above the horizon, thus leading to rich hues and colours in the background sky. The blue waters of the Aegean added the final touches to the field of view, which was breathtaking both to the naked eye and through the camera's viewfinder.

BACKGROUND: The Moon's orbit around the Earth is not a perfect circle and sometimes our natural satellite looms closer, appearing up to 14 per cent larger in the sky. When the closest point in the Moon's orbit coincides with a full Moon, we get a perigee-syzygy, otherwise known as a 'supermoon'. Another effect can also make the Moon seem larger – the so-called 'Moon illusion', an optical trick of the brain which occurs when the Moon is close to the horizon.

Takahashi FSQ 106 f/5 telescope; Canon 5D Mark I camera; ISO 200; 1/200-second exposure

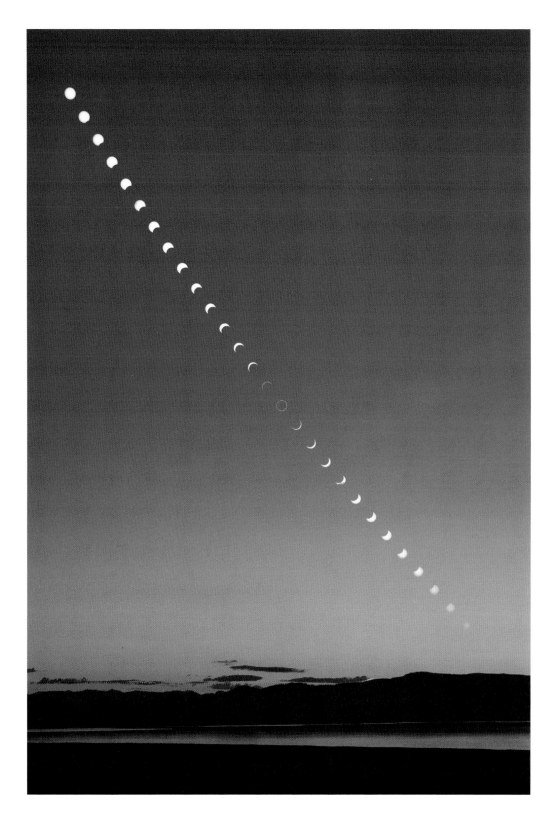

Strand of Pearls
[*20 May 2012*]

RICK WHITACRE: This image shows the 2012 annular eclipse from Pyramid Lake, Nevada. This location was on the 'centre-line' of the eclipse so the Moon was perfectly centred on the Sun.

BACKGROUND: A series of exposures captures the progress of an annular eclipse, as seen from Nevada on 20 May 2012. Annular eclipses occur when the Moon is at the furthest point in its orbit around the Earth, so that its apparent size is smaller than that of the Sun. At the height of the eclipse, a ring, or annulus, of the Sun is still visible around the Moon's disc.

Canon 5D Mark II camera; Canon 24–105mm f/4 lens at 47mm; ISO 400; 1/250-second exposure

Λ

ANDREW STEELE *(UK)*

Shropshire Paraselene
[*4 June 2012*]

ANDREW STEELE: Rainbow-coloured paraselenae, or 'moon dogs', are caused by moonlight refracting through ice crystals. By the time I'd taken the rightmost exposure in this panorama, the fleeting spectacle over this barley field had already vanished.

BACKGROUND: 'Paraselene' means 'beside the Moon', and the way these patches of reflected light appear to flank the Moon, like faithful dogs following their master, gives rise to their common name of 'moon dogs'. The rainbow colours are normally too faint for the naked eye to see but this digital camera is able to pick them out.

Nikon D90 camera; 70–200mm f/2.8 lens; ISO 400; 10-second exposure

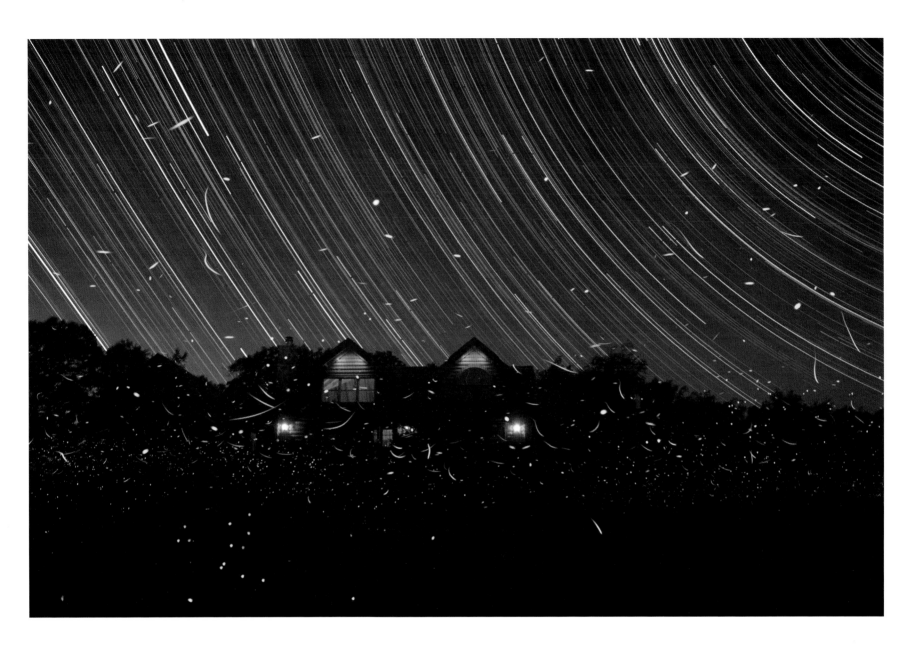

Λ

MICHAEL A. ROSINSKI (USA) HIGHLY COMMENDED

Summer Nights in Michigan
[20 June 2012]

MICHAEL A. ROSINSKI: I've been taking combined fireflies and star trail images since 2010: it's a learned technique. I noticed that, due to the hot weather, the fireflies seemed to be peaking much earlier than in either 2010 or 2011 – four to five weeks sooner. With the heat wave, the fireflies were going bonkers on this particular evening, so I was motivated to capture them! I had to start imaging at 11 p.m., as it was too light before that.

BACKGROUND: Earthly and heavenly sources of light are contrasted in this long-exposure image. Up in the sky, the rotation of the Earth draws the stars out into neat concentric trails, while down on the ground the swarming of fireflies creates a more frenzied pattern.

Canon T1i camera; Canon 15–85mm zoom lens at 15mm; ISO 800; 25-second exposure

"What I like about this image is the way it makes you think. When you realize what's being shown, you can't help but feel that this is a very clever picture. Here you have the ordered trails of the distant stars captured during a long exposure mixed with the random, somewhat chaotic motion of fireflies. The contrast between the regular star arcs and the defiantly irregular firefly trails is truly beautiful."
PETE LAWRENCE

"Physics and biology seem to collide in this image – the crazy antics of the fireflies are a brilliant contrast to the stately rotation of the Earth."
MAREK KUKULA

HAROLD DAVIS *(USA)*

Distant Night Storm in the Patriarch Grove
[*28 August 2011*]

HAROLD DAVIS: I was leading a night photography workshop in the Patriarch Grove of ancient bristlecone pines high in the White Mountains along the California-Nevada border ... I set up this image sequence, and then left my camera shooting on an intervalometer while I was assisting workshop participants. I noticed a bit of a storm in the east, over the great desert, but didn't think anything much of it – so I was pleasantly surprised when I looked at my captures and noticed the lightning storm.

BACKGROUND: The long exposure time needed to capture the star trails in this nocturnal image makes the landscape below appear as though it is basking in an eerie form of daylight. Off to the right, bolts of lightning provide a dramatic additional source of illumination.

Nikon D300 camera; 12mm f/4 lens; ISO 400; 4-minute exposure

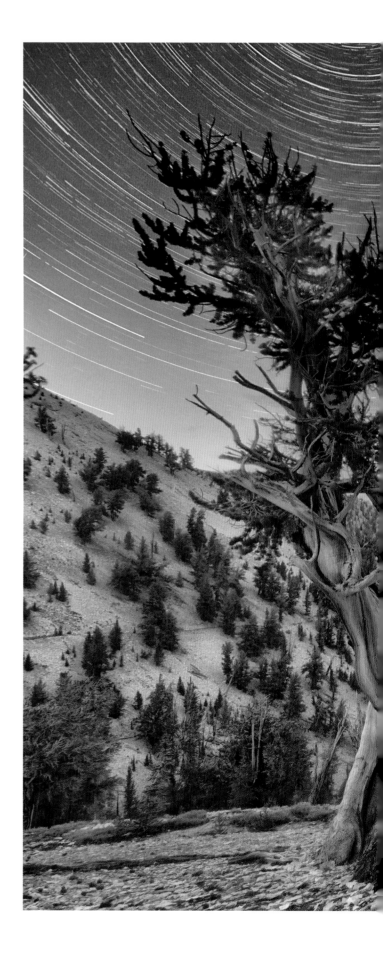

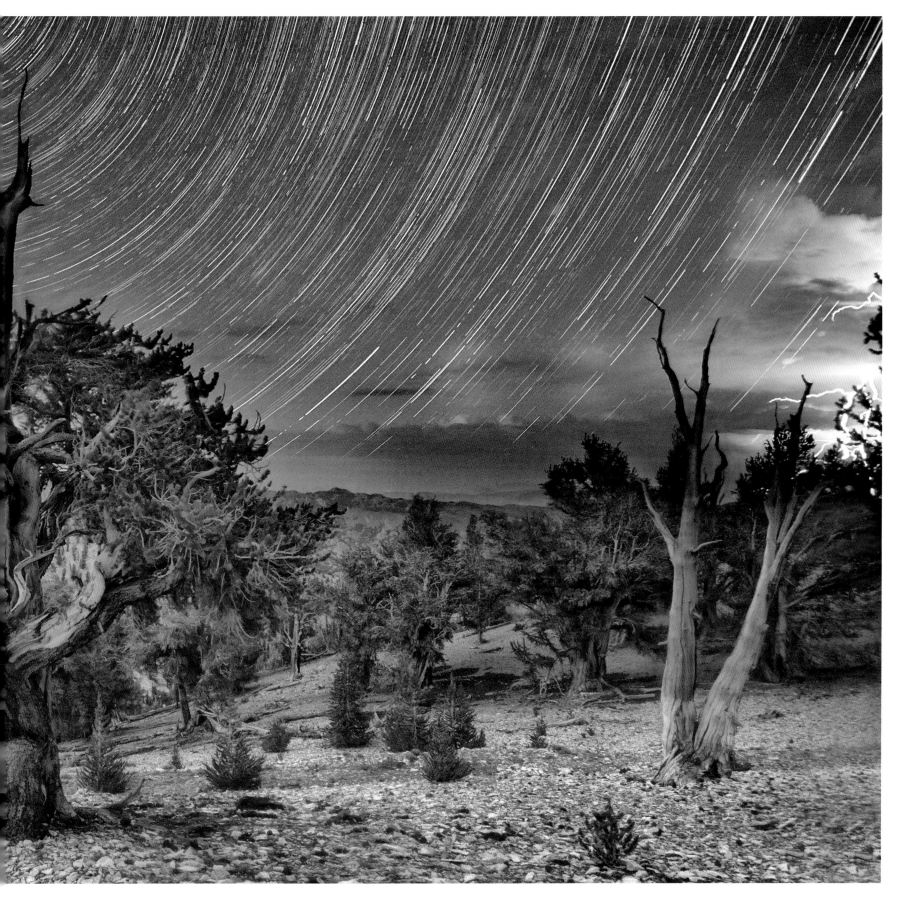

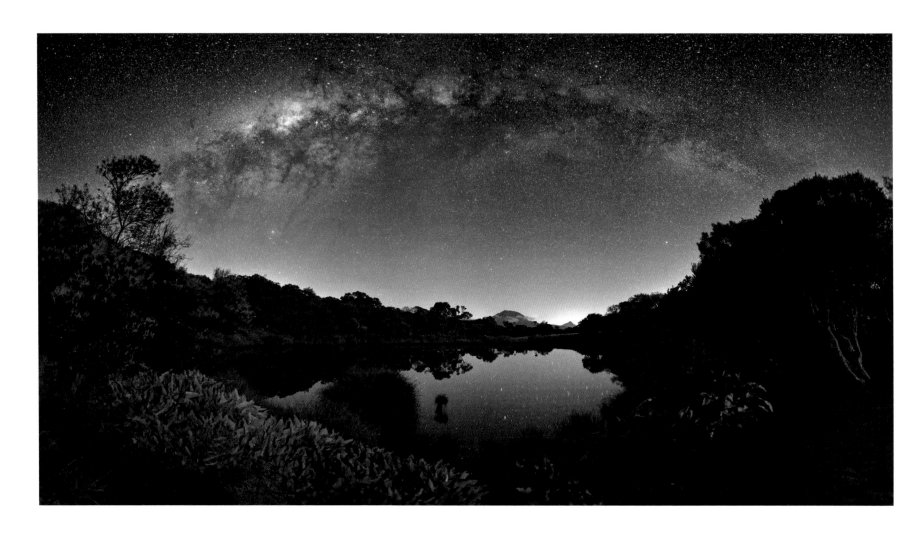

∧

LUC PERROT *(Réunion Island)* HIGHLY COMMENDED

The Milky Way View from the Piton de l'Eau, Réunion Island
[24 June 2012]

LUC PERROT: Here is a picture of the Piton de l'Eau, an ancient crater filled with water. At the centre of the picture you can see the Piton des Neiges, the highest peak of Réunion, which is 3069 metres tall. I waited two years before all the combined conditions were favourable to succeed with this photo.

BACKGROUND: This is a spectacular view of the Milky Way arching over a tranquil lake on the island of Réunion. The bright patch to the left of the image marks the bulge of stars at the heart of our galaxy. However, our view of the centre is blocked by thick clouds of interstellar dust, which are clearly visible in this image.

Nikon D700 camera; Nikkor 24mm f/1.4 lens; ISO 3200; 15-second exposure

"This is a perfect Earth and Space image with great balance between the star-laden sky and what's going on below. The mirroring of the stars in the water is amplified by the mirroring of the Milky Way 'arch' and the curve of the foliage below the water. For me, this is a very beautiful and engaging composition."

PETE LAWRENCE

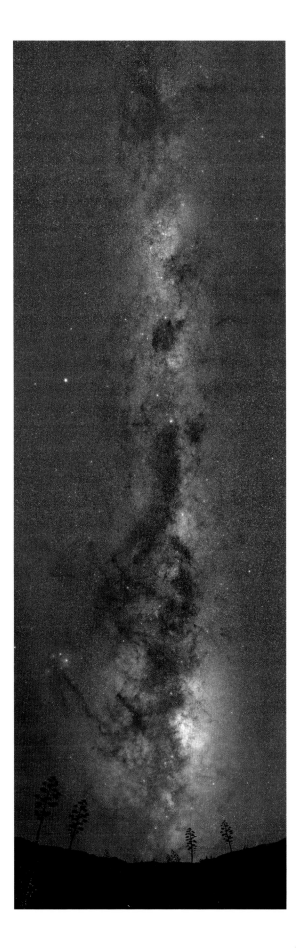

LUIS ARGERICH *(Argentina)*

The Rise of the Giant Emu
[18 June 2012]

LUIS ARGERICH: The Milky Way rising vertically, as seen from the southern hemisphere, looking like a giant emu rising from the horizon. I took many surplus images to make sure I depicted the complete Milky Way. I took a second shot without tracking for the forest, and then combined the two to create this image.

BACKGROUND: People all around the world have drawn patterns among the brighter stars, carving out constellations that resemble people and animals. For the aboriginal people of Australia, the dark dust clouds that streak the Milky Way also seemed to form striking patterns. Here, rising from the horizon, are the legs, body, neck and head of the 'Emu in the Sky'.

Canon 5D Mark II camera; Zeiss 50mm f/2 lens

CHRIS WARREN (UK) *WINNER*

Transit of Venus 2012 in Hydrogen-Alpha
[*6 June 2012*]

CHRIS WARREN: A single unprocessed raw frame shot between second and third contact. Our first and only glimpse of the transit before third contact, through a thin patch in the cloud.

BACKGROUND: In previous centuries, careful observations of transits of Venus were used to make the first accurate measurement of the distance between the Earth and the Sun. Expeditions were sent out around the globe to ensure that at least some observers would avoid the curse of cloudy skies. This image, taken from London in 2012, sums up the anxious excitement of transit chasers throughout history: miss it and you may have to wait more than a century until the next one!

Lunt LS60THa telescope; Point Grey Grasshopper Express (ICX674) camera

"At first glance this may appear a strange image to win the Solar System category. It represents a result far from what the photographer had originally intended to achieve. Using a hydrogen-alpha (ha) filter, there's no ha detail visible here. Also, this is a single frame taken from a sequence of images which ideally should have been stacked together to produce a clearer and crisper end result. For me, it's clear that the clouds have caused havoc with the photographer's original plans but they have also created an image which has an enigmatic beauty all of its own. The shot does show the transit clearly but it also tells a story. For me, the image encapsulates the feeling of frustration that the weather can sometimes bring when it interferes with rare events such as this. It also sends out a message of hope though, by making the statement that persistence and determination can sometimes win out, despite what may at first seem like insurmountable odds. I love the shot; it's moody, atmospheric and powerful."

PETE LAWRENCE

"A beautiful image evoking all the drama and mystery of the transit."

MELANIE GRANT

"For me, this picture perfectly captures the excitement of the 2012 transit of Venus. After getting up at 4am on a cloudy morning it really didn't look as though the British weather was going to co-operate. But then, with just minutes to go, a gap appeared in the clouds and we got a precious glimpse of Venus in front of the Sun."

MAREK KUKULA

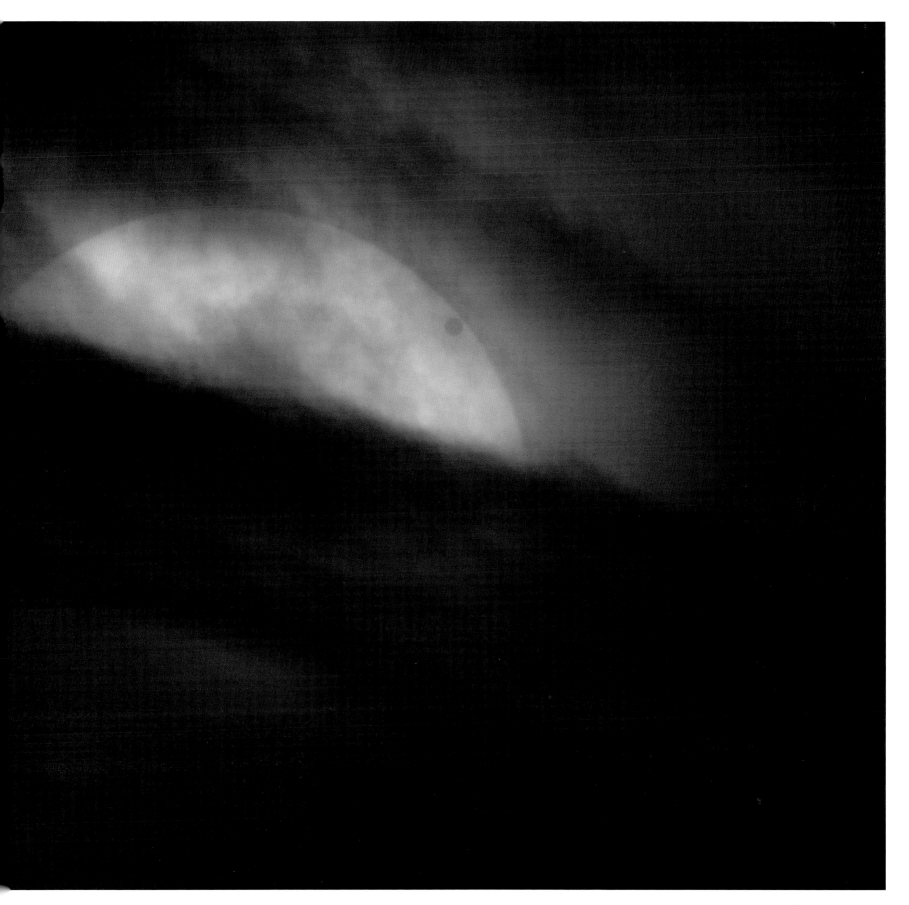

DAMIAN PEACH (UK)

Mars in 2012
[*March 2012*]

DAMIAN PEACH: The entire face of Mars during its aphelic opposition of 2012, where the apparent diameter reached only 13.9 arcseconds. Many interesting details can be seen, such as clouds surrounding the giant Tharsis volcanoes, and rifts and outlaying patches of ice around the north polar cap.

BACKGROUND: This sequence of photographs uses the rotation of Mars to build up a complete view of the planet's surface. It shows the gleaming north polar cap of water, ice and frozen carbon dioxide, the red equatorial deserts and the darker southern highlands. The photographer has captured an amazing level of detail, including wispy clouds in the thin Martian atmosphere.

356mm reflector; PGR Flea3 camera

"Damian's work never ceases to amaze. Here is a sequence of images that show a full rotation of Mars ... the technical expertise and sheer investment of time needed to produce images of this clarity and range, especially from the UK, is immense."

PETE LAWRENCE

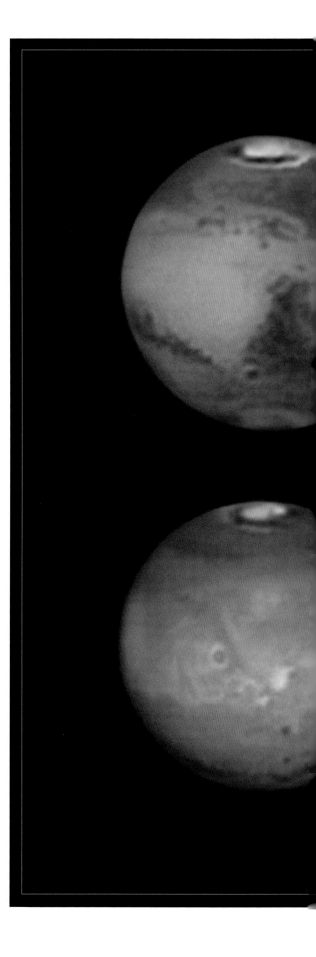

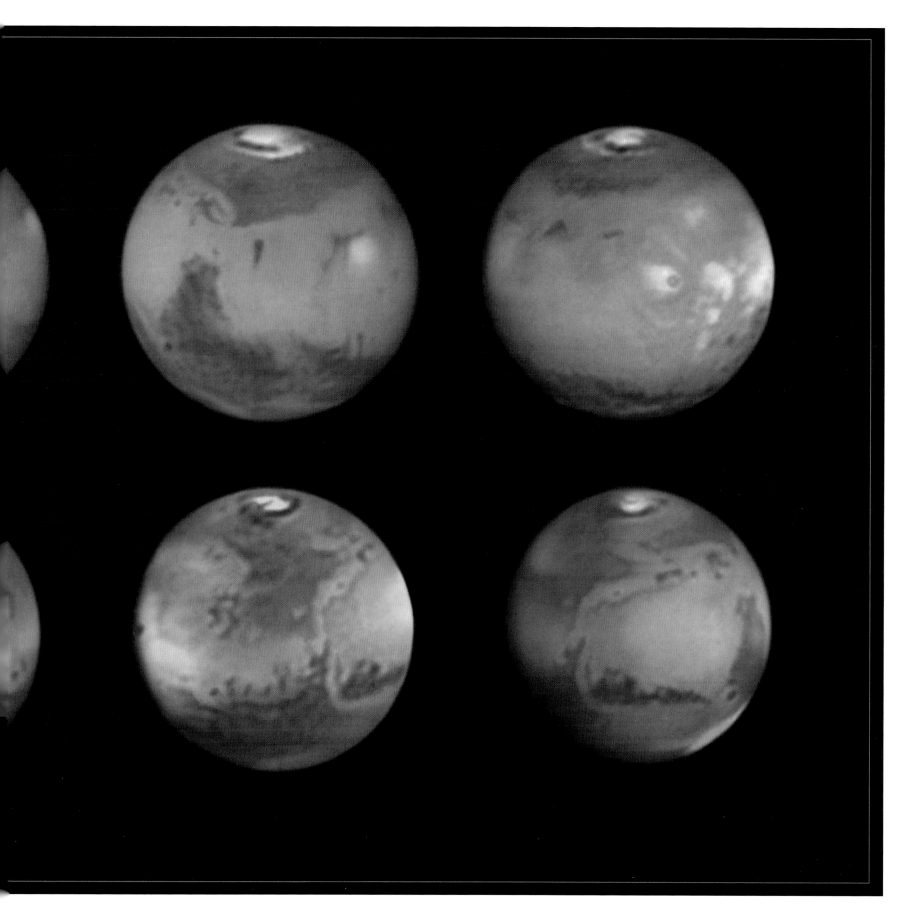

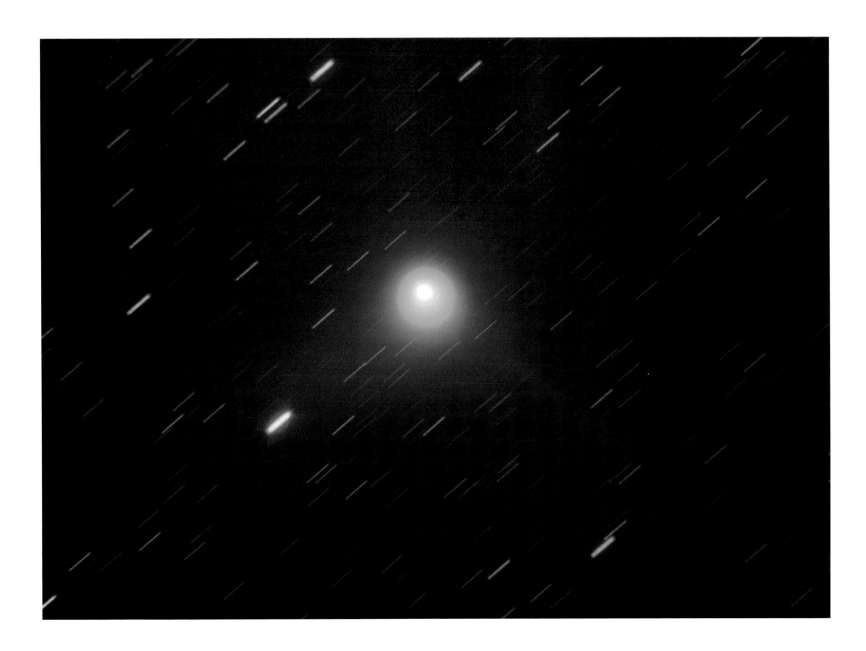

GRAHAM RELF (UK)

Comet C/2009 P1 (Garradd)
[*19 March 2012*]

GRAHAM RELF: Comet C/2009 P1 (Garradd) has been visible from the UK for many months. It never reached naked-eye visibility but could be seen through binoculars. Its orbit is hyperbolic, so it has come from outside the Solar System and will never be seen from Earth again. My photograph shows how the comet moved relative to the stars in 38 minutes. The brightest star here is magnitude 6.4.

BACKGROUND: The photographer has used a long exposure to bring out the greenish glow of the comet's halo. The star trails show how he has tracked the comet's orbital motion in order to keep it in the centre of the frame. Comet Garradd was discovered in 2009 as it approached the inner Solar System. It became visible through binoculars in 2011.

SkyWatcher 254mm Newtonian telescope; HEQ5 equatorial mount; f/4.8 lens; Canon 5D Mark II camera; ISO 6400; 32-second exposure

"I enjoy the muted colours in this photograph, the green of the comet nucleus, the blue of the faint tail, and the range of reds, blues, yellows and whites seen in the star trails. The sense of motion in the image conveys a fleeting glimpse of this icy visitor as it rushes through the inner Solar System."

OLIVIA JOHNSON

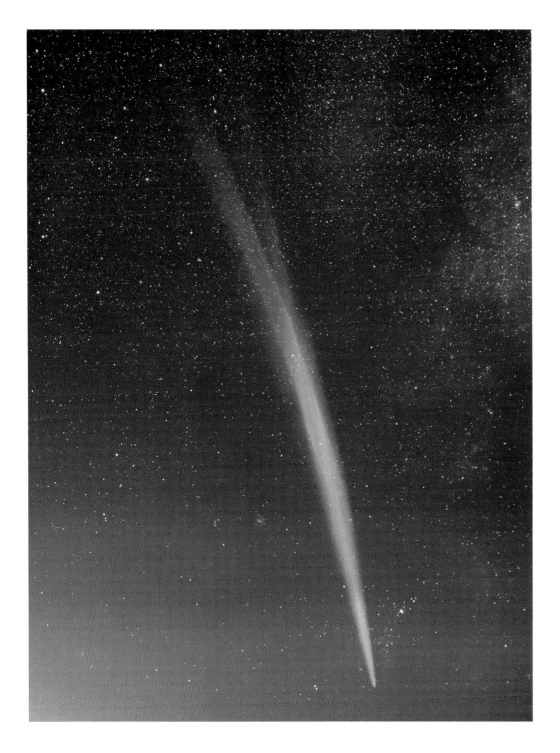

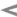

PHIL HART (Australia)

Lovejoy's Tail
[*24 December 2011*]

PHIL HART: I love a good comet, although very early on Christmas Eve was hardly convenient! I just dodged some early morning cloud to get this shot of Lovejoy's nice dusty tail.

BACKGROUND: Not every comet is as obvious as Comet Lovejoy, which put on a show for observers in the southern hemisphere in late 2011. This image shows the comet's long tail, composed of dust and vapour ejected from the tiny nucleus. Like all comets, the tail of Lovejoy points away from the Sun.

Canon 5D Mark II camera; 50mm f/2.2 lens, ISO 800; 60-second exposure

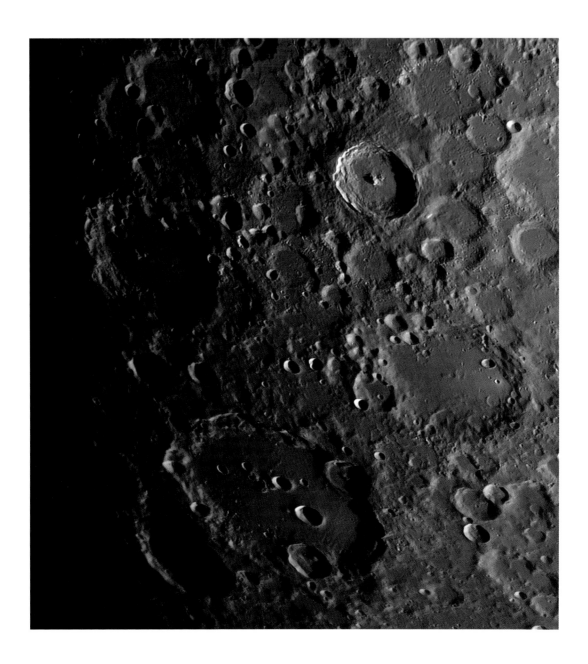

Λ

MICK HYDE (UK)

Tycho to Clavius
[4 January 2012]

MICK HYDE: Tycho crater is one of the most spectacular on the Moon, along with Clavius, which is one of the most complex and interesting.

BACKGROUND: This view of our Moon's rugged southern highlands shows a landscape dotted with craters of all sizes. Prominent in the upper right is the crater Tycho. Its wall to the left and its central peak are lit by the Sun, while the right side of the crater lies in deep shadow.

Celestron 9.2-inch telescope; TeleVue 3x Barlow lens; SKYnyx 2-0 camera

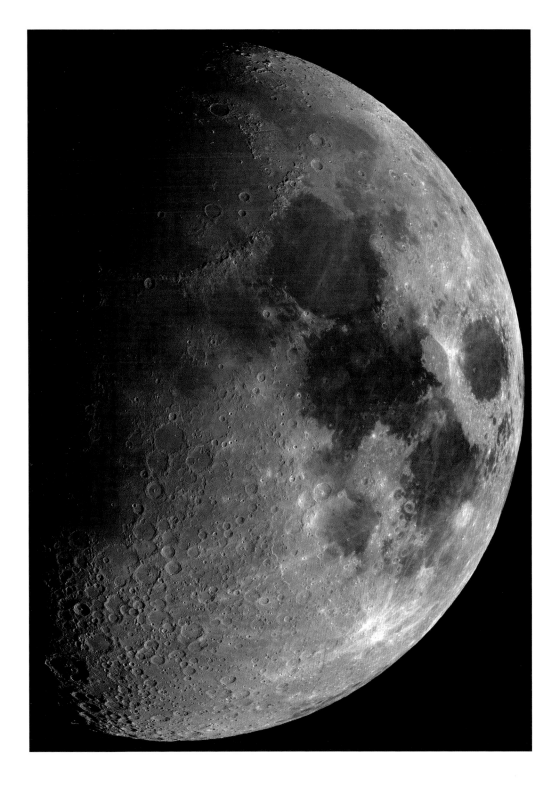

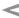

DAVID CAMPBELL *(UK)*

116 megapixel Moon Mosaic
[1 February 2012]

DAVID CAMPBELL: Lunar mosaics are a great way to get started in astrophotography with only modest equipment. I was lucky enough to use a larger telescope on an evening with excellent seeing conditions.

BACKGROUND: The Moon is our nearest neighbour in space, and therefore appears larger in our sky than any other astronomical object apart from the Sun. Even a telescope of quite limited magnification will only show a part of the Moon's surface at one time, meaning that multi-image mosaics such as this are needed to show large areas of its surface.

Meade LX200R 14-inch telescope at Bayfordbury Observatory, University of Hertfordshire; Lumenera SKYnyx 2-1 camera; Astronomik 807nm IR filter

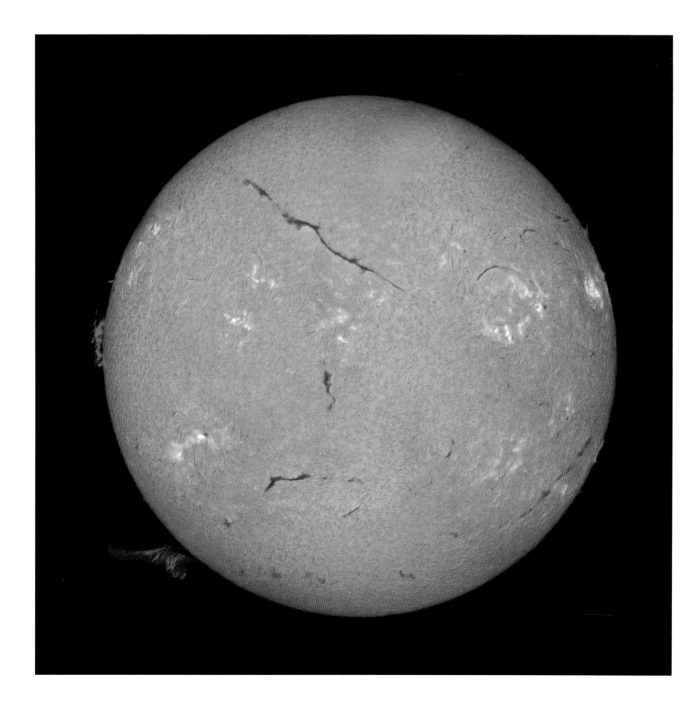

Λ

PAUL HAESE (*Australia*)

Active Sol
[*12 February 2012*]

PAUL HAESE: I remember this particular morning quite well. I went out to observe the Sun and saw this massive prominence. I just had to image it. To see the Sun with such a prominence is a joy.

BACKGROUND: 2012 saw the Sun moving towards the peak of its eleven-year cycle of activity following an unusually long and quiet lull. Sunspots, explosive flares and prominences are much more common now than in previous years, as demonstrated by this spectacular image of our closest star.

Coronado Solarmax 60 0.5A telescope; Imaging Source DMK41 camera; 6 panel mosaic with 723 frames in each panel

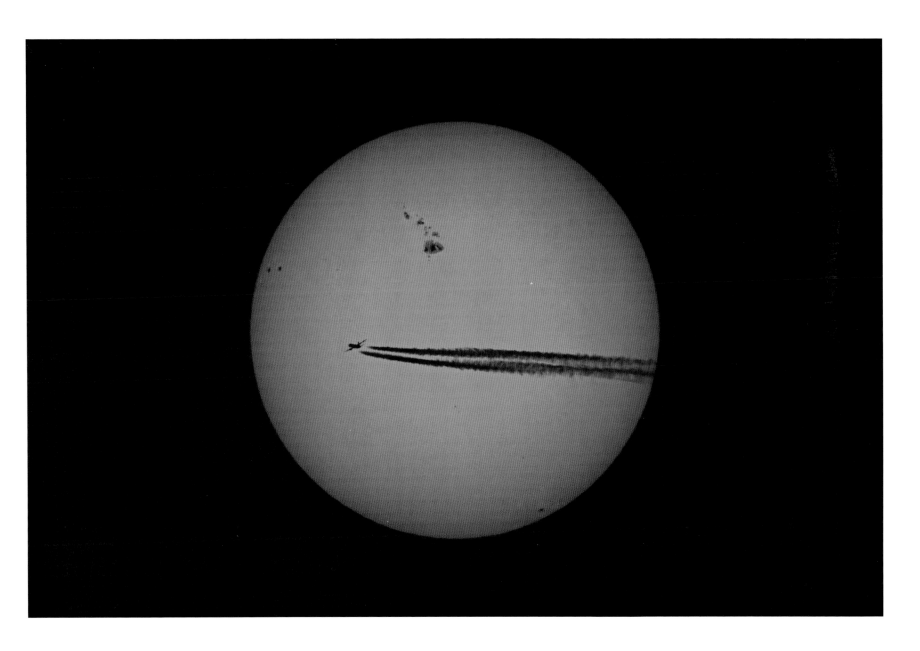

∧

DUNJA ZUPANIC *(Croatia)*

Sunny Airlines
[*9 May 2012*]

DUNJA ZUPANIC: I was doing ordinary Sun observations, looking through my telescope, when I saw this scene and was lucky to make the shot. Do not try this without special filters for the Sun, as you can damage both your eyes and photo equipment!

BACKGROUND: A chance alignment superimposes a jet and its twin vapour trails against the disc of the Sun. Also visible is an enormous sunspot complex, a region of the Sun's surface in which intense magnetic fields are suppressing the upwelling of heat from the solar interior. Sunspot activity has been increasing in 2012 as the Sun approaches the peak of its eleven-year cycle.

120/900 ED APO telescope, NEQ6 mount; Canon 450D camera; ISO 100; 1/125-second exposure

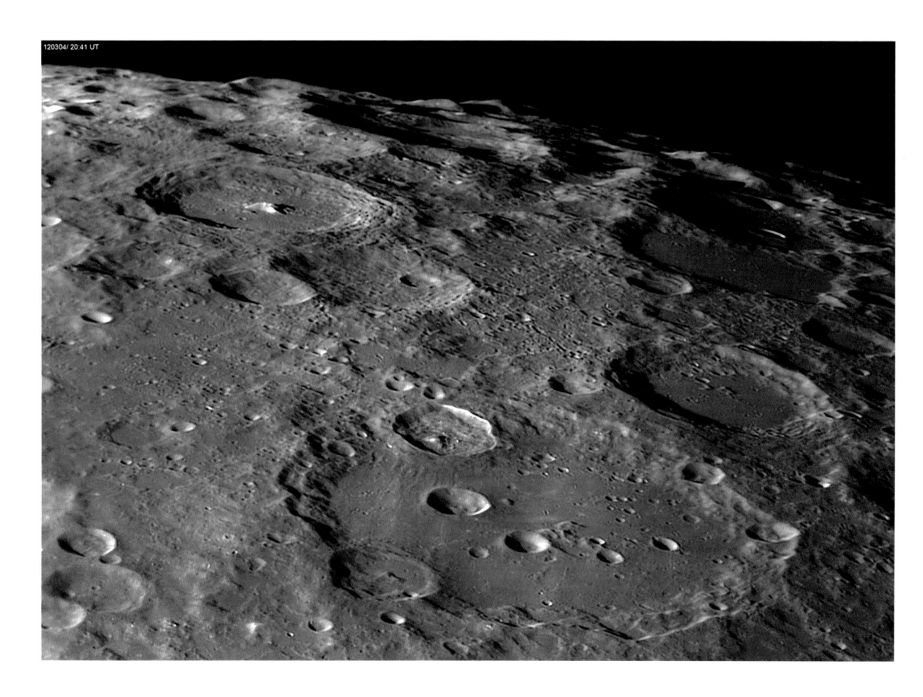

120304/ 20:41 UT

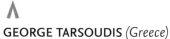

GEORGE TARSOUDIS *(Greece)*

The South Pole Area with the Great Crater Clavius
[27 June 2012]

GEORGE TARSOUDIS: The lunar south pole is of special interest to scientists because of the postulated occurrence of ice in permanently shadowed areas. Of the lunar poles, the south pole is of greater interest because the area that remains in shadow is much larger than that at the north pole. In my image you can see one of the biggest and most popular craters in the Moon's surface, the crater Clavius.

BACKGROUND: The vast crater Clavius, seen in the foreground of this image, at 255 kilometres across and 3.5 kilometres deep, is one of the largest on the Moon. As well as its enormous size, Clavius is also very old, as shown by the many smaller craters which dot its floor. These are the result of explosive meteorite impacts over the billions of years since the Moon's formation.

10-inch Newtonian telescope at f/6.3; Barlow 3x lens; Unibrain Fire-i 785 camera

∧

TED DOBOSZ (*Australia*)

Venus Transit of Sun in H-Alpha Band
[9 June 2012]

TED DOBOSZ: This image dramatically demonstrates the scale of the Sun compared to an Earth-sized Venus, and captures this black pearl against finely detailed surface structures and highly active regions of the Sun. This image was taken from Griffith which is a small rural town about 700 kilometres southwest of Sydney, Australia.

BACKGROUND: In the 21st century transits of Venus have acquired a new significance for scientists. By studying how sunlight is altered as it passes through the slender halo of atmosphere surrounding Venus, they can gain insights which will help them to understand the atmospheres of planets around other stars. In the future, this could help astronomers to investigate whether these exo-planets might harbour water, or even life.

Dedicated H-Alpha Lunt LS80Tha telescope; Losmandy G11 mount; 80mm objective; Imaging Source DMK41 video camera

Λ

PAUL HAESE (*Australia*) *HIGHLY COMMENDED*

Venus Transit
[9 June 2012]

PAUL HAESE: I wanted to record this for history, and this was my last chance. Never again will I see Venus transit the Sun. I hope my six-panel mosaic is a fitting tribute.

BACKGROUND: A spectacular view of the active Sun, streaked and blotched with filaments, sunspots and prominences. Venus, a world almost exactly the same size as the Earth, is dwarfed by the scale and power of our local star.

Coronado Solarmax 60 0.5A telescope; Imaging Source DMK41 camera; 6 panel mosaic with 750 frames in each panel

"Comparing this iconic photograph of the rare transit of Venus with those first achieved during the 1874 transit, we can see just how far we have come in the development of astronomy photography. This extraordinary level of detail of the solar surface, as well as the sharp silhouette of Venus crossing the Sun's bright disc, can now be captured by an amateur."

REBEKAH HIGGITT

Λ

CHRIS WARREN (UK)

Transit of Venus 2012 in Hydrogen-Alpha (Stacked)
[6 June 2012]

CHRIS WARREN: A stack of 200 frames shot between third and fourth contact, taken during a short break in the clouds at Blackheath in London.

BACKGROUND: Perhaps the biggest astronomical event of 2012 was the transit of Venus, which took place on 5–6 June. Transits occur when Venus passes directly between the Earth and the Sun, appearing as a small black disc passing across the face of our parent star. They occur in pairs, eight years apart, with each pair separated by over a century. The previous transit was in 2004 and the next will not be until December 2117.

Lunt LS6oTHa telescope; Point Grey Grasshopper Express (ICX674) camera

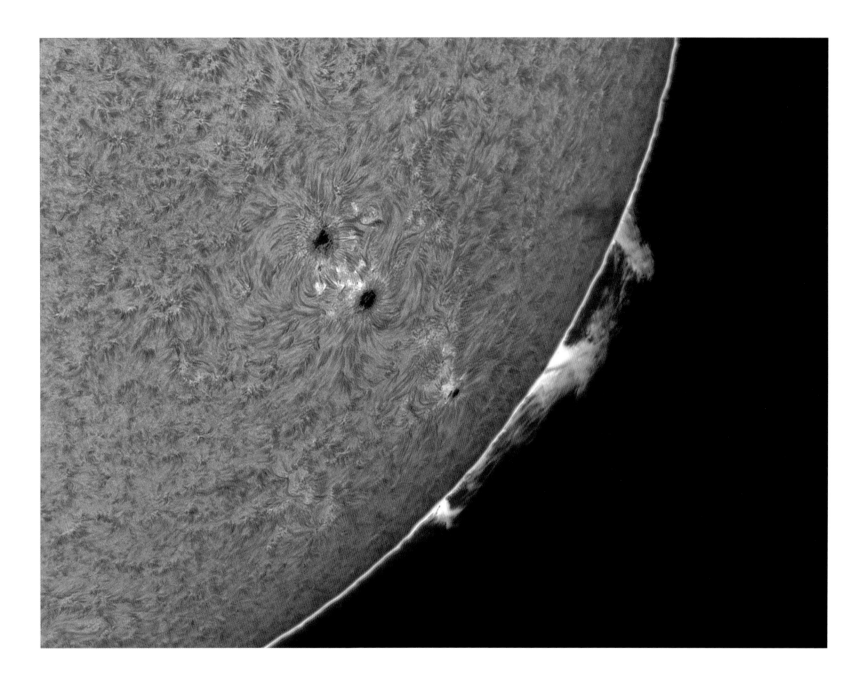

Λ

TED DOBOSZ *(Australia)*

Sun in H-Alpha Band
[*21 April 2012*]

TED DOBOSZ: This image was taken from Bankstown, Sydney, in Australia. It demonstrates how composite images can overcome extreme exposure differences. Fine and delicate prominent structures have been retained, whilst sharp surface details complement the arching fiery flows.

BACKGROUND: This part of the Sun's disc has been imaged through a special filter which is sensitive to the light emitted by hydrogen atoms. This has enabled the photographer to highlight several surface features of our local star, allowing us to appreciate its colossal scale. Each of the sunspots are about the size of the Earth, while the solar prominence arching over the horizon is so large that the Earth could easily roll beneath it.

Dedicated H-Alpha Lunt LS8oTha telescope; Losmandy G11 mount; 80mm objective; Imaging Source DMK41 video camera

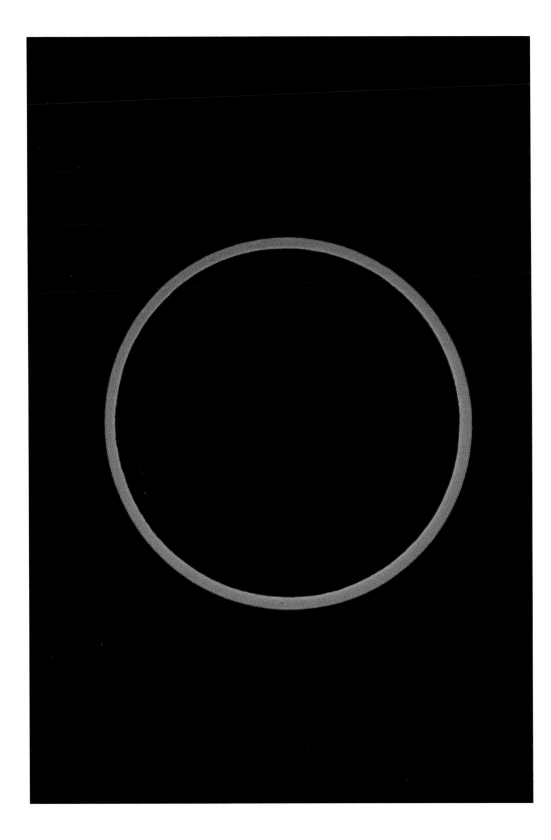

PHIL MCGREW (USA)

Annular Eclipse
[*20 May 2012*]

PHIL MCGREW: Annular eclipses are rare. Fortunately, I only had to travel seven hours for clear weather and a spot on the path centre line to photograph this celestial event by Pyramid Lake, Nevada.

BACKGROUND: Annular eclipses occur when the Moon is furthest from the Earth on its elliptical orbit. At this point its disc appears slightly smaller than that of the Sun and does not cover the whole of the solar disc. At first sight, this view appears almost impossibly geometric, but close inspection reveals that the dark rim of the Moon shows tiny irregularities. These are caused by lunar mountains, silhouetted against the sunlight.

Canon 7D camera; 100–400mm f/5.6 lens at 400mm; ISO 200; 1/1600-second exposure

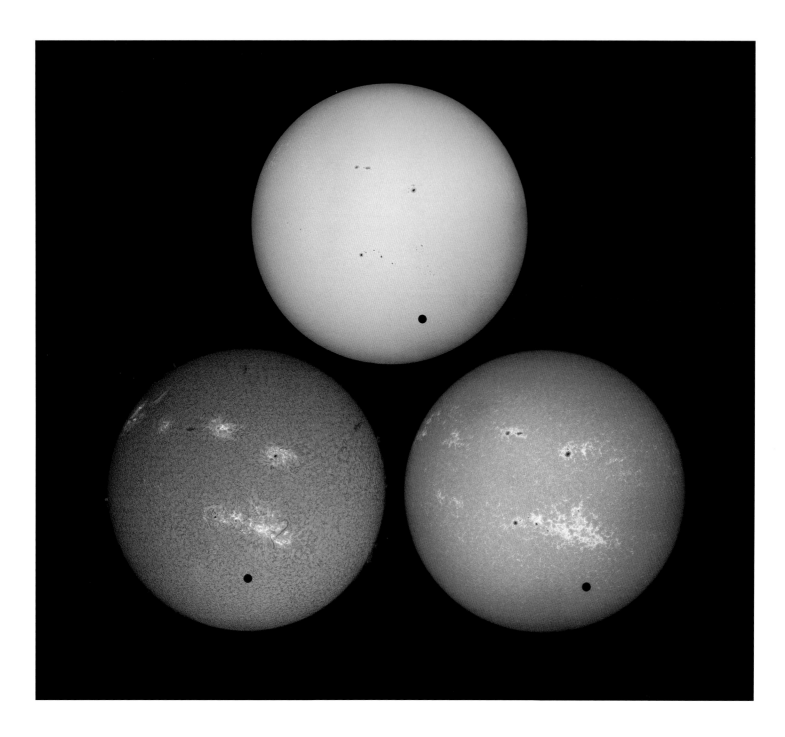

PETER J. WARD (*Australia*)

Tri-colour Transit
[*7 June 2012*]

PETER J. WARD: I am pleased with the image as it uniquely captures this rather rare event at high resolution. There are three distinct colour spectrums: the upper (hydrogen-alpha) and lower (calcium) chromosphere, as well as the photosphere (white light).

BACKGROUND: Taking photographs in different wavelengths of light helps to highlight the various physical processes occurring in the Sun. But in each of these three views the perfect black dot of Venus passing in front of the solar disc steals the show.

Astro-Physics AP130 f/6 refractor, fitted with Calcium K, Hydrogen-Alpha and white light filters; Lumenera SKYnyx 2-2 camera; mosaic of up to 12 fields for each filter

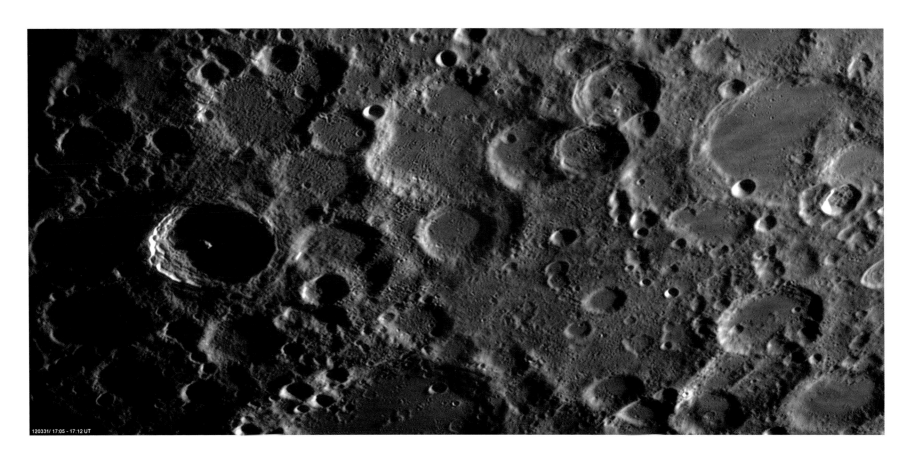

GEORGE TARSOUDIS (*Greece*)

The Great Area of the Crater Tycho
[*31 March 2012*]

GEORGE TARSOUDIS: Tycho is a prominent lunar-impact crater located in the southern lunar highlands. The surface around Tycho is replete with craters of various sizes, many overlapping still older craters. Traces of bright ray material from Tycho, located to the west, can be seen across the floor into the crater Stöfler.

BACKGROUND: The deep crater to the left in this image is named after the 16th-century Danish astronomer Tycho Brahe. It is 86 kilometres wide and has a prominent central peak, just visible here emerging from shadow in the low morning light. Tycho is a relatively young crater. Its explosive creation occurred around 108 million years ago and may even have been witnessed by the dinosaurs.

10-inch Newtonian telescope at f/6.3; Barlow 3x lens; Unibrain Fire-i 785 camera

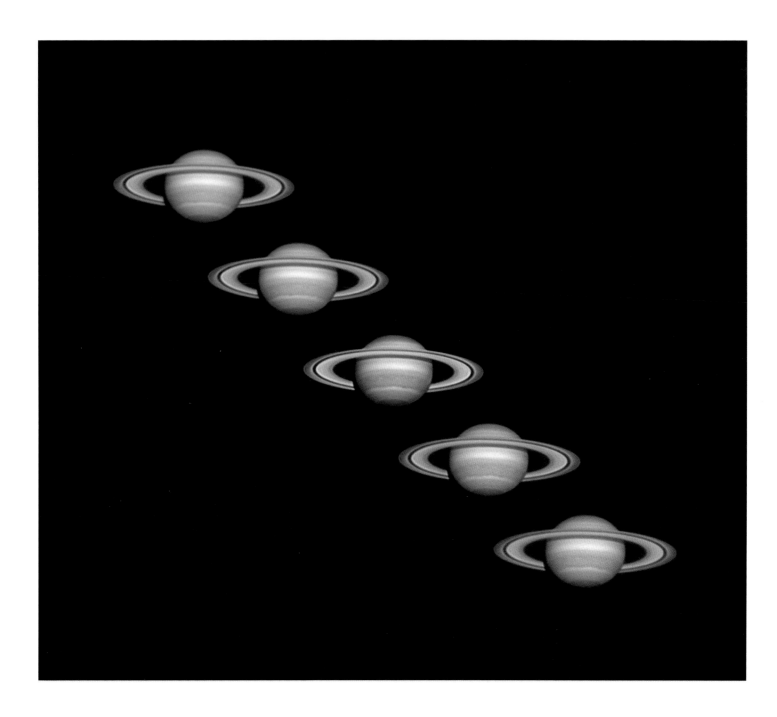

∧

PAUL HAESE *(Australia)*

Saturn 2012
[*10 April 2012*]

PAUL HAESE: With Saturn climbing higher in the southern hemisphere skies, it is our opportunity to capture images of this lovely ringed planet. In this image you can see small storms showing as white spots in the belts and even a dark spot.

BACKGROUND: Five views of Saturn show the subtle changes in its cloudy atmosphere. Although it may seem tranquil to observers here on Earth, visiting spacecraft have shown that Saturn is home to powerful weather systems, with vast lightning storms and some of the fastest winds in the Solar System.

Celestron C14 telescope; Point Grey Research Flea 3 camera; 3 stacks of 2000 frames

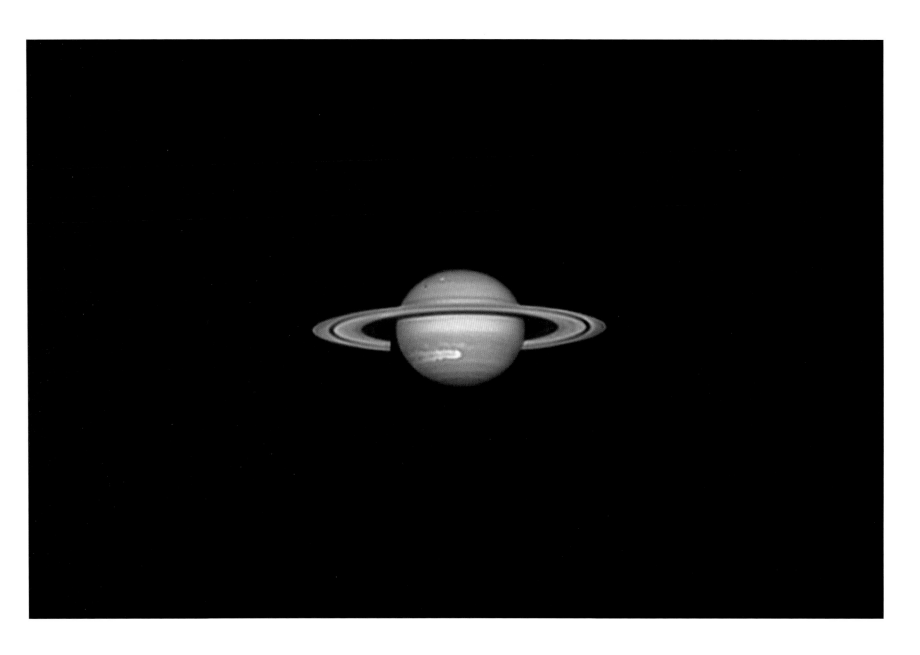

Λ

TROY TRANTER *(Australia)*

Saturn Super Storm
[*26 February 2011*]

TROY TRANTER: This image is unique because I was able to capture Saturn's large dragon storm (a rare event), as well as Tethys, Tethys's shadow, Dione and Enceladus at high resolution.

BACKGROUND: The deep, turbulent atmospheres of gas giant planets are the scenes of some spectacular weather. This image shows a vast pale storm streaking the cloud deck of Saturn, the second largest planet in our solar system.

C9.25-inch Schmidt-Cassegrain telescope; CG-5 GT mount; SKYnyx 2-0 camera

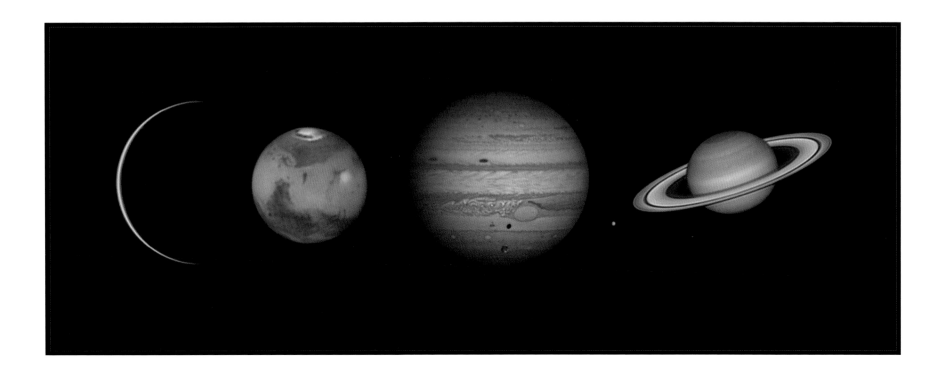

Λ

DAMIAN PEACH (UK)　　　　　　　*HIGHLY COMMENDED*

Worlds of the Solar System
[*February–May 2012*]

DAMIAN PEACH: Four different worlds are depicted. Firstly, the slender crescent Venus just a week before transit on 28 May. Mars on 29 February, showing the famous Syrtis Major feature at the centre, and brilliant clouds over the Elysium Mons volcano on the right. Jupiter on 1 February, showing Ganymede in transit, with Europa on the right, and its shadow cast onto the planet. Finally, Saturn close to opposition from 21 April, showing the remains of the giant storm from the year before, as well as fine details within the ring system.

BACKGROUND: This portrait gallery features four of our planetary neighbours in exquisite detail. The photographer shows the relative sizes of the planets as they appear to an observer on Earth. In reality, Jupiter and Saturn would dwarf the other planets, but they are both much further away from us.

356mm reflector; PGR Flea3 camera

"Damian Peach has captured breathtaking detail on four of the eight planets in our solar system. The unusual capture of Venus in a thin crescent phase, the patch of circular white cloud over Mars's 22-kilometre-high Olympus Mons, and pin-sharp details in the belts and rings of Jupiter and Saturn show an amazing mastery of planetary imaging."

CHRIS BRAMLEY

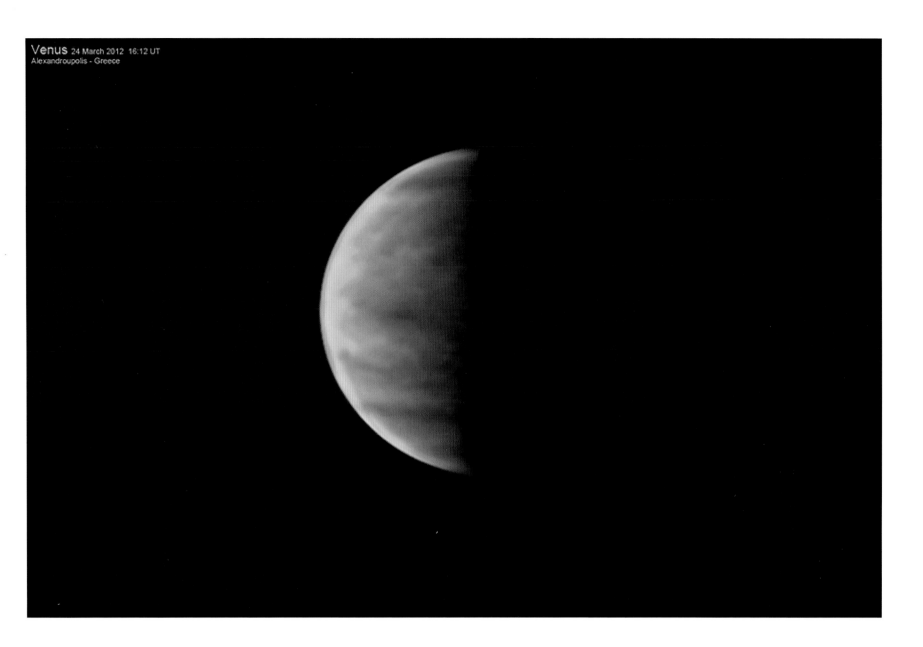

Venus 24 March 2012 16:12 UT
Alexandroupolis - Greece

Λ

GEORGE TARSOUDIS *(Greece)*

Planet Venus 2012
[24 March 2012]

GEORGE TARSOUDIS: The planet is named after Venus, the Greek goddess of love and beauty. Venus is the second planet from the Sun and it is not very easy to shoot in detail. In this image I used a UV filter for the L and B channel.

BACKGROUND: The transit of Venus across the Sun was one of the most memorable astronomical events of 2012. Venus, our neighbouring planet, appeared as a dark silhouette against the solar disc. By contrast, in the weeks leading up to the transit, Venus shone dazzlingly bright in the evening sky. This highly accomplished image shows us why: the planet is shrouded in a thick layer of sulphuric-acid cloud which reflects incoming sunlight.

10-inch Newtonian telescope at f/6.3; Barlow 3x lens; Unibrain Fire-i 785 camera

MARTIN PUGH (UK/Australia)

M51 – The Whirlpool Galaxy
[19 June 2012]

MARTIN PUGH: I was always going to be excited about this image given the exceptional seeing conditions M51 was photographed under, and the addition of several hours of Ha data has really boosted the HII regions.

BACKGROUND: A typical spiral galaxy, the Whirlpool or M51, has been drawn and photographed many times, from the sketches of astronomer Lord Rosse in the 19th century to modern studies by the Hubble Space Telescope. This photograph is a worthy addition to that catalogue. It combines fine detail in the spiral arms with the faint tails of light that show how M51's small companion galaxy is being torn apart by the gravity of its giant neighbour.

Planewave 17-inch CDK telescope; Software Bisque Paramount ME mount; Apogee U16M camera

OVERALL WINNER 2012

"This is arguably one of the finest images of M51 ever taken by an amateur astronomer. It's not just the detail in the spiral arms of the galaxy that's remarkable – look closely and you'll see many very distant galaxies in the background too."

WILL GATER

"The depth and clarity of this photograph makes me want to go into deep space myself! A breathtaking look at the Whirlpool Galaxy."

MELANIE GRANT

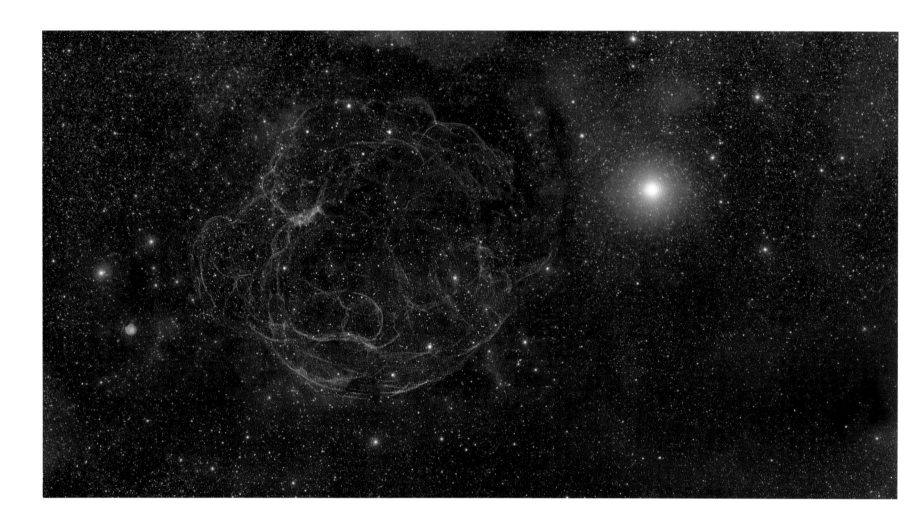

ROGELIO BERNAL ANDREO *(USA)* *RUNNER-UP*

Simeis 147 Supernova Remnant
[*11 April 2012*]

ROGELIO BERNAL ANDREO: Most images I've seen of this faint and large object (Simeis 147) deprive us from viewing the many other things happening around it. My goal was to produce an image that visually documents not only the main object, but also more of what's surrounding it.

BACKGROUND: Straddling the constellations of Auriga and Taurus, Simeis 147 is a supernova remnant, the expanding debris of a massive star which exploded around 40,000 years ago. As the wreckage continues to spread out into space it collides violently with the dust and gas between the stars, sculpting it into the glowing shells and filaments which have earned Simeis 147 the nickname 'Spaghetti Nebula'.

Takahashi FSQ-106 EDX telescope; Takahashi EM-400 mount; 385mm f/3.6 lens; SBIG STL 11000 camera

"Supernova remnant Simeis 147 looks for all the world like a delicate flower in Rogelio Bernal's capture of it. The detail in the twisted filaments of gas and dust, coupled with the wide star field that surrounds it, makes it seem like you're floating next to this object in space, rather than being 3000 light years away."

CHRIS BRAMLEY

"This object is a supernova remnant; the remains of a large dying star which literally exploded into space. Simeis 147 is an incredibly faint and extensive object in the sky. Rogelio has done an amazing job of capturing its faint tendrils and filaments in this extraordinarily wide-field view. This is a stunning result."

PETE LAWRENCE

"It's an eerie feeling to look at this tangle of space wreckage and know that thousands of years ago it was once a star like the thousands of others in the image. We like to think of space as being peaceful and unchanging, but it really isn't!"

MAREK KUKULA

BILL SNYDER (USA)

IC 1396 – Elephant-Trunk Nebula
[22 September 2011]

BILL SNYDER: I imaged this in narrowband, due to the light pollution around my home. This shows that a quality astro-image can still be obtained despite offensive light pollution.

BACKGROUND: It is not always obvious why some astronomical objects acquire their nicknames, but this column of dust in the constellation of Cepheus really does live up to its popular name of the Elephant's Trunk. New stars are currently forming deep within the dense clumps of dust and gas that make up the 'trunk'.

TMB 130mm telescope; Atlas EQG mount; Apogee U8300 camera

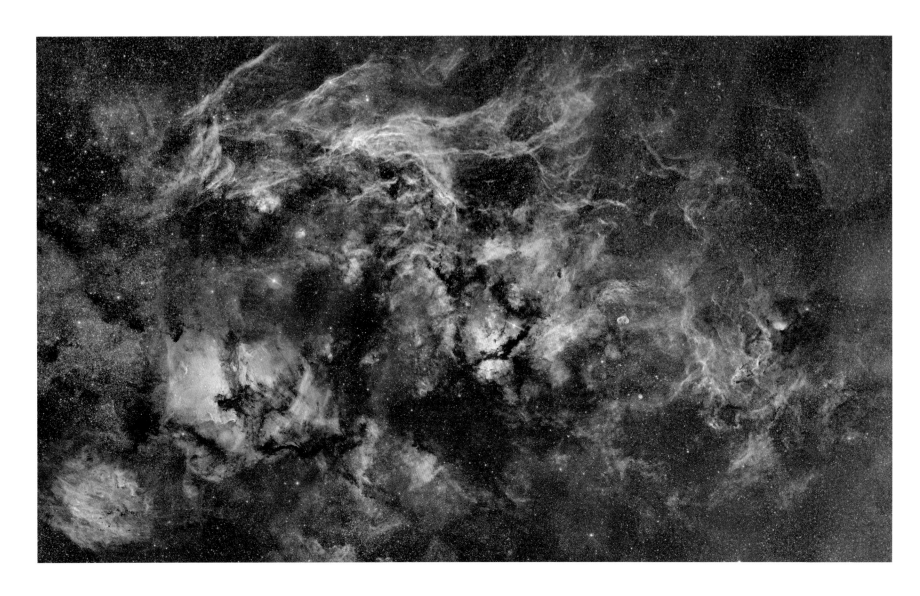

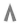

J.P. METSÄVAINIO (Finland)

Cygnus
[11 December 2011]

J.P METSÄVAINIO: This is my main imaging project from the autumn of 2011. The image covers 22 x 14 degrees of sky and it has eighteen individual image panels stitched together as a mosaic. Each image was imaged three times, through narrowband filters, to show three main emission lines – hydrogen, oxygen and sulphur – as a colour image.

BACKGROUND: This mosaic image reveals a huge swath of the sky in the constellation of Cygnus. Huge clouds of colourful glowing gas, and lanes of dark dust stretch across the field of view. Their light is too faint to register with the human eye, but long exposure times and special filters allow us to appreciate their grandeur and scale.

QHY9 camera; Canon EF 200mm f/1.8 lens

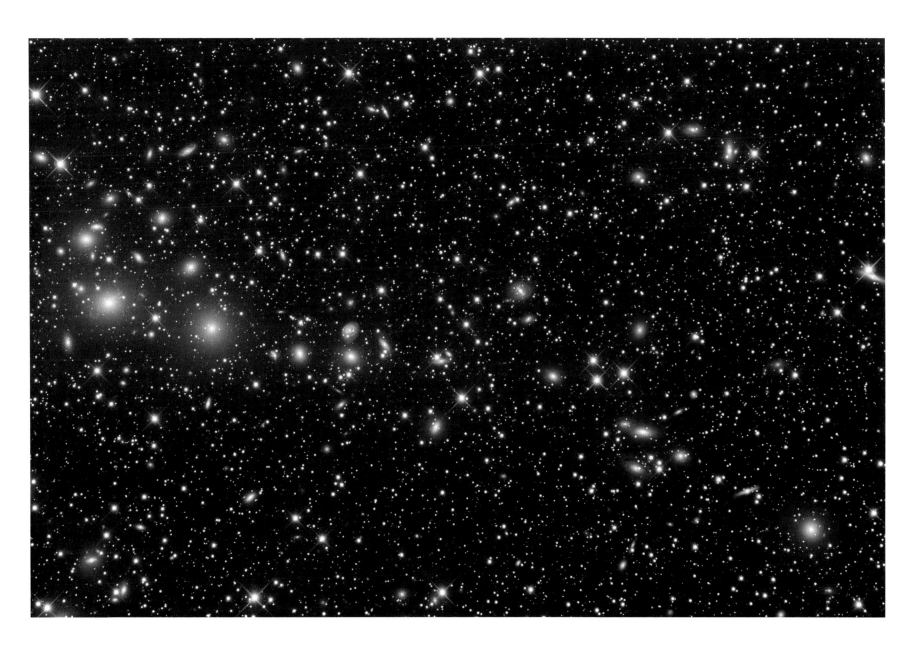

ROBERT FRANKE (USA)

The Perseus Cluster – Abell 426

[13 November 2010]

ROBERT FRANKE: I chose this composition because I like the left to right flow and wide variety of galaxies. Although this is no Hubble Deep Field, over a thousand galaxies are visible.

BACKGROUND: The harder you look, the more you see in this astonishing view of deep space. The points of light are relatively nearby stars in our own Milky Way galaxy. Far beyond them, at a staggering distance of almost 250 million light years, lie the myriad galaxies of the Perseus Cluster, also known as Abell 426. The cluster contains thousands of individual galaxies. Some are spirals like the Milky Way, while others are giant, smooth elliptical systems. Together they form one of the largest structures in the Universe.

RCOS 12.5-inch Ritchey-Chrétien telescope; Paramount ME mount; SBIG STL-11000 camera; 15-minute exposure

"This extraordinary image is packed full of galaxies of varying shapes and sizes. It's incredible to think that each one of these smudges of light contains millions, if not billions, of stars."

WILL GATER

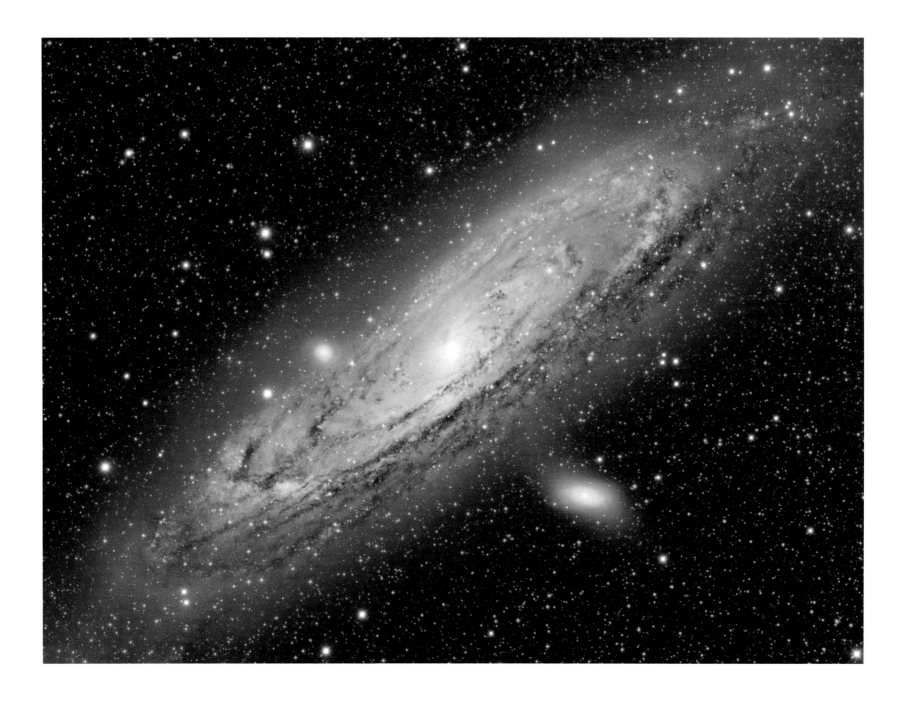

⋀

AGGELOS KECHAGIAS *(Greece)*

The Andromeda Galaxy
[*17 December 2010*]

AGGELOS KECHAGIAS: I have taken this image from a very special mountain at 1420 metres above sea level. It is called Mount Parnon and it is near Sparta, Peloponnese, in Greece. I go there with my friends every month to bring back some wonderful photos and I think I have succeeded with this image of M31.

BACKGROUND: The Andromeda Galaxy is one of our closest galactic neighbours. Like a giant frisbee, it fills the frame with its swirling spiral arms, composed of billions of stars mixed with dark lanes of dust and gas. New stars are being born in the clouds of glowing pink hydrogen gas.

Takahashi FSQ 106 f/3.6 telescope; QHY 9 mount

OLEG BRYZGALOV *(Ukraine)* HIGHLY COMMENDED

Sharpless-136: 'Ghost' in Cepheus
[16 July 2011]

OLEG BRYZGALOV: The constellation Cepheus is very rich in a variety of astronomical objects. Spooky shapes seem to haunt this starry expanse, drifting through the night. Of course, the shapes are cosmic dust clouds faintly visible in dimly reflected starlight. To shoot this image I had to drive 1000 kilometres to reach the mountains of the Crimea where the sky was dark enough.

BACKGROUND: Dust clouds like these are an important component of the Milky Way galaxy, filling huge volumes of space between the stars. The dust consists of tiny grains of minerals and ices and is an important building block for the formation of future stars and planets.

Newtonian 10-inch reflector; WS-180 mount; 1200mm f/4.7 lens; QSI-583wsg camera; 10-minute exposure

"The more muted colours and ghostly forms of this cosmic dust cloud instantly captured my imagination as something that evokes the mystery of the deep sky – although looking more closely you spot the almost humorous 'figures' waving a salute."

REBEKAH HIGGITT

"I love the subtle colours and undulating shapes of the dust clouds in this image. Dust like this is the material that planets are made from, so it's really important stuff."

MAREK KUKULA

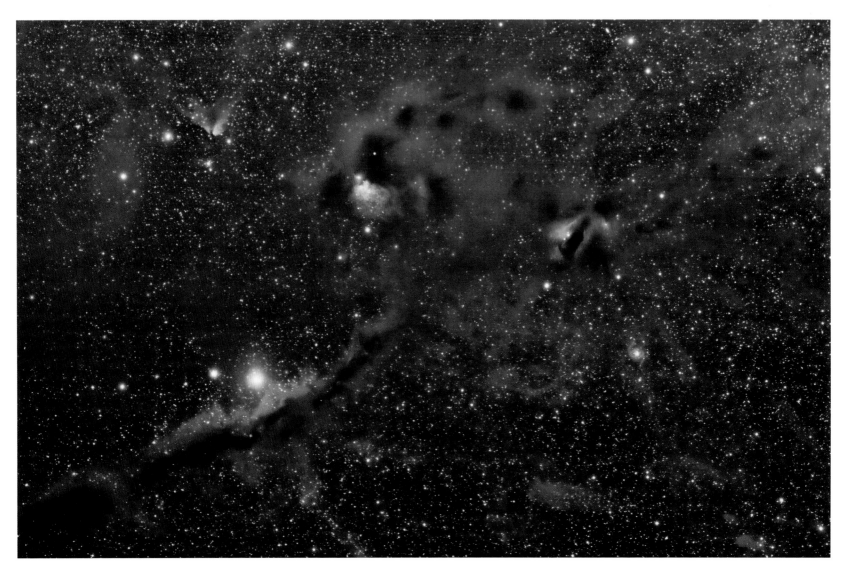

Λ

LEFTERIS VELISSARATOS *(Greece)*

IC 359 and UGC 2980 Spiral
[*17 May 2012*]

LEFTERIS VELISSARATOS: Sometimes taking distant light from hidden, rarely seen objects is like a journey to the unknown. Besides the well-known, glorious celestial objects, countless amazing places in the sky are sending their ancient faint light. The chance to light the darkness of these exotic worlds is more than astrophotography for me, it is a never-ending adventure.

BACKGROUND: Coils of interstellar dust partly obscure the background stars in this region of the constellation Taurus. Towards the right of the image, just below one of the densest knots of dust, the spiral galaxy UGC 2980 shines in the distance.

FSQ106 EDX f/5 telescope; STL11000M camera

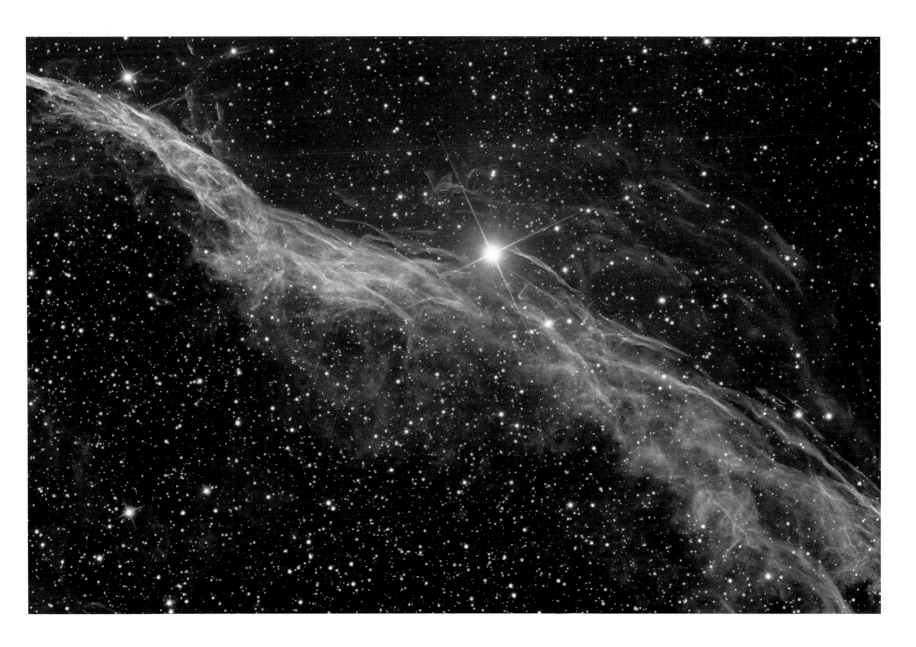

Λ

ROBERT FRANKE *(USA)* *HIGHLY COMMENDED*

NGC 6960 – The Witch's Broom
[*9 September 2010*]

ROBERT FRANKE: This synthetic colour image was created with Ha and OIII filters. These narrowband filters greatly increase the detail while giving a reasonable representation of the nebula's colour. The Veil Nebula is located in the constellation Cygnus, at a distance of about 1400 light years.

BACKGROUND: Part of the Veil Nebula, the 'Witch's Broom' is the glowing debris from a supernova explosion – the violent death of a massive star. Although the supernova occurred several thousand years ago, the gaseous debris is still expanding outwards, producing this vast cloud-like structure.

RCOS 12.5-inch Ritchey-Chrétien telescope; Paramount ME mount; SBIG STL-11000 camera; 15-minute exposure

"This is a wonderfully delicate image of intricate tendrils of enriched stellar material returning to interstellar space, following the explosion of a star thousands of years ago. Capturing the light from this faint, diaphanous source in such rich detail is really impressive."

OLIVIA JOHNSON

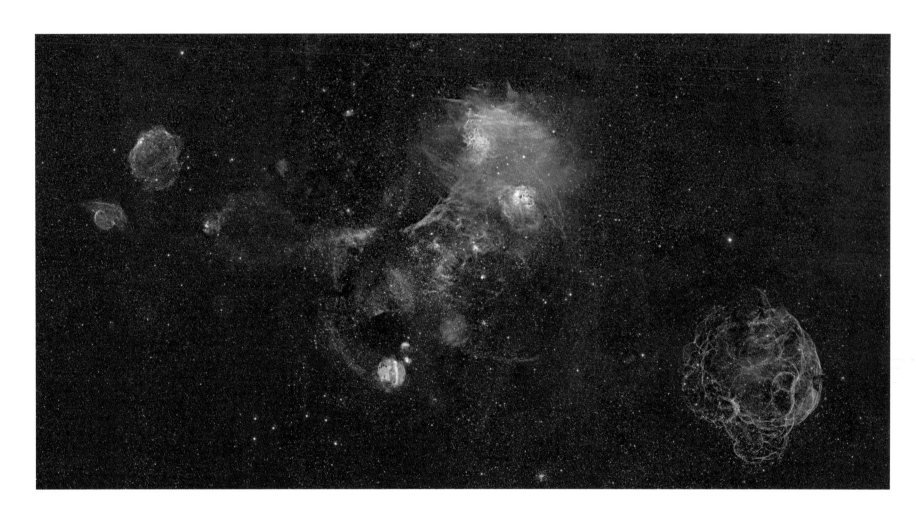

Λ

J.P. METSÄVAINIO *(Finland)*

Auriga Panorama
[8 March 2012]

J.P. METSÄVAINIO: This is my main imaging project from Spring 2012,
just before we lost the astronomical darkness for about six months.
The image covers 21 degrees of sky and has twelve individual image
panels, each imaged three times through narrowband filters for a colour
image. Generally mosaics need lots of work but nothing beats the final
resolution. Another reason to produce wide-field mosaics is to show the
true scale and orientation of the otherwise well-known objects. Even
experienced astro imagers don't always have an idea how large many
emission targets really are.

BACKGROUND: Several astronomical phenomena can be seen in this
panoramic image. In the centre, the glowing gas of the Flaming Star
Nebula is lit by the star AE Aurigae. Meanwhile, in the lower right, the
thread-like wreckage of an exploded star forms the Simeis 147 supernova
remnant.

QHY9 camera; Canon EF 200mm f/1.8 lens

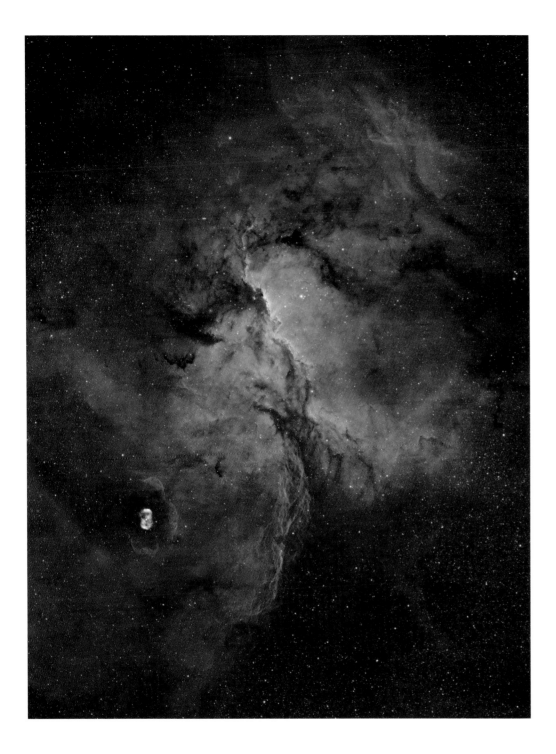

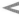

MARTIN PUGH *(UK/Australia)*

NGC 6188
[16 May 2012]

MARTIN PUGH: This is a fabulous piece of sky to image with narrowband filters and the combination of the telescope and camera allows the inclusion of the wonderful emission nebula NGC 6164 and its halo.

BACKGROUND: Just as ancient people saw heroes and animals in the patterns of the stars, modern observers like to give fanciful names to nebulae and galaxies. The rather dull sounding NGC 6188 is also known as the 'Fighting Dragons', based on its contorted and evocative structure.

Takahashi FSQ 106N telescope; Software Bisque Paramount ME mount; SBIG STL11000M camera; 13-hour exposure

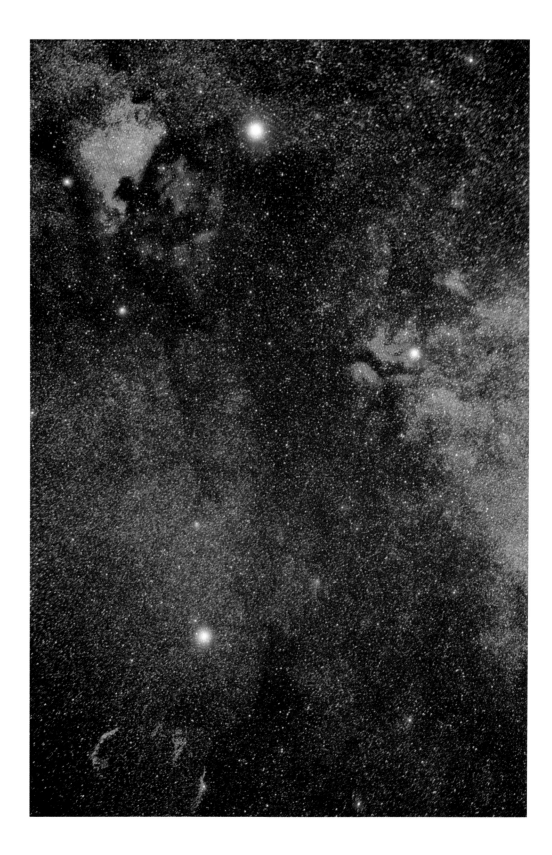

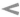

BRENDAN ALEXANDER *(Ireland)*

The Wing of the Swan
[*1 September 2011*]

BRENDAN ALEXANDER: Over the weekend I stacked and processed my data, going through the usual train of thought ... Does that look right? ... Maybe if I just tweak this ... I finally settled on the image opposite. The bright star in the top centre of the image is Deneb and forms the tail of the swan while the star in the right centre of the frame is called Sadr and represents the mythical swan's body. Gienah, the star in the bottom left of the image, forms part of the wing of the swan. Finally, the dark dust lane of the Milky Way is visible in the image as the dark river running between the three stars Deneb, Sadr and Gienah.

BACKGROUND: This vast mixture of dark dust and glowing hydrogen gas is characteristic of the stellar nurseries that are scattered throughout the spiral arms of our galaxy. Perhaps the most striking aspect of this image, however, is the sheer number of stars that it reveals, but this is still only a tiny fraction of the hundreds of billions of stars that make up the Milky Way.

Self-modified 1000D camera; Sigma 70–300mm APO lens at 70mm; ISO 1600; 10-minute exposure

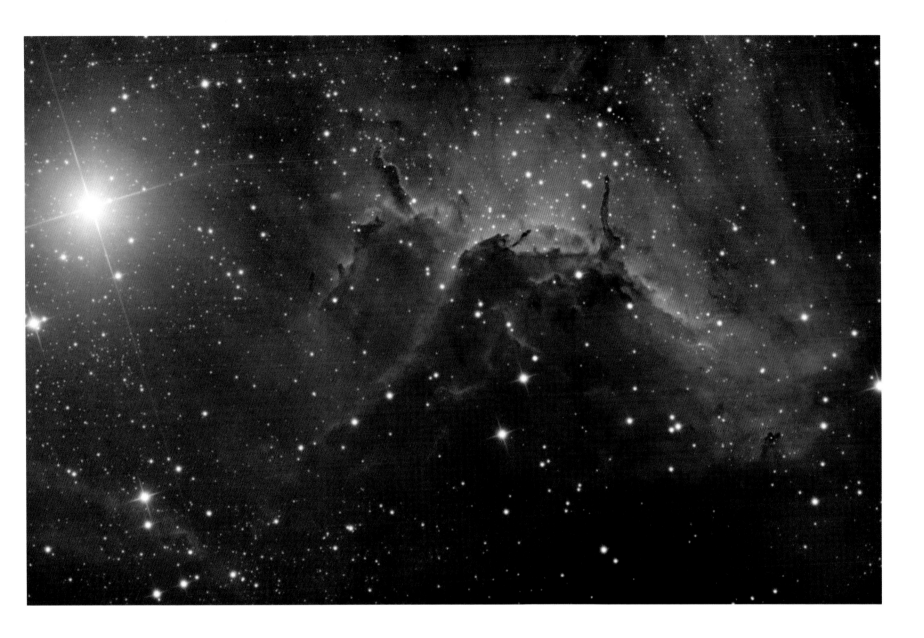

∧

GEORGE VIDOS *(Greece)*

IC 5067 – The Pelican Nebula
[*29 October 2011*]

GEORGE VIDOS: The Pelican Nebula is an HII region associated with the North America Nebula in the constellation Cygnus. The nebula resembles a pelican in shape, hence the name.

BACKGROUND: The birth of new stars is revealed in this colourful view of a star-forming nebula. In the centre of the image, a cloud of dust is collapsing under its own gravity, with the densest clumps destined to condense into new stars. On the left, this process is already complete, and the newly formed stars are blazing with light and heat. Their intense radiation is eroding the dust cloud in which they were born, carving it into peaks and tendrils and causing the surrounding hydrogen gas to glow.

RCOS 12.5 telescope; Paramount Me mount; SBIG STL-11000M camera; 10–30-minute exposure

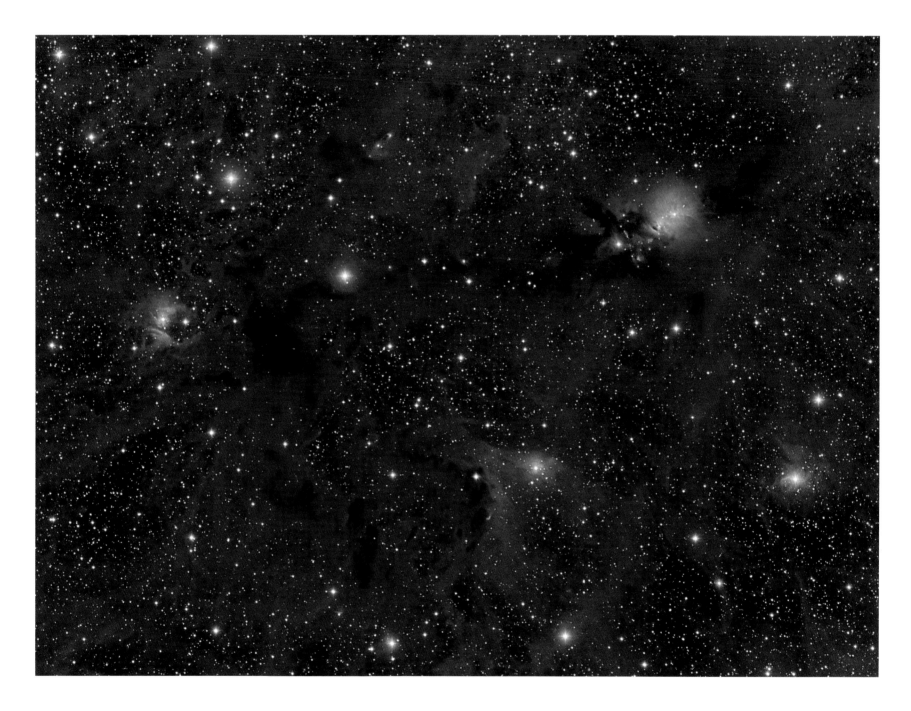

Λ

LEONARDO ORAZI (Italy)

From Aries to Perseus
[27 November 2011]

LEONARDO ORAZI: This is the deepest image I ever made so far ... It's been exciting to highlight this kind of cosmic web.

BACKGROUND: This astonishing image clearly shows that the space between stars is rarely entirely empty. Here, the sky is crowded with clumps and wisps of interstellar dust which are occasionally illuminated by nearby stars. The dust grains themselves are tiny, similar in size to smoke particles here on Earth. There are so many of them, however, that in some places they entirely block the light of the background stars.

Takahashi FSQ 106EDXIII f/3.6 telescope; AP Mach1 GTO mount; ATIK 383L+ camera; 15-minute exposure

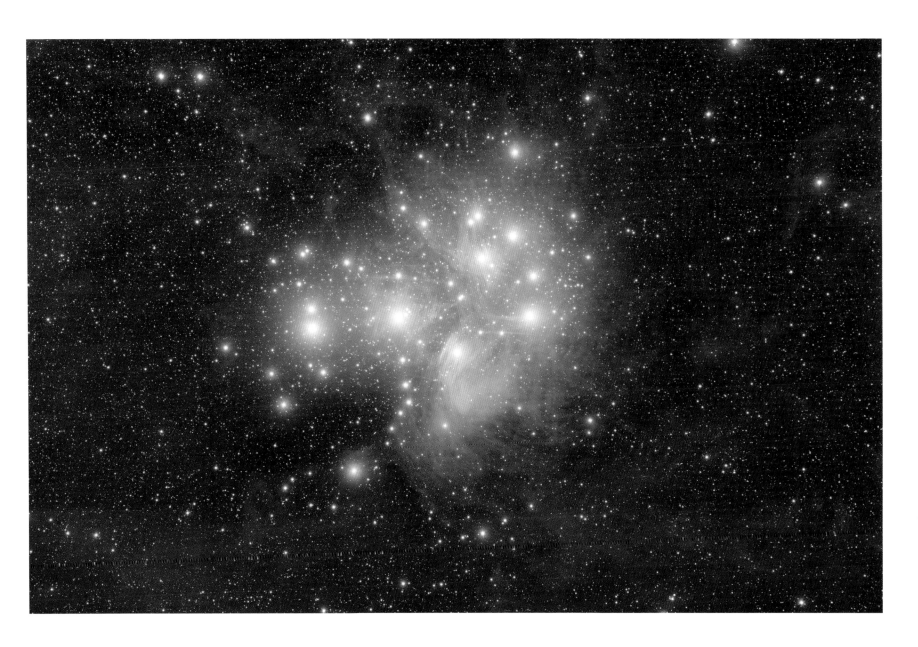

Λ

TOM O'DONOGHUE (Ireland)

The Pleiades Star Cluster in Taurus
[29 October 2011]

TOM O'DONOGHUE: I love the way the star cluster is set against the background Taurus molecular cloud, with the gorgeous swaths of blue reflection nebulosity passing in front of the stars.

BACKGROUND: The stars of the Pleiades are easily visible to the naked eye but this long-exposure image shows them in a startling new light. We see that the familiar star cluster is embedded in a huge cloud of interstellar dust, which catches and reflects their blue-white light. Further from the stars the dust appears dark and cold.

Takahashi FSQ 106N telescope; EM200 Takahashi mount; Atik 11000 CCD camera

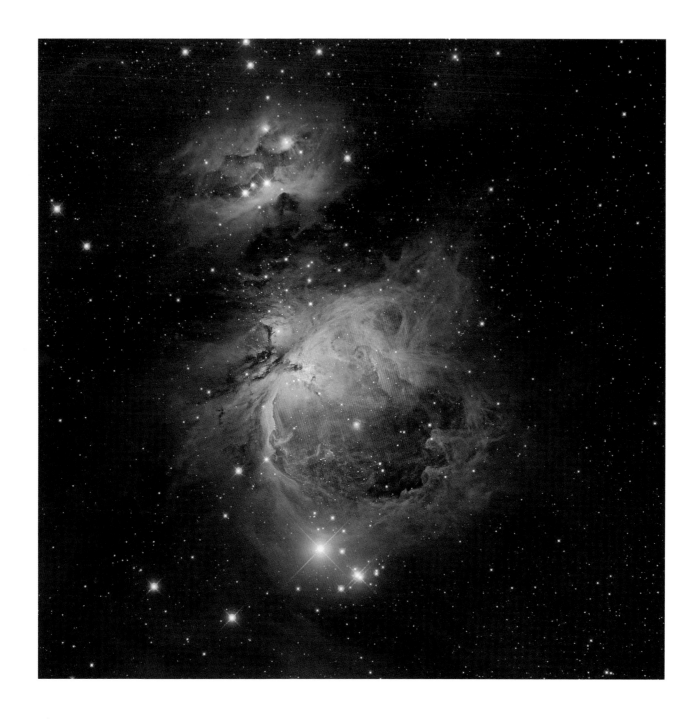

^

MICHAEL SIDONIO *(Australia)*

The Smoking Sword
[*24 December 2011*]

MICHAEL SIDONIO: The Orion Nebula region is often imaged but I wanted to produce a result that was natural and subtle in appearance, looked real by being bright where it should be and actually looked like dust and gas floating in space.

BACKGROUND: To the naked eye the Orion Nebula appears as a small patch of hazy light among the stars. The true scale and complexity of the Orion's Sword nebula only becomes apparent when viewed through a telescope. In the centre of the nebula newly-formed stars blast their surroundings with radiation, carving out a cavity in the dust and causing the hydrogen gas to glow pink.

Orion Optics 12-inch f/3.8 telescope; Takahashi NJP German Equatorial mount; FLI ProLine 16803 camera; 10–60-minute exposure

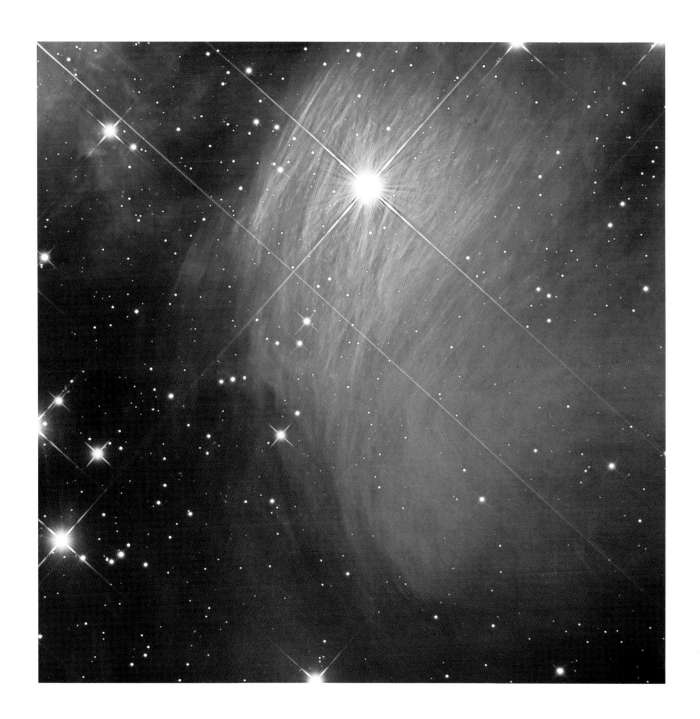

∧

LEONARDO ORAZI (Italy)

Merope Reflection Nebula
[24 January 2012]

LEONARDO ORAZI: From the first frame of this picture I noticed the beautiful nebular structures present. It was a pleasure to discover, during processing, how intricate and spectacular our universe is. Astrophotography is a fantastic passion.

BACKGROUND: A 'reflection nebula' occurs when starlight is reflected by a cloud of interstellar dust. Here light from the bright star Merope at the centre of this image illuminates the filamentary structure of the nearby dust cloud to great effect.

ATIK 4000LE camera; GSO RC 10-inch f/8 2000mm lens; 5-minute exposure

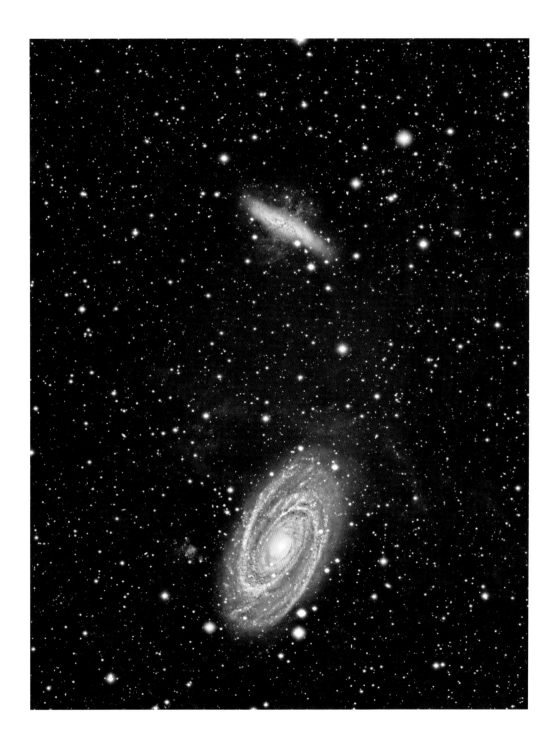

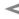

JULIAN HANCOCK (UK)

M81–82 HaLRGB
[26 February 2012]

JULIAN HANCOCK: I have never imaged M81/M82 and was astounded by the detail I managed to capture. Not only the two galaxies but also the dwarf, irregular Holmberg Galaxy. The icing on the cake was the flux nebulosity from our own galaxy.

BACKGROUND: The galaxies M81 and M82 in Ursa Major (the 'Great Bear') are a popular target for astrophotographers. Like our own Milky Way, M81 is a regular, orderly spiral. Its companion M82 is a 'starburst galaxy' in which new stars are forming at a furious rate. The red tendrils of hydrogen gas extending from the galaxy are being blasted from its centre by the violent processes occurring there.

William Optics FLT 110mm refractor; EQ6 mount; QSI 583WSG CCD camera

Λ

LÓRÁND FÉNYES (Hungary)

M106, NGC 4217, 4226, 4231, 4232
[23 April 2012]

LÓRÁND FÉNYES: M106 has been a well-known radio source from the 1950s … The main feature of the M106 active galaxy is the very bright central core … In addition the photograph also includes numerous celestial cities. The most conspicuous spot is the so-called NGC 4217 galaxy with its prominent dust lanes which can easily be detected by using a 20 cm telescope. A few hundred million light years further away NGC 4226, 4231 and 4232 galaxies can be found. Well-practised eyes can spot a reddish group (approximately a billion light years away) in the upper third of the picture.

BACKGROUND: Although it appears to be a tranquil spiral like the Milky Way and Andromeda, the galaxy M106 hides a violent secret. The supermassive black hole at its heart is greedily pulling in the surrounding gas, causing the centre of the galaxy to glow with X-ray radiation. Look closely at the image and you will also see several other, more distant galaxies among the foreground stars of the Milky Way.

GSO-Orion 200/800 telescope; SkyWatcher HEQ5 mount; Canon 1000D camera; ISO800; 6–10-minute exposure

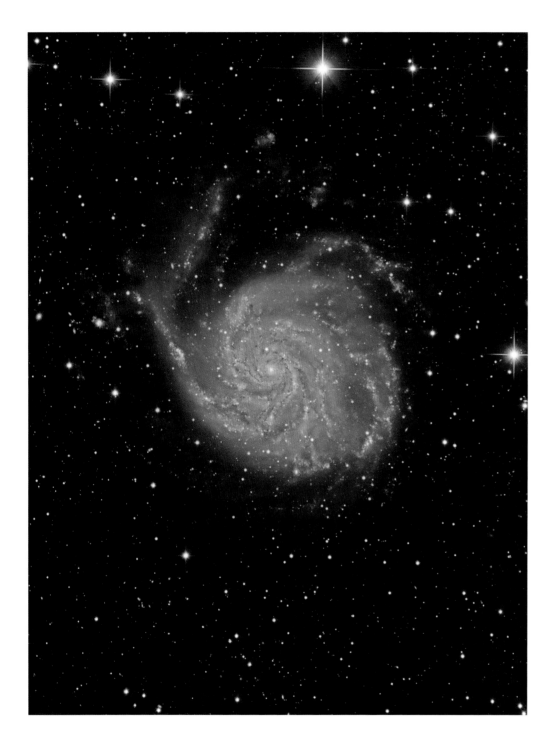

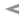

OLEG BRYZGALOV (Ukraine)

M101 – The Pinwheel Galaxy and Supernova SN 2011fe
[26 May 2012]

OLEG BRYZGALOV: Pictures like this show the beauty and perfection of the structure of our universe. Between the ideal logarithmic spiral arms of the galaxy shines a distant supernova in navy blue. We see death and birth.

BACKGROUND: Most of the individual stars in this image are part of our own Milky Way. Far beyond, the billions of stars that make up the Pinwheel Galaxy appear blended together as swirling haze of light. In 2011 one of the Pinwheel's stars suddenly came to prominence when it exploded as a supernova. For a few weeks the dying star (just to the left of the large spiral arm) was visible across a distance of more than 20 million light years.

Newtonian 10-inch reflector; WS-180 mount; 1200mm f/4.7 lens; QSI-583wsg camera; 7–15-minute exposure

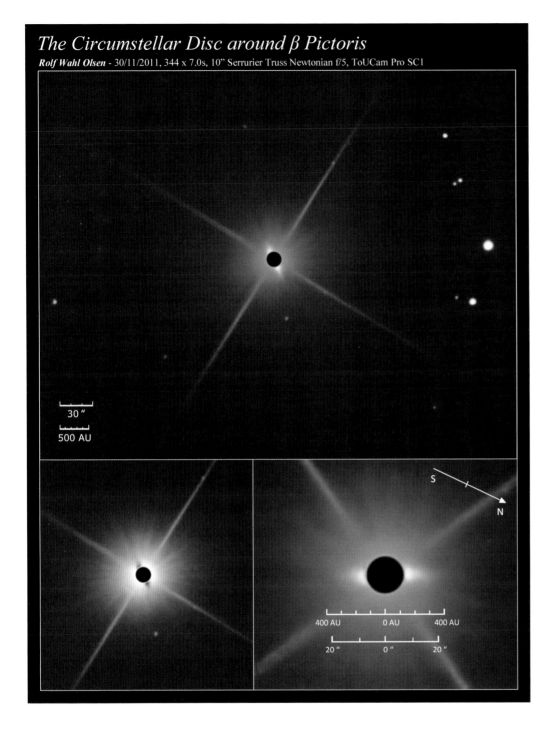

The Circumstellar Disc around β Pictoris
Rolf Wahl Olsen - 30/11/2011, 344 x 7.0s, 10" Serrurier Truss Newtonian f/5, ToUCam Pro SC1

30 "
500 AU

S
N

400 AU 0 AU 400 AU

20 " 0 " 20 "

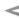

ROLF OLSEN *(New Zealand)*

The Circumstellar Disc around Beta Pictoris
[*30 November 2011*]

ROLF OLSEN: I have always enjoyed going off the beaten path in astrophotography, and I am very happy with having managed to take this first amateur image of another planetary system.

BACKGROUND: Beta Pictoris made headlines in 1984 when scientists detected a ring of dust and gas encircling the star. This is believed to be the first stage in the formation of a new solar system. Less than thirty years later this ring of dust has been imaged for the first time by an amateur astronomer – an astonishing achievement which demonstrates how new technology and painstaking effort are continuously advancing the field of astrophotography.

Homebuilt 10-inch Serrurier Truss Newtonian telescope; Philips ToUCam Pro camera; 4–7-second exposure

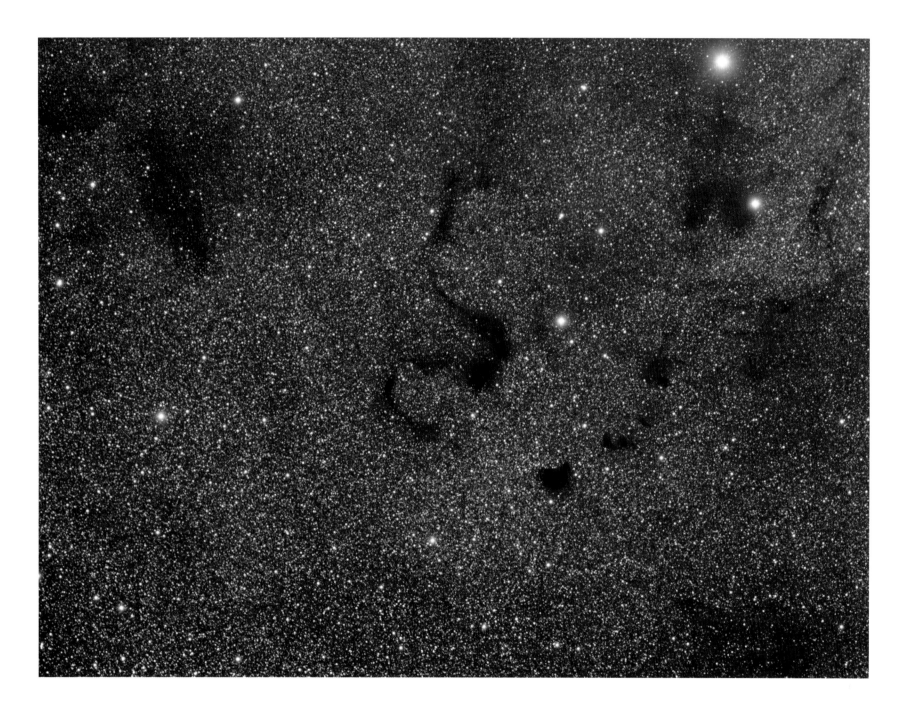

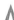

VANGELIS SOUGLAKOS *(Greece)*

Snake Nebula
[25 June 2012]

VANGELIS SOUGLAKOS: The Snake Nebula (also known as Barnard 72) is a dark nebula in the Ophiuchus constellation. It is a small but readily apparent S-shaped dust lane that snakes out in front of the thousands of colourful Milky Way stars. Barnard 68, Barnard 69, Barnard 70 and Barnard 74 are found to the right side of the Snake Nebula.

BACKGROUND: Coiling in front of the dense star clouds of the Milky Way, the Snake Nebula sinuously lives up to its name. The nebula is composed of tiny particles of dust, coated with frozen gases, which absorb and block the light from the stars behind.

Officina Stellare Veloce RH200 Astrograph telescope; Astrophysics Mach1 GTO mount; ATIK 383L+ Mono camera; 4-hour exposure

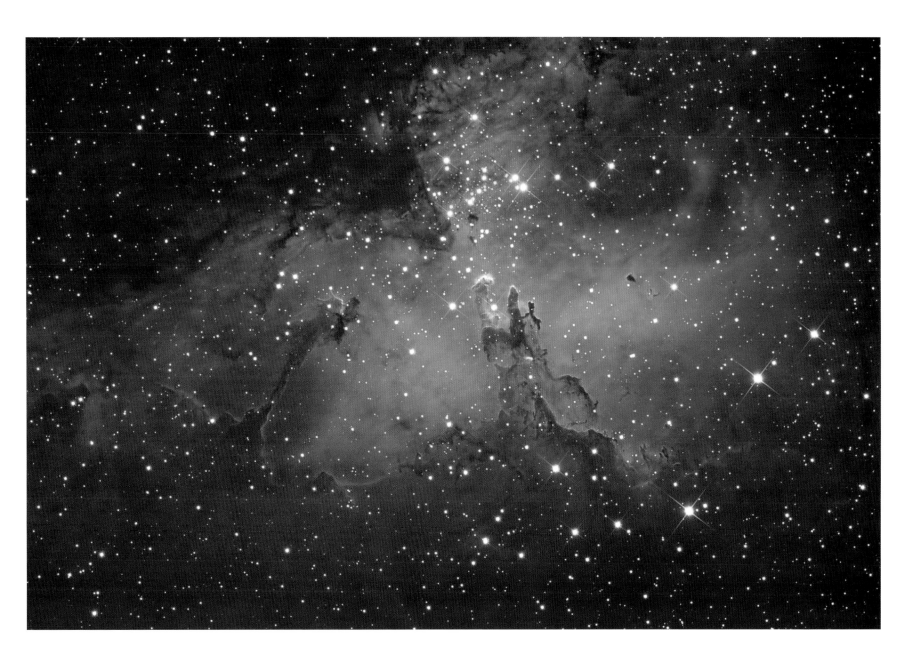

BILL SNYDER (USA)

M16 – Eagle Nebula Hybrid Image
[27 June 2012]

BILL SNYDER: I took this because I wanted a wide-field image of one of the more famous images produced with the Hubble Telescope, the 'Pillars of Creation'.

BACKGROUND: The Eagle Nebula was made famous by the Hubble Space Telescope's 'Pillars of Creation' image in 1995. It is a site of active star formation, in which dense clumps of gas and dust are collapsing under gravity to form new generations of stars. Towards the top of the image harsh radiation from a cluster of young stars is blasting out a cavity in the nebula. Dense knots of dust shield the material behind them, forming slender columns which stretch away from the central stars.

TMB 130mm telescope; Atlas EQG mount; TMB 130mm lens; Apogee U8300 camera

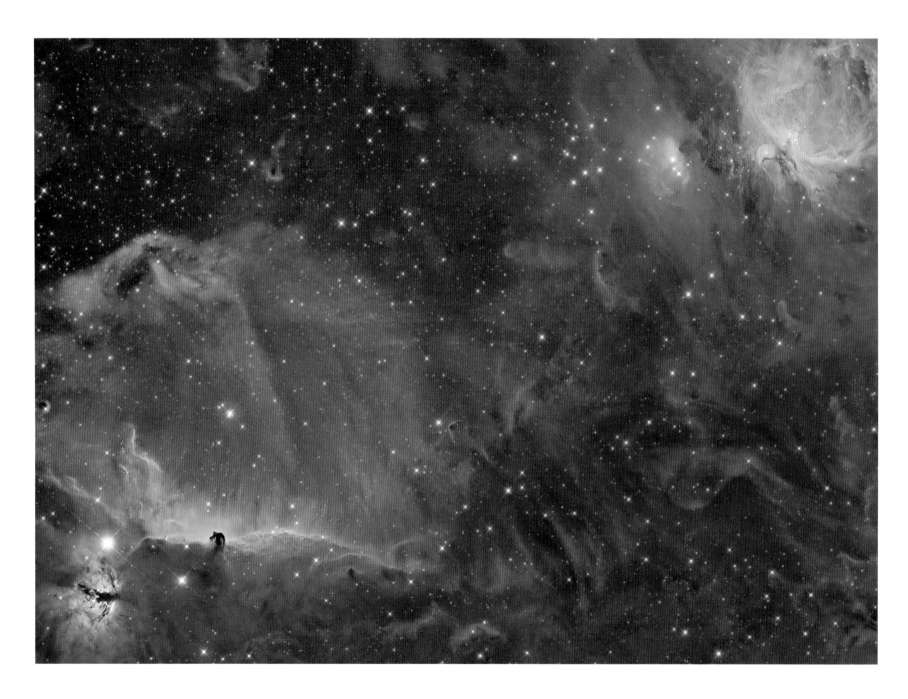

Λ

AGGELOS KECHAGIAS *(Greece)*

Horse and Orion Wide Field
[*19 January 2012*]

AGGELOS KECHAGIAS: I have taken this image from my observatory at Korinthos, Peloponnese, in Greece. My home is 3.5 kilometres outside the town of Korinthos but I have a very light-polluted southern view because of the highway to Athens. I cannot believe that I have managed to complete this photo from my home and for that reason it is one of my favourites.

BACKGROUND: The Orion Molecular Cloud Complex is a vast star-forming region stretching across an area of sky from Orion's belt to his sword. Mostly invisible to the naked eye, the complex includes familiar objects such as the Orion Nebula (top right) and the Horsehead Nebula (lower left).

Takahashi fs60cb CCD telescope; HEQ5 pro mount; Takahashi f/4.2 lens; QHY5 camera

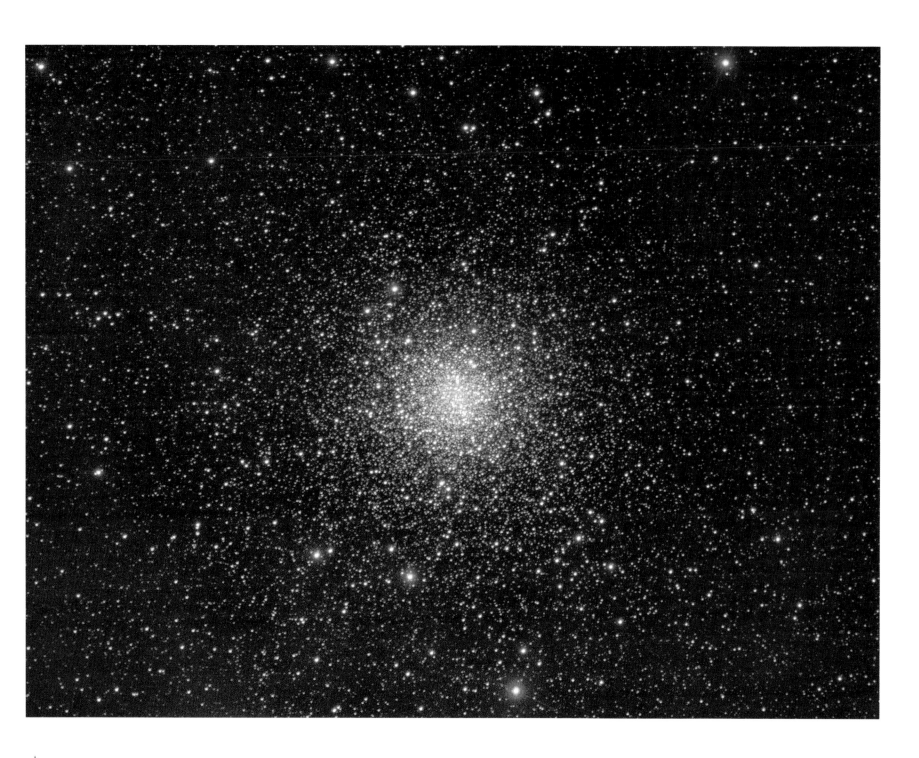

Λ

ROLF OLSEN *(New Zealand)*

The Nearest Globular – Messier 4 in Scorpius
[22 June 2012]

ROLF OLSEN: This rather overlooked globular would be one of the most splendid in the sky if not obscured by the Rho Ophiuchi clouds which can just be seen on the left.

BACKGROUND: Messier 4 has been studied by astronomers for more than 250 years, and it was the first globular cluster in which individual stars could be distinguished as telescope technology improved. Those early astronomers would doubtless have been thrilled by this detailed image, in which thousands of ancient red stars can be seen crowding towards the cluster's dense core.

Homebuilt 10-inch Serrurier Truss Newtonian telescope; QSI 683wsg camera

LÓRÁND FÉNYES *(Hungary)*       WINNER

Elephant's Trunk with Ananas
[*2 February 2012*]

LÓRÁND FÉNYES: I bought my first tube at the end of 2010. I didn't have any information about astronomy, so I started to learn the basic things about the sky and tried serious astrophotography at the beginning of 2011. It is my first attempt at entering your competition. The Elephant's trunk is my 34th photo.

BACKGROUND: The Elephant's trunk seems to uncoil from the dusty nebula on the right of the image, its tip curled around a cavity carved out by the radiation produced by young stars. Capturing a deep-sky object like this takes great skill and painstaking attention to detail.

GSO-Orion 200/800 telescope; SkyWatcher HEQ5 mount; Canon 1000D camera; ISO1600; 8-hour exposure

"Imaging a deep sky object like this takes skill and dedication. This photographer makes it look easy! This mysterious scene could have come from the cover of a 70s Sci-Fi novel. A wonderful picture and a great achievement."

MAREK KUKULA

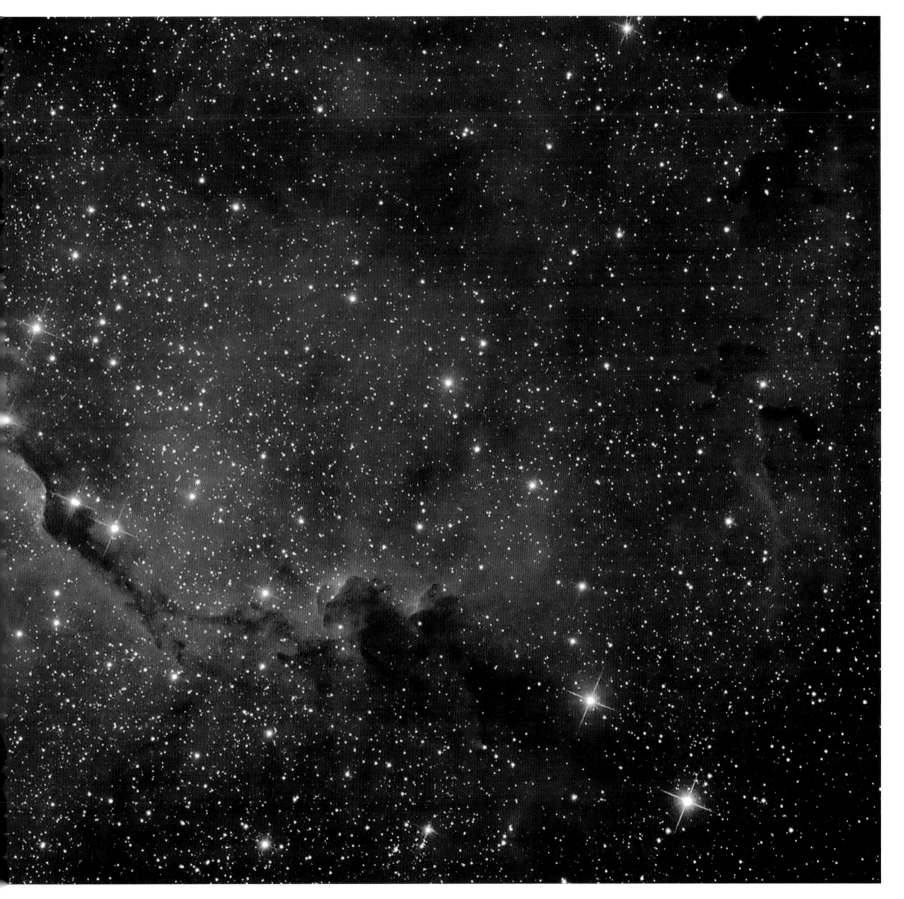

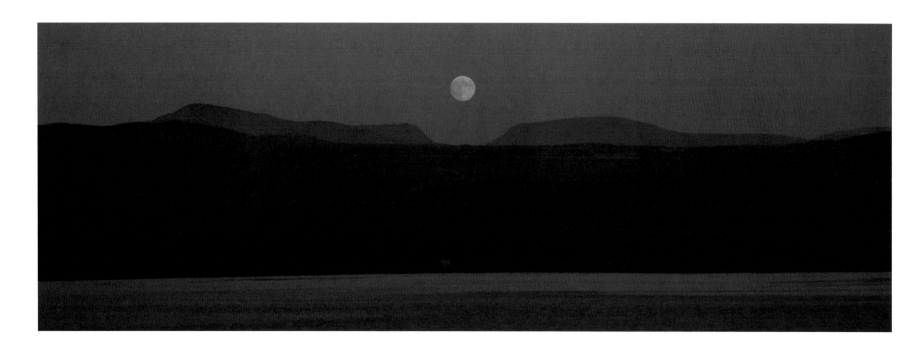

Λ

SIMON BELCHER (UK)

Moonrise over Snowdonia
[14 July 2011]

SIMON BELCHER: I had aimed for a moonrise shot, but it took a lot of planning and timing to get the Moon centred in the hollow of the hills across the bay.

BACKGROUND: Taking the perfect astronomy photograph can sometimes be a question of being in the right place at the right time. Careful planning enabled this photographer to catch the full Moon poised perfectly between a gap in the Welsh mountains.

Sony DSC-W90 camera; 17.4 mm f/5.2 lens; ISO 125; 1/60-second exposure

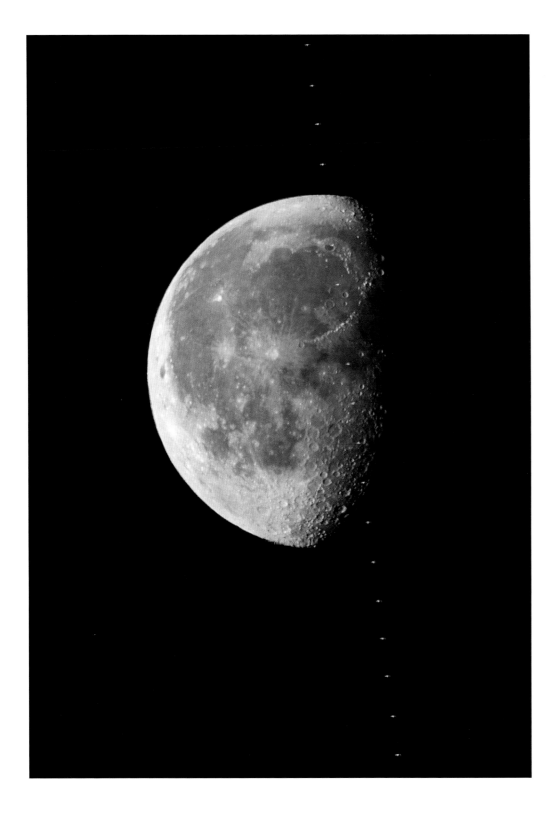

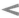

PHIL MCGREW *(USA)*

Space Station Flies across the Moon!
[*14 January 2012*]

PHIL MCGREW: Finding a setting Moon, a sunlit space station, and a place where the two will meet was the most challenging photograph I've ever taken.

BACKGROUND: In a man-made echo of 2012's transit of Venus across the Sun, this image captures the swift transit of the International Space Station in front of the Moon in a series of split-second exposures. To take an image like this requires foresight, skill and planning.

Canon 7D camera; 500mm f/4 lens; ISO2500; 1/1600-second exposure

PAULA RITCHENS *(Australia)*

Omega Centauri NGC 5139
[*11 June 2012*]

PAULA RITCHENS: I think Omega Centauri is the most beautiful globular cluster, not only to photograph but also to observe.

BACKGROUND: Globular clusters like Omega Centauri are compact stellar swarms, sometimes containing hundreds of thousands of stars. More than 150 globular clusters are known to orbit the Milky Way and they are composed almost entirely of very old red stars. The astonishing density towards the centre of the cluster has been skilfully captured in this image.

Saxon ED100 telescope; Meade Starfinder mount; Canon 1100D camera; ISO 800; 15-second exposures

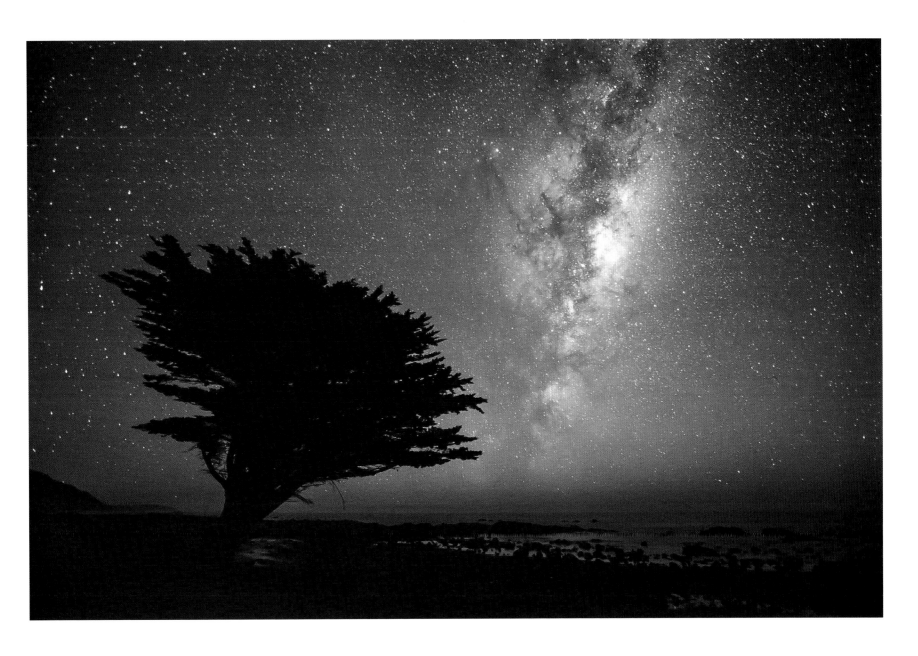

Λ

MARK GEE *(New Zealand)*

Tree under the Stars
[21 April 2012]

MARK GEE: A lone tree stands in silhouette against the night sky as the Milky Way rises overhead. I shot this image near the remote coastal community of Castlepoint in New Zealand.

BACKGROUND: Silhouetted against a starlit sky, this tree appears to lean towards the disc of the Milky Way galaxy.

Canon 5D Mark II camera; Canon EF 14mm f/2.8 lens; ISO 3200;
30-second exposure

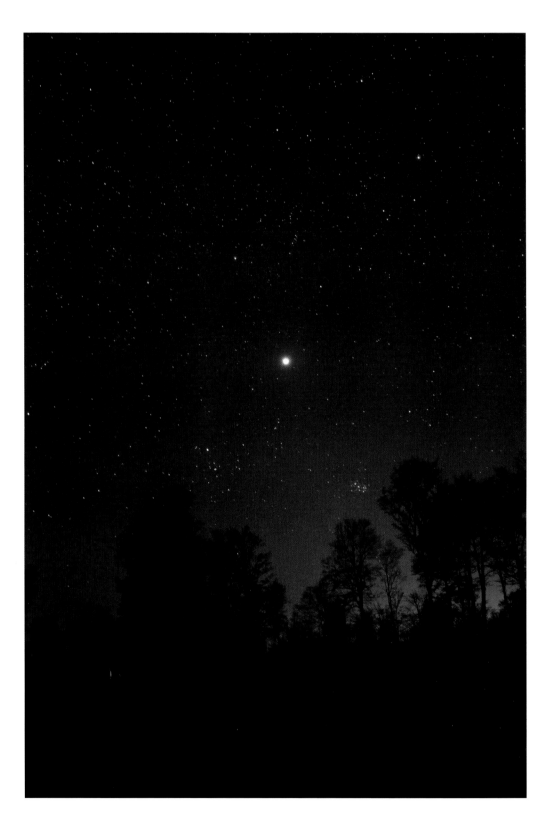

SCOTT TULLY (USA)

Venus and Pleiades in Zodiacal Light
[*18 April 2012*]

SCOTT TULLY: This was my first attempt to capture the zodiacal light since I started shooting the night sky last year. The results were better than I could have ever imagined!

BACKGROUND: By using sensitive cameras, long exposures and special filters, astrophotography can reveal amazing cosmic vistas that would otherwise be invisible to the naked eye. But this photographer has taken a different, more subtle approach, accurately capturing the night sky as it would appear to human eyes and creating a haunting, tranquil scene.

Canon Rebel T2i camera; EFS 18–55mm f/3.5 lens at 18mm; ISO 1600; 25-second exposure

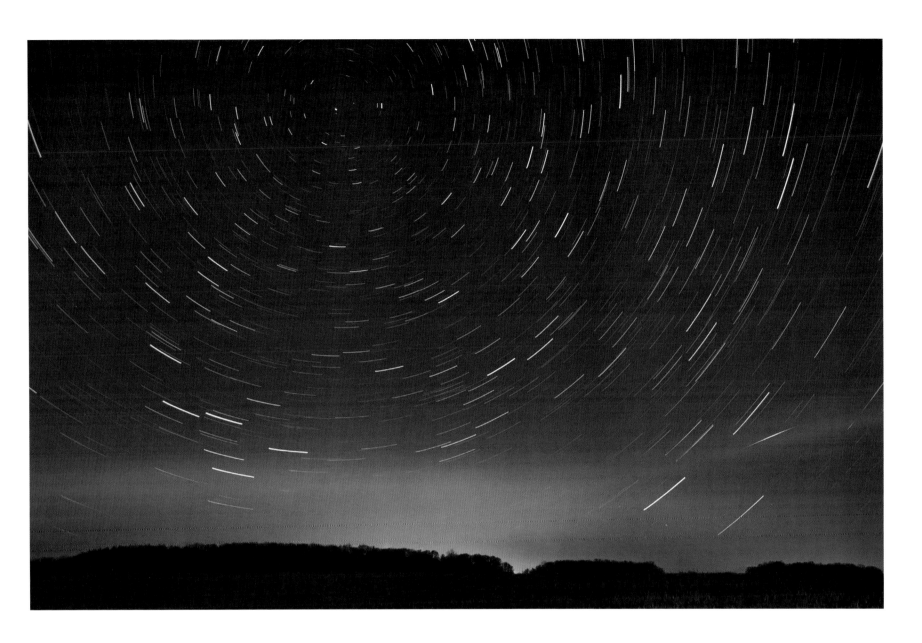

KEVIN PALMER *(USA)*

Aurora and Star Trails
[24 April 2012]

KEVIN PALMER: On this night in April, I was happy to see the aurorae for the second time in my life. I drove to a dark roadside to shoot this picture. The aurorae really didn't move or change much so I used the opportunity to shoot a 26-minute star trail image at the same time.

BACKGROUND: To simultaneously photograph two astronomical phenomena might seem like an ambitious goal, but this photographer has succeeded in capturing both star trails and an auroral display.

Pentax K-x camera; Tamron 17–50mm f/2.8 lens at f/3.5; ISO 800; 15-second exposure

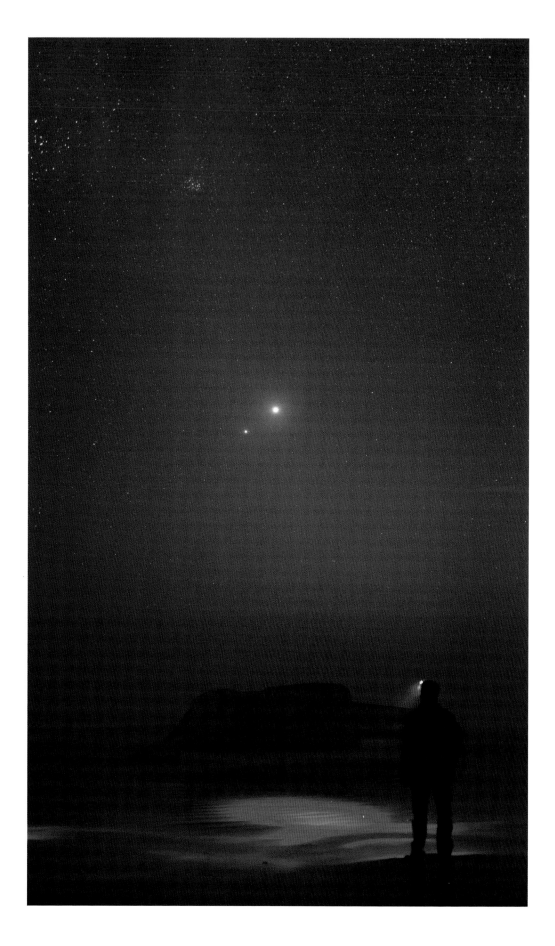

LAURENT LAVEDER *(France)*

Facing Venus-Jupiter Close Conjunction
[*15 March 2012*]

LAURENT LAVEDER: In this image Venus is higher and to the right of Jupiter. I take my place in the lower right corner of the frame to complete the diagonal formed by me, the two planets, the Pleiades and Taurus. With my red flashlight on my head, I illuminate the beach and the wet sand from the low tide.

BACKGROUND: The conjunction of Venus and Jupiter, when the two bright planets appeared noticeably close together in the sky, was one of the astronomical highlights of 2012. Their apparent closeness was an optical illusion – Jupiter was in fact millions of kilometres further away than Venus. This picture nicely demonstrates a stargazing tip: astronomers often use red torches to find their way about in the dark as these help to preserve their night vision.

Canon 5D Mark II camera; Sigma 50mm f/1.4 lens at f/2.0; ISO 3200; 8-second exposure

"The brightness of the planets and their close conjunctions were the theme of my sky-watching earlier this year, so I was glad to spot this image, despite the fact that the landscape in which I found myself was much less evocative than that framed in this beautiful shot."

REBEKAH HIGGITT

"A lovely shot of a celestial display I enjoyed myself earlier this year, when the conjunction of two bright planets stood out even in the heavily light-polluted skies of London. I like the feeling of pilgrimage evoked by this image of someone enjoying ideal conditions for stargazing: the dark-adaption friendly red light reflecting off the wet sand, and the perfectly dark sky over the misty ocean."

OLIVIA JOHNSON

"This picture is a great reminder of the 2012 conjunction of Venus and Jupiter. The two planets were so conspicuous, even from light-polluted urban areas, and it really got the public asking questions and talking about astronomy."

MAREK KUKULA

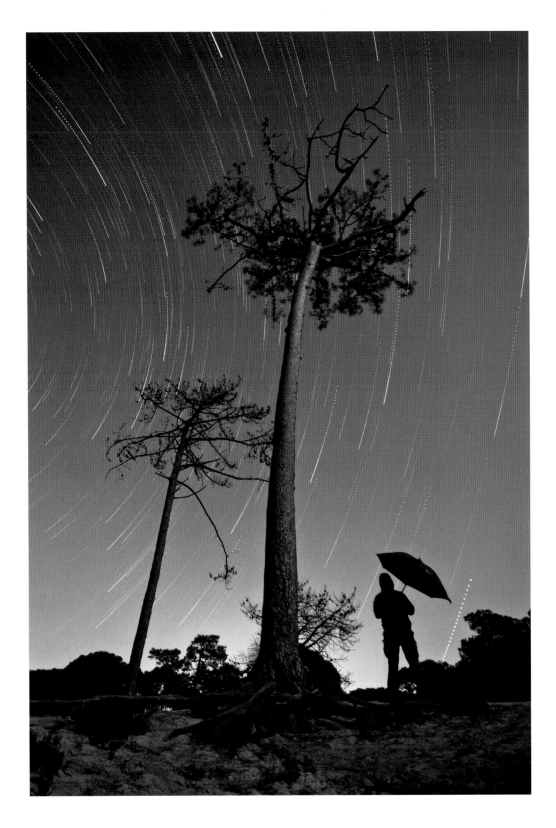

MIGUEL CLARO (Portugal)

It's Raining Stars
[14 August 2011]

MIGUEL CLARO: A cautious observer prepared with his umbrella for a rain of stars in the Perseid meteor shower. The image shows what should be a true meteor shower, had it not been for the full Moon hiding, with its intense glare, most of the shooting stars. Jupiter is visible on the right of the silhouette.

BACKGROUND: A dash of humour in this time-lapse shot makes the normally imperceptible rotation of the Earth seem almost hectic!

Canon 50D camera; 12mm f/6.3 lens; ISO 800; 25-second exposure

>

STEVEN CHRISTENSON *(USA)* *RUNNER-UP*

Lost in Yosemite [C 033706]
[*24 July 2011*]

STEVEN CHRISTENSON: As two lost hikers stood in the distances of the Yosemite wilderness, I was struck by how small they seemed against the immensity of our galaxy – and how lost they might have remained had we not found them.

BACKGROUND: With two tiny figures beneath the immense dome of the sky, this picture seems to capture the wonder, beauty and awe of astronomy.

Canon 5D Mark II; Canon EF 16–35mm f/2.8 lens; ISO 400; 30-second exposure

"A great image showing the scale of Yosemite and giving us an imaginative take on people in space. One of my top five."

MELANIE GRANT

"This image really stood out for me in the 'People and Space' category. The composition perfectly evokes the dramatic human story related by the photographer – that of two underprepared hikers lost in the woods as night falls. You can see the last hint of dwindling daylight in the sky to the right, but only a dark, seemingly endless expanse of stars over the heads of the lost hikers, who huddle over their map in a small bubble of torchlight set within a vast, pitch-black forest. I love this photo because it illustrates how humbling, even frightening, both the natural world and the cold depths of space can be for us as tiny, fragile human beings."

OLIVIA JOHNSON

"I love the way this picture conveys a real sense of our smallness compared to the vast scale of the Universe. The human figures seem so tiny, huddled in their little circle of torchlight."

MAREK KUKULA

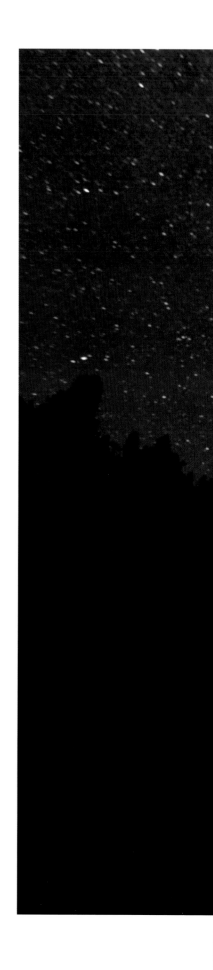

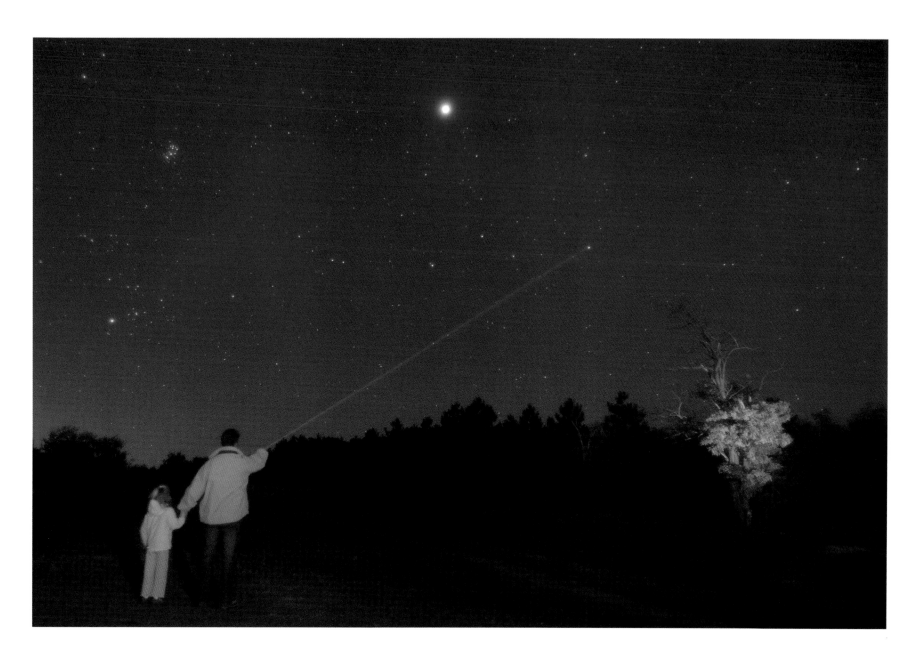

Λ

TAMAS LADANYI *(Hungary)*

Mira mira Mira
[*1 October 2011*]

TAMAS LADANYI: I am showing my daughter a special star in Cetus called Mira with a green laser. I have named my daughter after this famous variable star Mira. The yellow-red Mira is shining at its brightest in this image. Mira was about as bright as it has been in living memory. The title 'Mira mira Mira' is the Spanish translation for Mira watches Mira! The Hyades, Pleiades and Jupiter are also visible in this picture.

BACKGROUND: A father uses a green laser beam to point out his daughter's namesake among the stars. Many famous astronomers can probably trace their passion for the subject back to a similar childhood encounter with the beauty and wonder of the night sky.

Nikon D3s camera; Nikon 24mm f/1.4 lens at f/2.5; ISO 2500; 10-second exposure

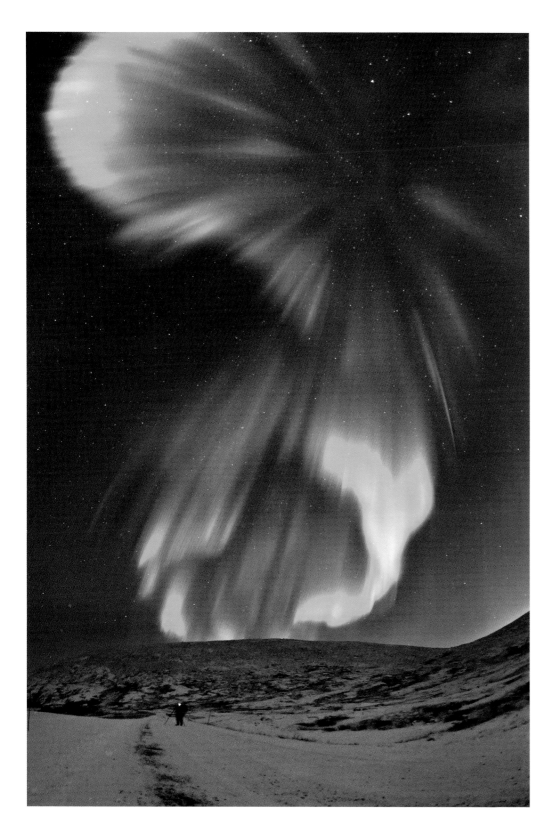

OLE C. SALOMONSEN *(Norway)*

Celestial Illumination
[29 November 2011]

OLE C. SALOMONSEN: This was a night containing spectacular aurorae from a CME (coronal mass ejection) which hit the Earth. It had it all – red and green curtains, and auroral-coronas above our heads. I suspected this evening could be special so I attached my full-frame fish-eye lens to my camera, to be able to catch as much as possible. Man, am I glad I did! I used one of my friends to frame the shot on the road, to put things into perspective. You can see him standing there, exposed, and looking up in awe of this wonderful and fascinating phenomenon! What makes this shot so special to me is the scale of it, and me being able to capture both red and green rays of light, with a corona on top above my head.

BACKGROUND: The shimmering lights of the *aurora borealis* have to be one of the most awe-inspiring sights in astronomy. The tiny human figure in this scene emphasizes their scale and grandeur.

Canon 5D Mark II camera; 15mm f/3.5 lens; ISO 3200; 6-second exposure

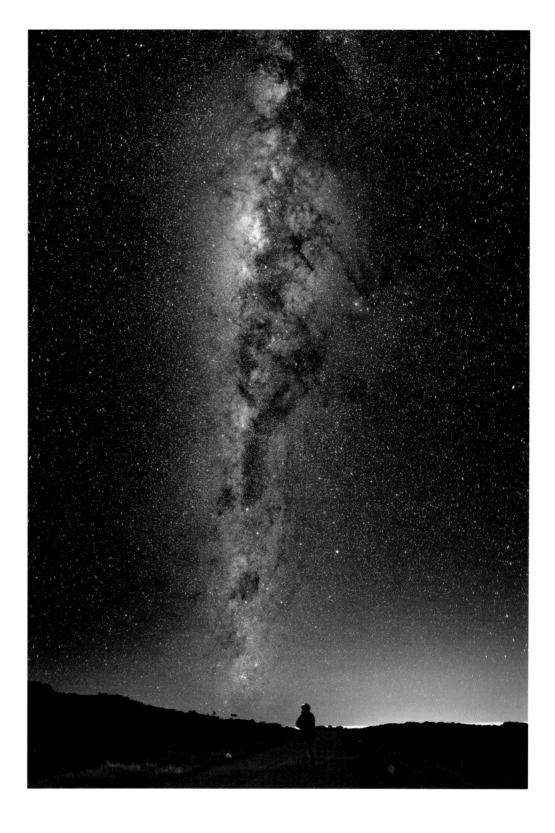

The Milky Way from the Volcano Road
[*24 June 2012*]

LUC PERROT: This picture shows a good part of our Milky Way. It was photographed in Réunion Island, on the road to the volcano Piton de la Fournaise. This site is relatively unaffected by light pollution. The first plan shows the photographer watching the sky.

BACKGROUND: Light pollution from our towns and cities makes the Milky Way all but invisible to most of us. Where the skies are still dark, however, the view can be spectacular. This is why the world's most powerful telescopes are often built in remote areas like this.

Nikon D700 camera; Nikkor 24mm f/1.4 lens; ISO 3200; 15-second exposure

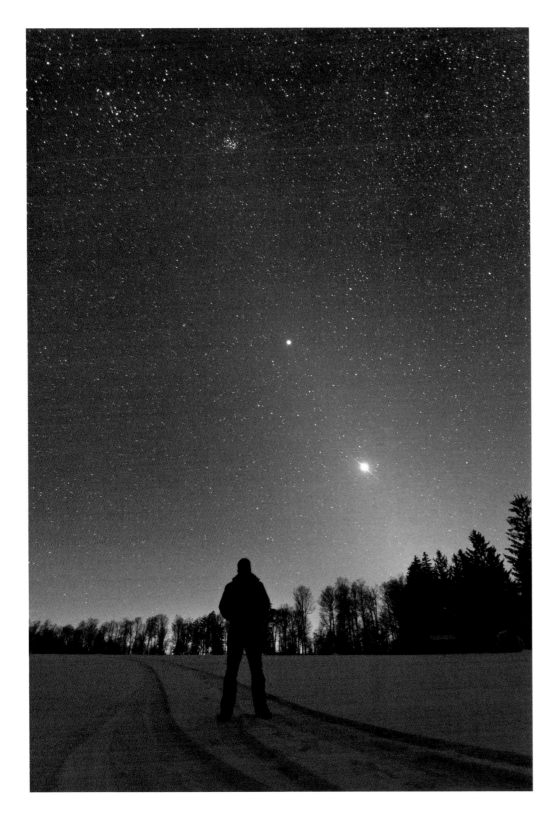

JACK FUSCO *(USA)*

Zodiacal Light and Man
[*23 February 2012*]

JACK FUSCO: I placed myself in this shot to serve as a reminder that as long as we're willing to look, these beautiful night sky views are still out there.

BACKGROUND: In this atmospheric scene a faint band of bluish light angles up from the horizon, where the Sun has already set. This is the zodiacal light, caused by sunlight reflecting from trillions of tiny grains of dust which drift between the planets. This misty band marks out the plane of our solar system, in which all of the planets orbit the Sun. Three of them can be seen here: dazzling Venus, bright Jupiter and, in the foreground, the Earth itself.

Canon 7D camera; Tokina 11–16mm f/2.8 lens; ISO 2500; 25-second exposure

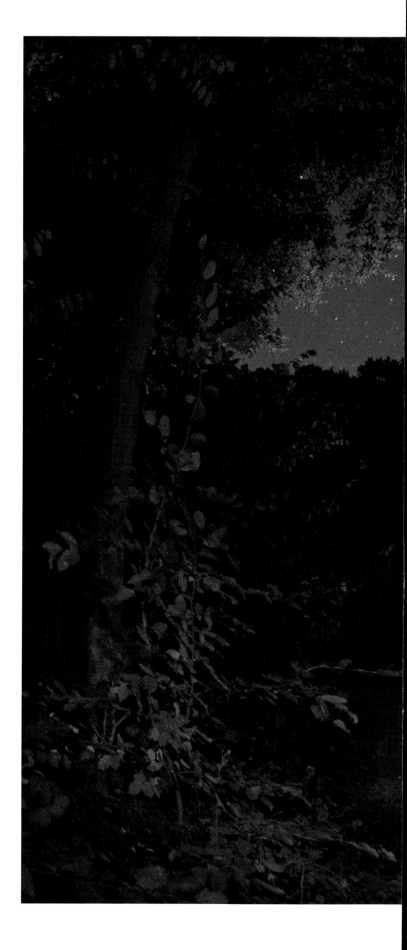

>

TAMAS LADANYI *(Hungary)*

Photographer and Jupiter
[*5 September 2010*]

TAMAS LADANYI: The bright 'star' which greets the photographer in this forest view from Hungary is planet Jupiter. Imaged near the date of the 2010 Jupiter opposition, it completely overpowers every actual star in the night sky. Coincidentally, during September 2010, Jupiter was also passing almost in front of the planet Uranus. Find Uranus like a faint star just to the upper right of Jupiter in this image.

BACKGROUND: The romance of the dedicated astrophotographer: alone with telescope, camera and night sky! An 'opposition' occurs when a planet is directly opposite to the sun in the sky – meaning that it is at its closest to the Earth and therefore also at its brightest.

Canon 500D Mark II camera; Sigma 10mm f/2.8 lens; ISO 3200;
46 second-exposure

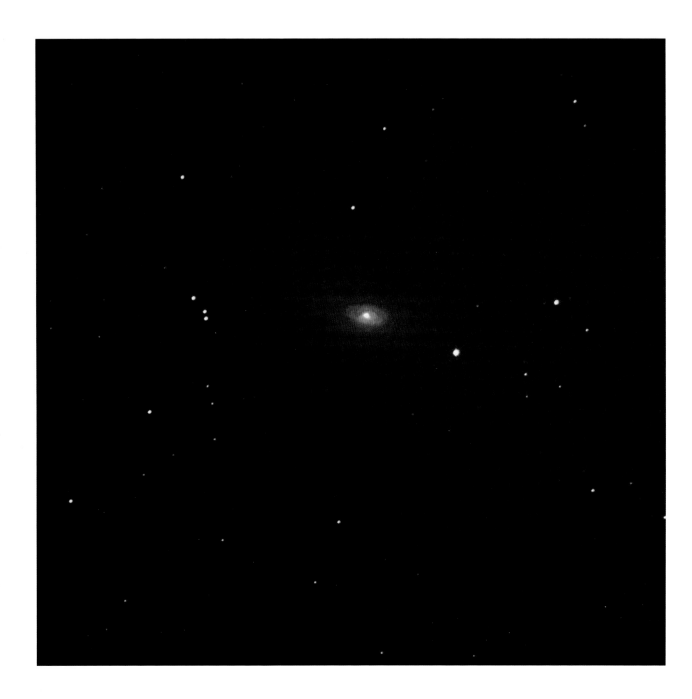

Λ

THOMAS READ *(UK)*, AGED 12 *WINNER*

The Sunflower Galaxy
[23 *February 2012*]

THOMAS READ: I love this image as it shows fantastic detail in the spiral arms. I was curious about the Sunflower Galaxy and how to maximize photographic results for such a distant galaxy.

BACKGROUND: A spiral system like the Milky Way, Messier 63 has arms which encircle the yellowish centre of the galaxy like the petals of a flower. This is why it has earned the nickname of the 'Sunflower Galaxy'.

Bradford Robotic telescope online; Galaxy telescope in Tenerife

"Robotic scopes give the public access to some pretty powerful astronomical equipment but it still takes skill and judgement to capture a great photo. I'm really impressed by what this young photographer has achieved here."
MAREK KUKULA

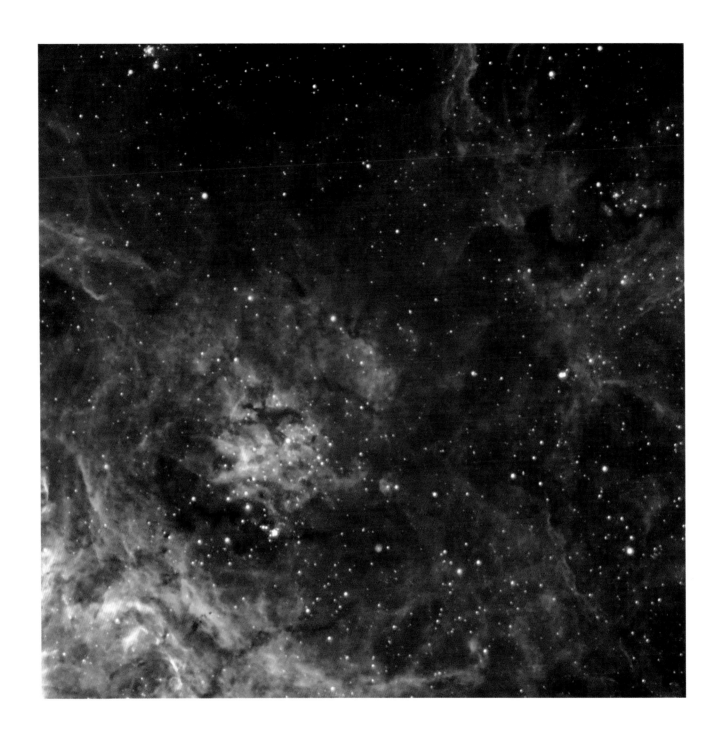

Λ

NICK HOWES *(UK)*

The Heart of the Spider
[*17 January 2012*]

NICK HOWES: This image shows what a robotic telescope is capable of doing. The intricate tendrils of the Tarantula Nebula and its vast, star-forming cauldron light up the southern skies.

BACKGROUND: The Tarantula Nebula is an enormous star-forming region, lying at the edge of our neighbouring galaxy, the Large Magellanic Cloud. This image shows a part of the nebula, with its chaotic jumble of gas and dust.

Robotic 2m Educational Faulkes telescope; Fairchild 486BL CCD camera

JACOB VON CHORUS *(Canada)*, AGED 15 *WINNER*

Pleiades Cluster
[27 August 2011]

JACOB VON CHORUS: This image was a test to see what would happen with such a long exposure. It was taken near dusk, with only two frames and an hour of exposure. This image has since become one of my best.

BACKGROUND: Among the nearest star clusters to Earth, the Pleiades is easily seen with the naked eye in the northern hemisphere's winter skies. While they are often called the Seven Sisters, this beautiful photograph reveals many more of the hot, young stars which comprise the cluster. The young photographer has also captured the swirling wisps of a diaphanous gas cloud through which the cluster is currently passing, lighting it with reflected starlight.

Sky Watcher Equinox 80ED telescope; Celestron CG-5 mount; f/6.25 lens; Stock Canon 100D camera; ISO 800; 30-minute exposure

"The young astrophotographer category has once again produced some stunning results and this shot of the Pleiades (Messier 45) is simply breathtaking. The light from the stars reflects and scatters off the dust to produce the delicate blue-hued nebula you can see here. Jacob has rendered the colours of the nebula and stars beautifully to produce a result that many experienced astrophotographers would be extremely pleased to have achieved."

PETE LAWRENCE

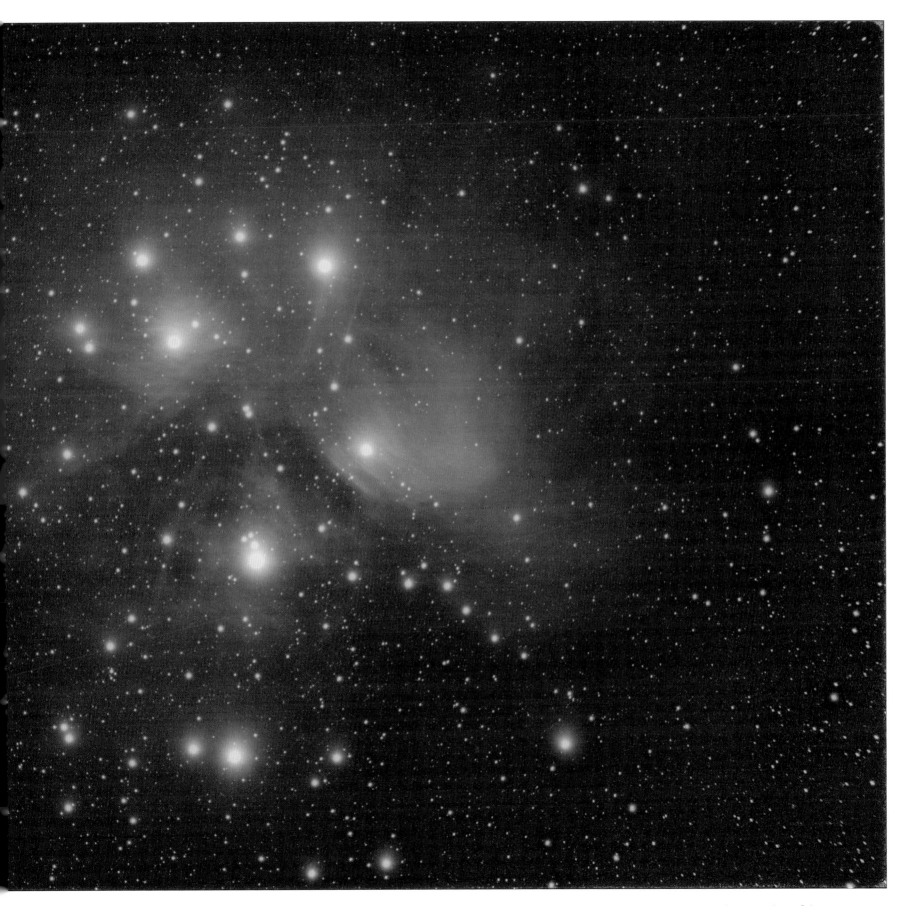

LAURENT V. JOLI-COEUR *(Canada)*, AGED 15 *RUNNER-UP*

Daytime Lunar Mosaic
[*2 October 2010*]

LAURENT V. JOLI-COEUR: I have always wondered why we never see mosaics of the Moon taken under a deep blue sky. I gave myself this challenge and was surprised by the unique result!

BACKGROUND: This young photographer has knitted together several high-resolution images of the Moon in the daytime sky to form a colourful mosaic. This wonderfully detailed view shows the smooth dark *maria* and lighter, bumpier highlands of the Moon, both dotted with craters. The peaceful blue colour of the daytime sky is caused by scattering of blue light in the Earth's atmosphere.

Celestron Nexstar 5SE telescope; Orion StarShoot Solar System Imager III camera

"This is a beautiful, detailed mosaic of the Moon in a lovely blue daytime sky. Another judge mentioned that they particularly liked the ragged edge, with the extent of the individual mosaic frames clearly visible. I agree – the visual representation of the process by which this highly accomplished image has been made makes it more interesting."

OLIVIA JOHNSON

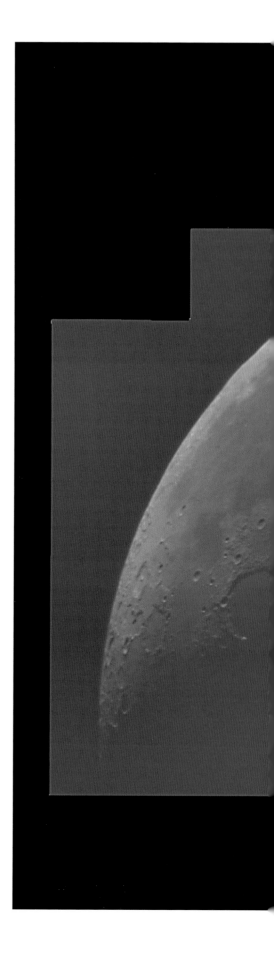

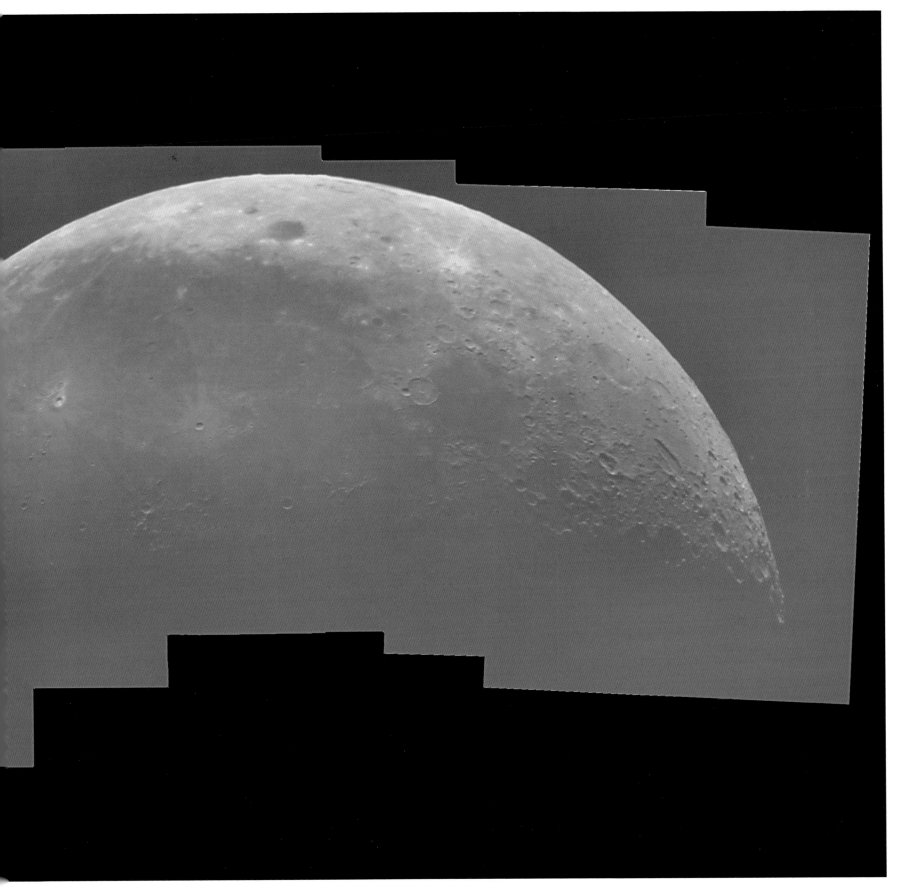

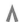

CARL ADAMS-WAITE *(UK)*, AGED 15

Orion, Pleiades, Venus and Jupiter Arc
[27 March 2012]

CARL ADAMS-WAITE: Although this was one of
my first attempts at astrophotography, the rare conjunction of
these celestial bodies over our planet's horizon made it special in
my eyes.

BACKGROUND: To capture this peaceful scene, the young photographer
has travelled away from the city lights which dot the horizon to watch a
celestial parade. On the left are the familiar stars of Orion the hunter,
who seems to stand above the nearby trees. To the right, arranged in an
arc leading towards sunrise, are the Moon, the clustered young stars of
the Pleiades, and the planets Venus and Jupiter.

Canon 1000D camera; Canon 18–55mm EFS f/3.5 lens; ISO 400

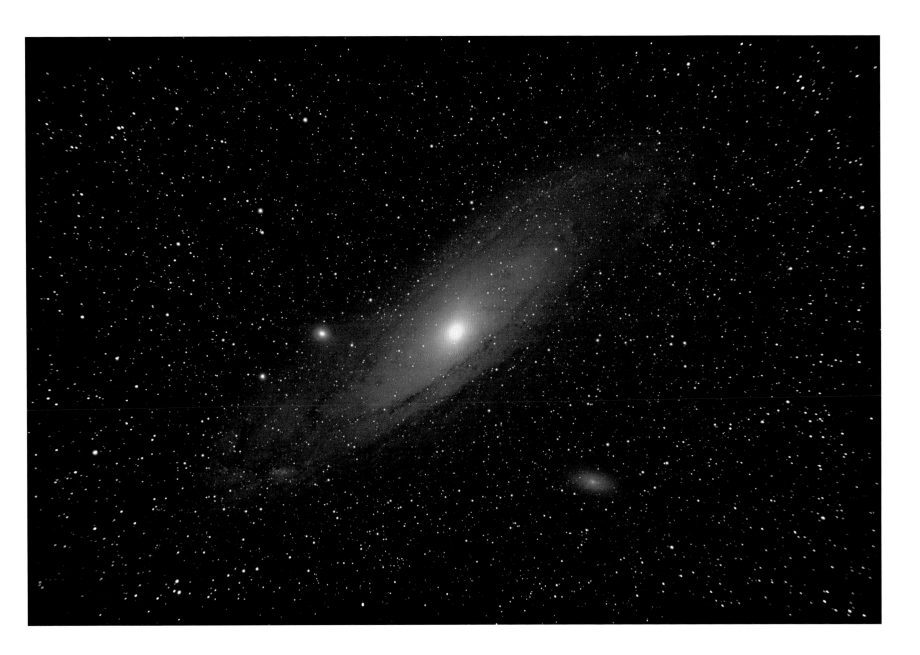

∧

JACOB VON CHORUS *(Canada)*, AGED 15

Andromeda Galaxy
[*4 August 2011*]

JACOB VON CHORUS: I have always liked Messier 31. To obtain this image of M31, also known as the Andromeda Galaxy, two nights of exposure were required. The light pollution made this image very difficult to edit. Eventually, I ended up with an edit I was happy with.

BACKGROUND: Andromeda, our nearest galactic neighbour, is seen here through stars in our own Milky Way. It contains over a trillion stars arranged in a flat disc shape and threaded with dark lanes of dust and gas. This skilful young photographer has produced a wonderfully crisp image of the structures within a huge galaxy, capturing light which has travelled for 2.5 million years to his lens.

Sky Watcher Equinox 80ED telescope; Celestron CG-5 mount; f/6.25 lens; Stock Canon 100D camera; ISO 1600; 10-minute exposure

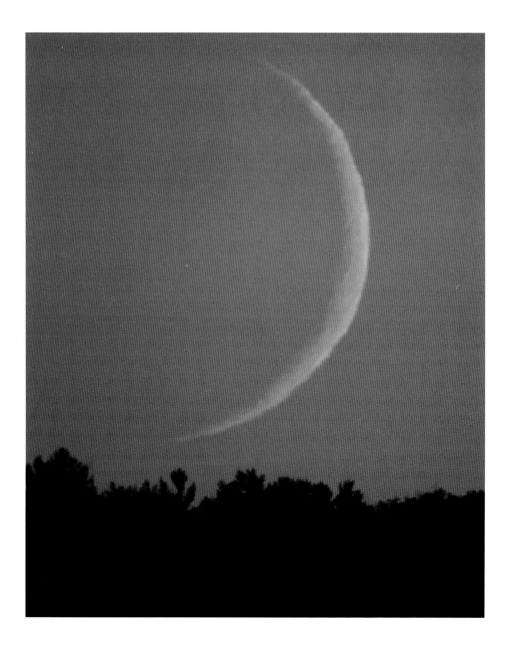

LAURENT V. JOLI-COEUR *(Canada)*, AGED 15

Colorful Moonset
[*10 October 2012*]

LAURENT V. JOLI-COEUR: I walked by a window a few minutes after sunset and was amazed to see this beautiful, two-day-old crescent Moon. I set up my equipment in record time and was able to capture only one image before it disappeared behind the horizon

BACKGROUND: This gorgeous photo by a young photographer shows a crescent Moon just before it sets below the western horizon. The brilliant orange hue is caused by the Earth's atmosphere filtering light from the Sun. At sunset and sunrise, objects near the horizon are viewed through a thick band of atmosphere, which efficiently scatters blue light but transmits the red-orange part of the spectrum.

Celestron Nexstar 5SE telescope; Canon Rebel T1i camera

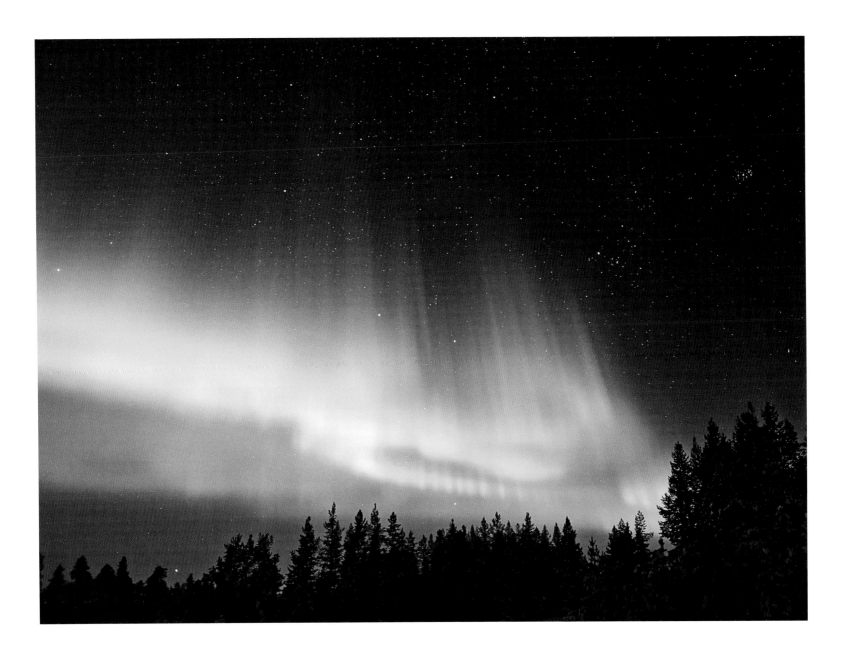

∧

JATHIN PREMJITH *(India)*, **AGED 15** *HIGHLY COMMENDED*

Heavenly Showers
[25 January 2012]

JATHIN PREMJITH: It was breathtaking to see the whole sky filled with
long streams of light and colours in the company of innumerable
twinkling stars when the huge solar storm hit the Earth in January.
I really like this photo because of the variation in colour from red to
glowing green and I have also managed to capture Orion, Taurus,
Procyon, Sirius and the Pleiades.

BACKGROUND: This young photographer has skilfully framed the
streaming, swirling patterns of the Northern Lights with treetops below
and a starry sky above. In the centre of the image. Orion the hunter is
just visible through the bright auroral display. Taurus the bull and the
bright Pleiades star cluster are seen in the clear area to the upper right.

Canon 7D camera; Nikon 14–24mm f/2.8 lens; ISO 800; 10-second exposure

*"A great aurora photo by a talented young photographer. What I
particularly enjoy about this image is the way Orion is just visible, seeming
to stand on the treetops among the swirling curtains of light. The patch
of dark sky containing Taurus and the Pleiades really emphasizes the
colourful aurora – a great composition."*

OLIVIA JOHNSON

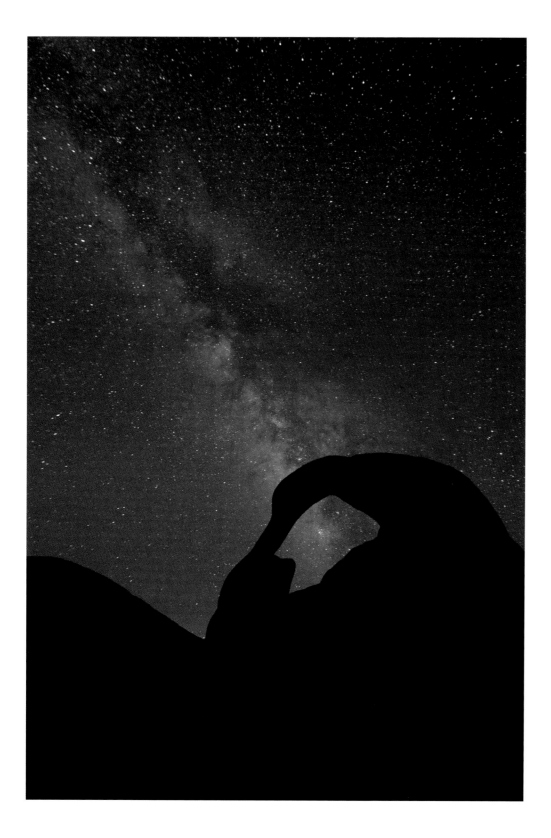

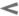

THOMAS SULLIVAN *(USA)*, **AGED 13**

Mobius Arch and Milky Way
[30 June 2012]

THOMAS SULLIVAN: Last year, my Dad, sister and I drove 1000 miles to take cool astronomy photos. This place was my favourite, with dark skies and a bright Milky Way over rock arches.

BACKGROUND: The disc of our Milky Way, containing hundreds of billions of stars and dark clouds of gas and dust, is tethered to Earth by the silhouette of a rock arch in this composition by a young astrophotographer. The faint orange glow along the horizon emphasizes the foreground features and the very dark sky overhead.

Canon 5D Mark II camera; 16 mm f/2.8 lens; ISO 6400; 30-second exposure

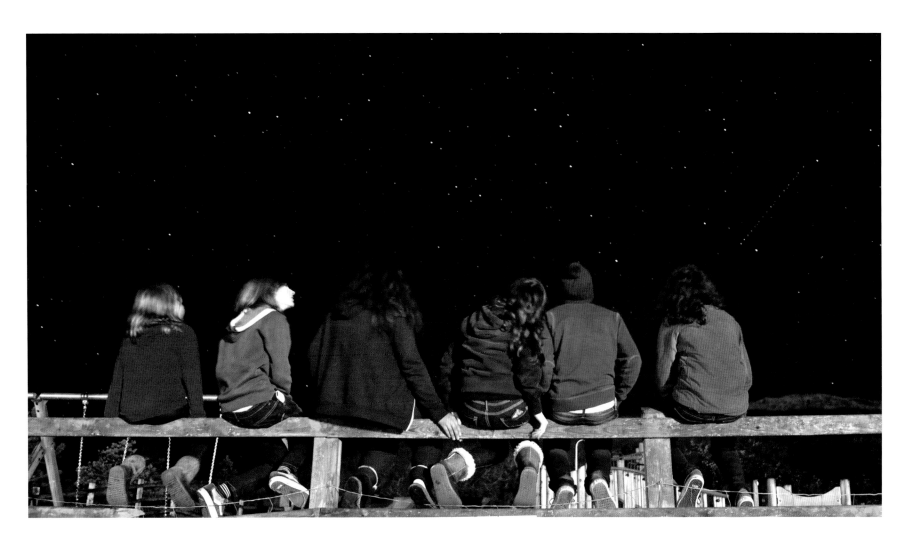

Λ

JESSICA CATERSON *(UK)*, AGED 15

Stargazers
[*27 October 2011*]

JESSICA CATERSON: I took the image on my caravan site in the Gower Peninsula and it is a self-portrait (I am on the far right) with my friends. Since being highly commended last year I have looked more at the stars, and my friends have taken interest too. This is why I like the shot, because it was not just staged, we were genuinely looking up. I took it because that night the stars were great and there were a few comets too.

BACKGROUND: A shared love of astrophotography between friends and some advanced processing techniques were needed to produce this wonderfully evocative image of a stargazing party. Several short exposures were aligned and combined to capture the crisp stars and dark sky, while minimizing trailing due to the Earth's rotation; the visible progress of the aeroplane in the upper right reveals this process. Adding the final frame of the backlit friends gives context to the scene.

Nikon D5000 camera; 18–55mm f/3.5 lens; 20-second exposure

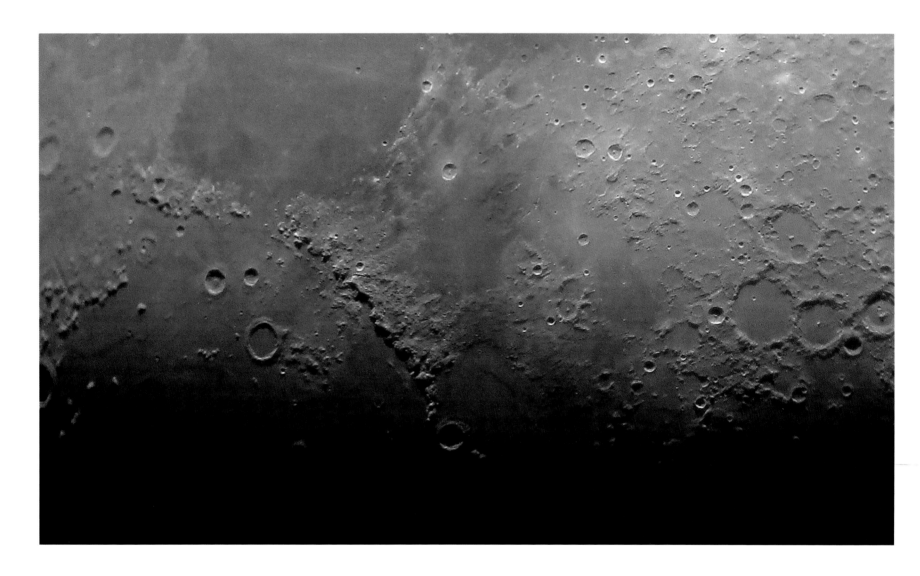

\bigwedge

JACOB MARCHIO *(USA)*, AGED 13 *HIGHLY COMMENDED*

Lunar Mountains
[31 *January* 2012]

JACOB MARCHIO: I like this image because of all the details in the mountains; to me it looked almost like a lunar map image.

BACKGROUND: This skilled young astrophotographer has captured a beautifully sharp and artfully framed detail of the Moon. The terminator – which separates the daytime and night-time parts of the Moon – is aligned with the bottom edge of the photograph. The Sun's light shines at a low angle onto the surface of the Moon just above this line, showing the contrast between smooth *maria* (lunar 'seas') and rugged crater rims to the best advantage.

Canon PowerShot SD1300 IS camera; Orion AstroView 6EQ scope

"A nice, detailed study of a small area of the Moon, which evokes a tactile appreciation of the contrasting textures of the smooth maria and rugged highlights. I also enjoy the way the young astrophotographer has framed the image, with the bright area of the Moon seeming to fade from the bottom up."

OLIVIA JOHNSON

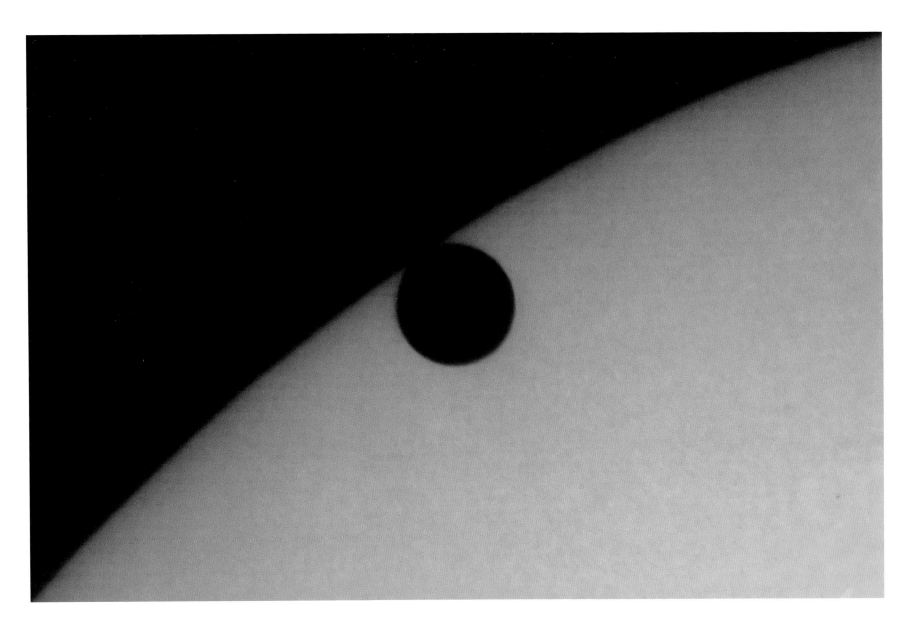

∧

JATHIN PREMJITH (India), AGED 15

The 'LOVE'ly Touch
[6 June 2012]

JATHIN PREMJITH: Transits of Venus are among the rarest of predictable celestial phenomena. I was very particular to capture the 'Black drop effect', in which a small 'teardrop' appears to connect Venus's disc to the solar disc, before the third contact. Also, Venus is the Roman goddess of love and beauty, hence the name: The 'LOVE'ly Touch.

BACKGROUND: Precise timing and artful framing were both needed to produce this highly technical yet beautiful image of a once-in-a-lifetime event, the 2012 transit of Venus. The young photographer has captured the moment of 'second contact', when the full dark disc of Venus is visible against the bright disc of the Sun for the first time. There will not be another opportunity to observe this phenomenon until December 2117.

Celestron CPC 800 Schmidt-Cassegrain telescope; TeleVue 4x Powermate lens; Canon 7D camera; ISO 2500; 1/640-second exposure

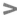

Origins of Life on Earth
[19 *June* 2012]

THOMAS SULLIVAN: All life on Earth contains material from the stars, including bristlecone pines up to 4844 years old! The light is from my Dad taking a picture to the side.

BACKGROUND: Earth and space are evenly weighted in this wonderfully framed image of a Californian landscape beneath the Milky Way. The young photographer has chosen a view in which the sloping trunk and gnarled branches of the ancient tree provide perfect counterpoint to the edge-on view of the starry disc and knotted structure of our galaxy.

Canon 5D Mark II camera, 16mm f/2.8 lens; ISO 6400; 30-second exposure

"A beautiful take on a popular location. The colour of the sky and shadow on the tree contrast nicely with the Earth. Well composed."

MELANIE GRANT

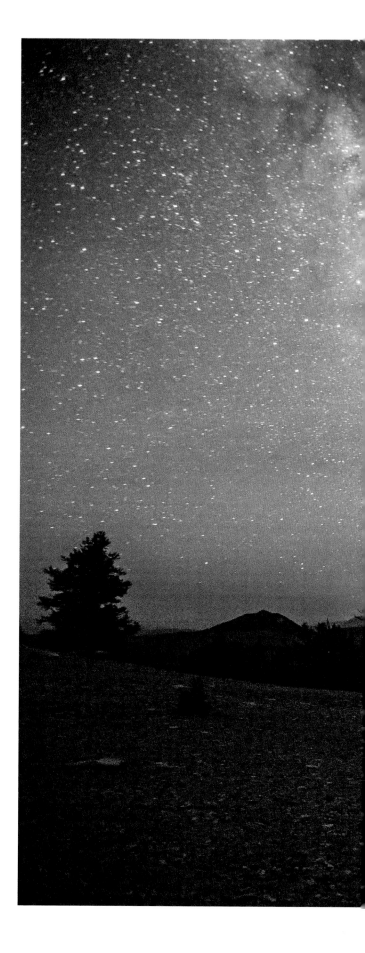

Sky at Night MAGAZINE

GUIDE TO ASTROPHOTOGRAPHY

> YOUR FIRST PHOTO OF THE STARS

Capture the night sky with nothing more than a compact camera and a tripod.

The night sky is just waiting to be captured, and you can take great pictures of it with simple equipment. Many of us have a compact camera, so why not turn it on the night sky? Today's compacts can take reasonable images in low-light conditions.

The ability to adjust a camera's settings for yourself will make for much improved images. With the Canon PowerShot compact, you can keep the camera's shutter open to the starlight for up to 15 seconds, and make its imaging chip very sensitive to light, with ISO values up to 3200. The Nikon Coolpix P500 also allows for manual shooting at these high ISO values.

DSLR (Digital Single Lens Reflex) cameras offer a much wider range of functions, and most experienced astrophotographers will have one in their arsenal. They have the widest range of settings, providing full manual control. They also have interchangeable lenses so you can swap to a more powerful lens to get close in on a bright star cluster or a faint nebula, and wide ISO sensitivity ranges, allowing the faint light from many more stars to be recorded for great results.

With a DSLR you can set the opening of the camera's shutter – the exposure – in increments of seconds up to 30 seconds. After that, they'll have a manually controlled bulb or 'B' setting for even longer exposures – great for capturing star trails. In our equipment reviews at *Sky at Night Magazine*, Canon and Nikon DSLRs have performed well. The Canon 1100D, 550D and 600D models are all good entry-level DSLRs for astrophotography, as is the Nikon D3000 and D90. Fuji's S3 Pro has also performed well in our tests.

To take nightscapes you also need a tripod to give you the stability for vibration-free long exposures. Exposures over one-thirtieth of a second will start to lose sharpness and show camera shake – it is very difficult to hand-hold a camera for long periods. Sturdy tripods are best, even if they are more expensive, since lightweight tripods can still shake slightly with just a breeze and this will spoil any nightscapes you take. Makes to consider include SLIK, Manfrotto and Velbon.

And there's one more thing to consider too: you can't simply press the shutter release button. You'll need a remote shutter release cable to do this. The act of pressing the shutter release to take the picture can move the camera enough to shake the image. A remote shutter-release cable can make a big difference between a shaky picture and a shot with pin-sharp stars.

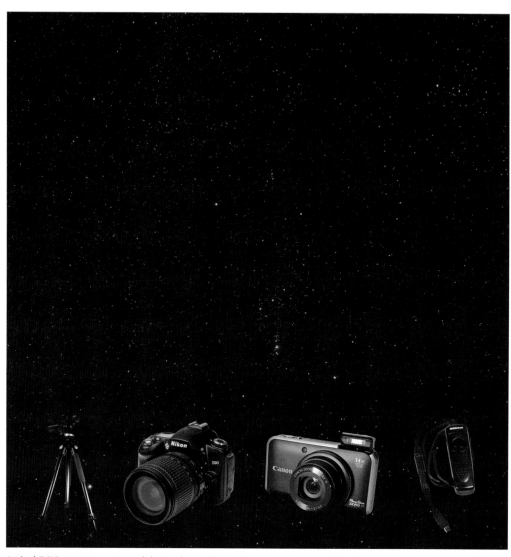

A tripod, DSLR or compact camera and shutter release cable are all you need to get started. With these you can take great pictures of the stars and constellations. (picture – Sky at Night Magazine/Will Gater)

TARGET PRACTICE

With a DSLR and tripod there are many night-sky targets you can capture using your camera's basic settings

Aurorae

Images of the Northern Lights will benefit from long exposures of between 3 and 30 seconds, making the green and red colours appear more vivid than if you were looking at them with your own eyes.

Conjunctions

Conjunctions are when two or more bright planets appear close together in a twilight sky. These are a great target for testing out your camera's auto settings.

Milky Way

During summer and early autumn, the swarm of stars in our home galaxy cuts high across the night sky. Take exposures between 15 and 40 seconds long from a really dark site.

TAKING PHOTOS WITH A TELESCOPE
Image fainter and further into space with a scope and some key accessories

> Accessories
To fit a DSLR into your telescope's focuser you need two accessories: a 'T-mount' adapter ring specific to your camera make, which sits in place of the lens on the DSLR's body (pictured); and an eyepiece barrel to slot into the focuser. If your scope accepts it, a 2-inch barrel is best. The barrel screws into the adapter ring.

> Mount
For sharp photos of faint night-sky objects, you'll need to open the camera shutter for quite a long time, sometimes for several minutes. As the stars appear to move through the night this can introduce blurring, unless you have a driven equatorial mount that tracks the stars' movement, like the Celestron CG-5 computerized mount (£699) or the Sky-Watcher EQ5 Pro Skyscan mount (£579; pictured).

> Software
Even great astro images can be made better with some careful editing in photo-editing software, such as GIMP and DeepSkyStacker (free), Photoshop Elements (£58), or Photoshop (£652). You can also use programs to help you plan when night-sky targets are best placed for imaging with software such as Stellarium (free; pictured) or Starry Night (from £51.50).

> Telescope
Connected to a DSLR, a telescope acts just like a telephoto lens. For good shots, choose a scope with a focal length between 400 and 2000 mm, that has good colour correction and doesn't distort the light passing through it. A solid, lockable and rotatable focuser is also desirable. Models include the William Optics ZenithStar ZS70 (£369) and the Sky-Watcher Quattro f/4 Imaging Newtonian (£599).

all pictures – *Sky at Night Magazine*

V ASTRO IMAGING WITH A DSLR
Master your camera to take the best night-sky shots

DSLRs are great for astro imaging because they are so flexible. The interchangeable camera lenses alone can give a wide range of magnifications, giving views similar to what you'd take in with your own eyes right up to what you'd see through a pair of binoculars. Their ability to take long exposures at light-sensitive, high ISO values means that from a dark site they can also capture vistas of the Milky Way that can't be seen by the naked eye. This is because when light reaches the eye, it sends signals immediately to the brain. But with a long exposure, light can build up on a camera's sensor before the shutter comes down.

A DSLR camera's auto settings aren't so good for the night sky. When it's dark, these auto routines find it hard to cope with the low light levels. Instead, use manual settings to control the ISO, exposure and lens aperture when taking shots of the heavens. The best way to do this is to bracket your exposures: take a range of different exposure lengths at various ISO values to see which produces the image with the best overall balance between sky darkness and star brightness. Try exposing for 5 seconds either side of an initial exposure of 15 to 20 seconds.

First, attach your camera to a tripod and plug in the remote shutter release cable. If you don't have one, use the camera's delayed timer setting. From a moderately dark site, you can get a good picture of a constellation such as Leo with a 50 mm focal-length lens by setting the ISO to 400, and using an exposure of 15 seconds (use the bulb setting if the long exposure range is limited). Set the lens aperture to a wide f-number of f/1.8 or f/2. Once you've taken the image, check it for elongated stars. If there is any of this 'star trailing', take another picture with the same settings but with an exposure of 10 seconds.

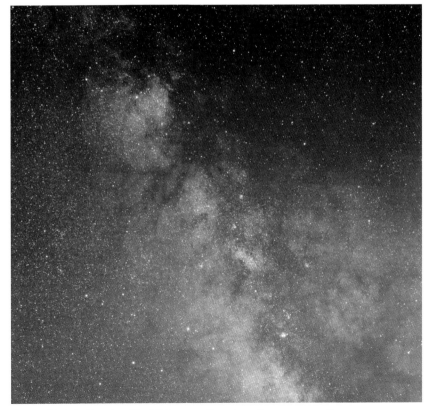

Pictures of the Milky Way taken with a DSLR camera will reveal more than you can see with your eyes. (picture – Will Gater)

Placing objects in the foreground of your nightscape shot can create a nice composition. (picture – Will Gater)

Λ CAPTURING CONSTELLATIONS
How to take stunning photos of the shapes in the stars

The night sky is full of patterns – constellations that have helped civilizations from the ancient Greeks and Romans to the Aboriginal Australians find their way round the night sky. Photographing the constellations is a great way to start taking astrophotos – you'll end up with some captivating images and learn your way around the night sky too.

It's not just constellations that make recognizable patters in the sky. Asterisms, such as the Plough in the constellation of Ursa Major, also make good, identifiable photo subjects. These familiar patterns typically consist of the brightest stars in a constellation, omitting the fainter stars that make up a constellation's main shape. Another nice asterism to train your camera on is the Sickle in Leo, which looks like a back-to-front question mark. The swarm of stars that is the Milky Way makes for a good target too, especially during the summer and early autumn, when the band of our galaxy cuts high across the night sky.

When they're high in the sky, constellations are ideal if you want to create an uncluttered photograph. But they can also look great when they're low on the horizon, either rising or setting. Adding a foreground object into the frame can really enhance the look of your nightscape photos too – experiment with houses, trees, people and your surrounding landscape.

Let's look at how we'd take a picture of the Sickle asterism in Leo with a DSLR camera. First, mount your camera on a tripod and attach the remote shutter release cable. Then set the aperture to its widest setting (the smallest f-number), choose an ISO setting of 400 and an exposure between 10 and 30 seconds long. Finally, press the shutter release to take the picture.

If you need to use the bulb setting, it's useful to have a watch that you can keep an eye on to check when to release the shutter. Once taken, have a look at the image on the camera's back screen and use the zoom function to see whether the stars in the image are sharp. If they look a bit blurred, try making the aperture smaller by one f-number and increasing the exposure time. To capture more stars you can increase the ISO to a higher value, but remember that if you're photographing from a light-polluted area, increasing the imaging chip's sensitivity will also increase the amount of orange streetlight glow that's picked up in the photo.

COMPOSITION
Your shots will benefit from some artistic licence

To complement the star field or constellation in your picture, include an object in the foreground, such as trees, buildings with lit windows, dramatic landscapes, telescopes or people.

Use a red- or white-light torch or camera flash to illuminate the foreground; combining this with a longer exposure will still reveal the stars. You can even get one person to appear in several places in the photograph. Give them a torch, get them to stand still with the torch on, and then switch it off while they move to a new position, before turning the torch on again. In the finished photo, they will appear in several places at once.

A twilight sky can add drama by producing a lighter background sprinkled with stars, enabling you to silhouette a foreground object. Cities and towns taken from a high vantage point can also be used to great effect in wide-field shots. There are a few things that won't work though, like nearby streetlights or security lights. Light from these interferes with the image and can create distracting blobs of light called lens flares. In extreme cases it can wash out the colour and reduce contrast in your pictures.

v IMAGING THE MOON
Capture lunar seas and craters with a telescope and a point-and-shoot camera

One way to take an image of the Moon with a scope is by holding a point-and-shoot camera up to the eyepiece and clicking away. This method is known as 'afocal photography' or sometimes 'digiscoping', and with it you can take shots of the whole of the Moon's disc so that it fills the picture frame.

It can be a little fiddly positioning the camera over the eyepiece. But once you've overcome that, you can get some very pleasing results. The great thing about this method is that it's simple and, if you already have the camera and telescope, you don't need any extra specialist equipment. That being said, there are several things you can do to make your afocal lunar photography more effective. The first is to place your camera – be it a DSLR or a point-and-shoot – on a tripod. This way you won't wobble and spoil the shot when positioning the camera lens to look down the eyepiece. Similarly, using the camera's delayed timer setting or a remote shutter release cable will reduce the likelihood of you blurring the image when you press the shutter button.

You can also buy a specialist accessory called a digiscoping bracket that clamps to the eyepiece end of the telescope. It enables you to position your camera sturdily over the eyepiece. This is the best way to take an afocal photo of the Moon: it's a better solution than using a separate tripod for the camera since, once in place, it will move with the scope.

It's also important to choose the right eyepiece to use. An eyepiece with a tiny lens opening can be difficult to point your camera through. It's best to try out different eyepieces with your camera, seeing which gives the best results; a good place to start would be a standard 20–30 mm Plössl eyepiece.

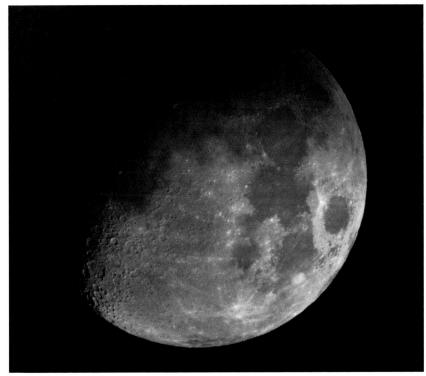

Using a compact camera and a telescope to take afocal images of the Moon can reveal a lot of detail.

(picture – Sky at Night Magazine)

CAPTURE STAR TRAILS
Four easy steps to a long-exposure photo that reveals the circular movement of stars through the night

➤ 1 Equipment
Wide-angle and standard lenses give the best results for star trails. Select your lens and fix your camera to a tripod. Adjust the tripod legs so that they provide a solid base. Attach the remote shutter release so you don't vibrate the camera when taking the shot.

Sky at Night Magazine

➤ 2 Camera settings
Set your lens aperture wide to f/1.8 or f/2 and select ISO 400, then switch the camera to 'bulb' mode so there's no limit to the length of the exposure, and focus. Make sure your flash is disabled and switch on the long exposure noise reduction if your camera has it.

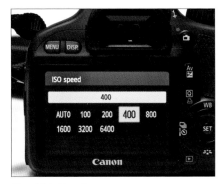

Sky at Night Magazine

➤ 3 Subject
As the Earth spins on its axis, the stars appear to rotate around Polaris, the star almost exactly on the north celestial pole. Star trails will come out shorter near Polaris and its constellation of Ursa Minor, and longer at constellations such as Orion which are nearer the celestial equator. Compose your shot depending on which trails you want in your photo.

Sky at Night Magazine

➤ 4 Capture and review
Take exposures of 5, 10, 20 and 30 minutes and notice how the star trails get progressively longer. If the sky is too bright, reduce the ISO to 100 or 200 and narrow the aperture to f/4 or f/5.6. Exposures of 3 to 4 hours or more reveal the sky's circular rotation, but can also pick up an orange glow from light pollution.

Will Gater

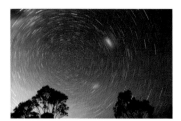

COVER AND 16
TED DOBOSZ *(Australia)*
Star Trails, Blue Mountains

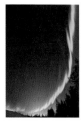

17
VINCENT MIU *(Australia)*
Venus, Jupiter and Moon Trails
over the Nepean River

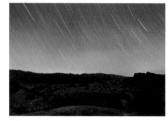

18
KARL JOHNSTON *(Canada)*
Bow of Orion

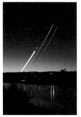

19
NIKHIL SHAHI *(USA)*
Death Valley Star Trails

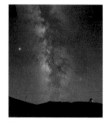

21
NIK SZYMANEK *(UK)*
Milky Way

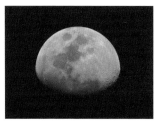

22
MICHAEL O'CONNELL
(Ireland)
Blue Sky Moon

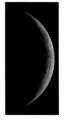

23
NICK SMITH *(UK)*
3.1 Day-old Moon

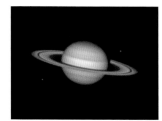

24
ETHAN ALLEN *(USA)*
Saturn

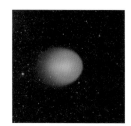

25
NICK HOWES *(UK)*
Comet Holmes

27
NICK SMITH *(UK)*
Clavius-Moretus Mosaic

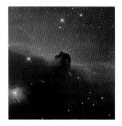

29
MARTIN PUGH *(UK/Australia)*
Horsehead Nebula (IC 434)

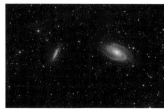

30
EDWARD HENRY *(USA)*
Galaxies M81 and M82

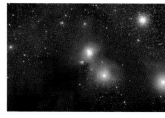

31
MARTIN PUGH *(UK/Australia)*
Galactic Dust in Corona Australis

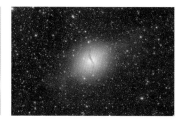

32
MICHAEL SIDONIO *(Australia)*
Centaurus A: Ultra-Deep Field

33
THOMAS DAVIS *(USA)*
Eta Carina Nebula

34
PAUL SMITH *(Ireland)*
Occultation of Venus

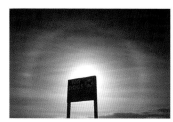

35
SARAH GILLIGAN *(UK)*
No Dogs on Beach

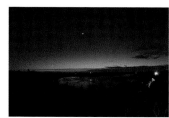

36
PAUL SMITH *(Ireland)*
Venus

37
BEN FERNANDO *(UK)*
Mercury and the Crescent Moon

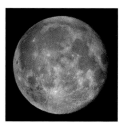

39
JATHIN PREMJITH *(India)*
Full Moon

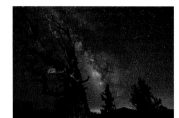

43
TOM LOWE *(USA)*
Blazing Bristlecone

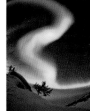

44
DAVE BROSHA *(Canada)*
Whisper of the Wind

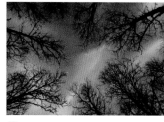

45
FREDRIK BROMS *(Sweden)*
Surrounded by Space

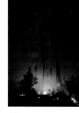

46
LARRY ANDREASEN *(USA)*
Primal Wonder

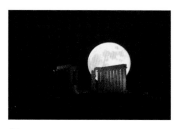

47
ANTHONY AYIOMAMITIS
(Greece)
Solstice Full Moon over Sounion

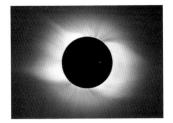

48
ANTHONY AYIOMAMITIS
(Greece)
Siberian Totality

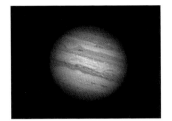

49
NICK SMITH (UK)
Jupiter

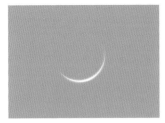

50
RICHARD HIGBY (Australia)
The Green Visitor – Comet Lulin

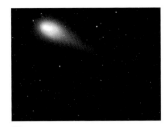

51
LORENZO COMOLLI (Italy)
The Crescent Venus

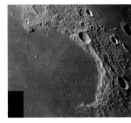

53
NICK SMITH (UK)
Sinus Iridum

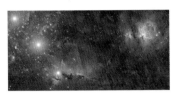

54
ROGELIO BERNAL ANDREO
(USA)
Orion Deep Wide Field

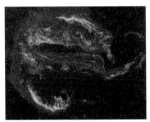

55
MARTIN PUGH (UK/Australia)
The Veil Nebula in Cygnus

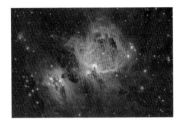

56
MARCUS DAVIES (Australia)
The Sword and the Rose
(Orion's Sword and M42)

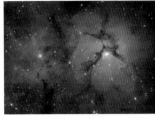

57
EDDIE TRIMARCHI (Australia)
The Trifid Nebula (M20)

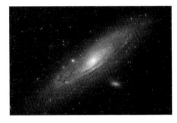

59
EDWARD HENRY (USA)
The Andromeda Galaxy (M31)

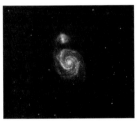

54
ROGELIO BERNAL ANDREO
(USA)
Orion Deep Wide Field

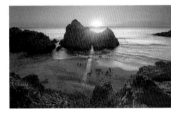

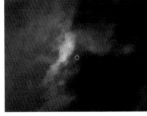

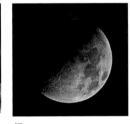

61
KEN MACKINTOSH (UK)
The Whirlpool Galaxy (M51)

63
STEVEN CHRISTENSON (USA)
Photon Worshippers

65
DHRUV ARVIND PARANJPYE
(India)
A Perfect Circle

66
LAURENT V. JOLI-COEUR
(Canada)
Solar Halo

67
JATHIN PREMJITH (India)
Half-Moon Terminator

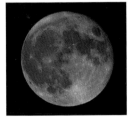

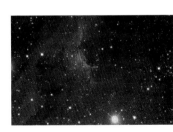

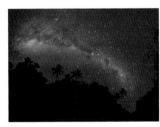

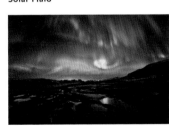

68
DANIEL MORTIMER (UK)
A Detailed Full Moon

69
ELIAS JORDAN (USA)
The Pelican Nebula Up-Close

73
TUNÇ TEZEL (Turkey)
Galactic Paradise

74
OLE C. SALOMONSEN (Norway)
Divine Presence

75
ÖRVAR ATLI ÞORGEIRSSON
(Iceland)
Volcanic Aurora

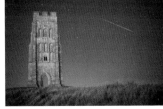

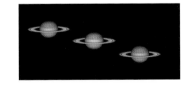

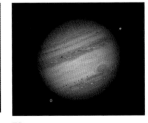

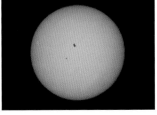

76
ANDREW STEELE (UK)
Red Moon rising over Oxford

77
MIKE KEMPSEY (UK)
Meteor at Midnight,
Glastonbury Tor

79
DAMIAN PEACH (UK)
Jupiter with Io and Ganymede,
September 2010

80
PAUL HAESE (Australia)
Dragon Storm

81
DANI CAXETE (Spain)
ISS and Endeavour
Crossing the Sun

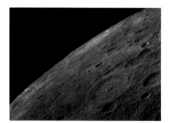

82
GEORGE TARSOUDIS (*Greece*)
Crater Petavius

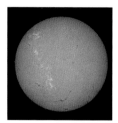

83
PETER WARD (*Australia*)
May 7th Hydrogen-Alpha Sun

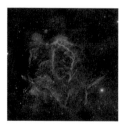

85
MARCO LORENZI (*Italy*)
Vela Supernova Remnant

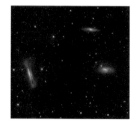

86
EDWARD HENRY (*USA*)
Leo Triplet

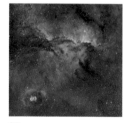

87
MICHAEL SIDONIO (*Australia*)
Fighting Dragons of Ara
(NGC 6188 and 6164)

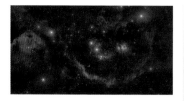

88
ROGELIO BERNAL ANDREO
(*USA*)
Orion, Head to Toe

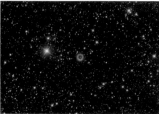

89
STEVE CROUCH (*Australia*)
Planetary Nebula Shapley 1

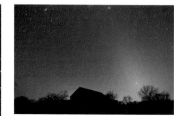

91
HARLEY GRADY (*USA*)
Zodiacal Light on the Farm

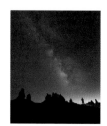

92
JEFFREY SULLIVAN (*USA*)
Stargazing

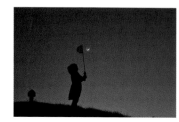

93
JEAN-BAPTISTE FELDMANN
(*France*)
Hunting Moon

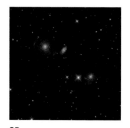

95
MARCO LORENZI (*Italy*)
Shell Galaxies
(NGC474 and NGC467)

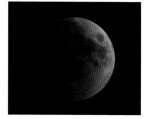

97
JATHIN PREMJITH (*India*)
Lunar Eclipse and Occultation

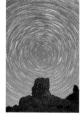

98
NICOLE SULLIVAN (*USA*)
Starry Night Sky

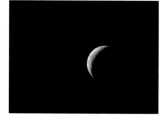

99
PETER PIHLMANN PEDERSEN
(*UK*)
Lonely Moon

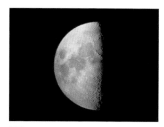

100
TOM CHITSON (*UK*)
First-Quarter Moon

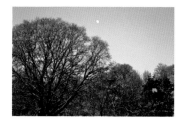

101
JESSICA CATERSON (*UK*)
Winter's Moon

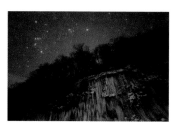

105
MASAHIRO MIYASAKA (*Japan*)
Star Icefall

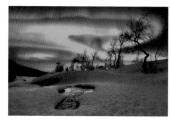

107
ARILD HEITMANN (*Norway*)
Green World

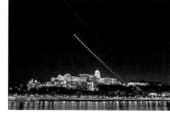

108
TAMAS LADANYI (*Hungary*)
Moon and Planets over Budapest

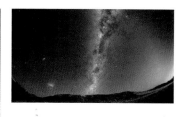

109
LUIS ARGERICH (*Argentina*)
Sources of Light

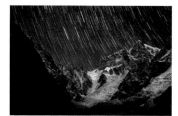

110
ATISH AMAN (*India*)
Star Trails over
Moonlit Himalayas

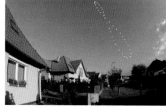

111
TAMAS LADANYI (*Hungary*)
Analemma over Hungary

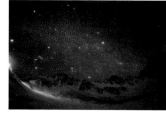

112
MASAHIRO MIYASAKA (*Japan*)
Christmas Stars Diamond

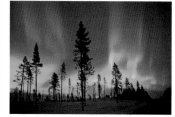

113
ANTONY SPENCER (*UK*)
Kiruna Aurora

114
BRAD GOLDPAINT (*USA*)
Galileo's Muse

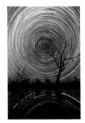

115
WAYNE ENGLAND *(Australia)*
Concentricity

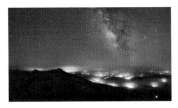

117
TUNÇ TEZEL *(Turkey)*
Sky away from the Lights

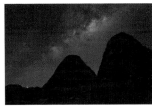

118
COLIN LEGG *(Australia)*
Galactic Domes

119
THOMAS O'BRIEN *(USA)*
Double Arch with a Perseid
Meteor and the Milky Way

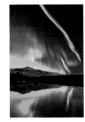

120
TOMMY ELIASSEN *(Norway)*
Sky Show

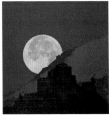

121
STEFANO DE ROSA *(Italy)*
Full Moon setting behind
the Alps

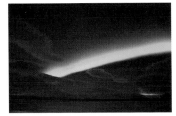

122
DEREK SHERWIN *(UK)*
Aurora over Lake Myvatn, Iceland

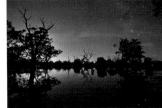

123
WAYNE ENGLAND *(Australia)*
Moonrise

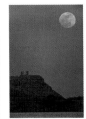

124
ANTHONY AYIOMAMITIS *(Greece)*
Super-Full Moon 2012 over
Cape Sounion

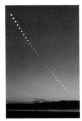

125
RICK WHITACRE *(USA)*
Strand of Pearls

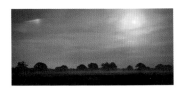

126
ANDREW STEELE *(UK)*
Shropshire Paraselene

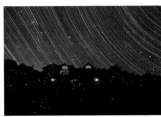

127
MICHAEL A. ROSINSKI *(USA)*
Summer Nights in Michigan

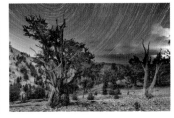

129
HAROLD DAVIS *(USA)*
Distant Night Storm in the
Patriarch Grove

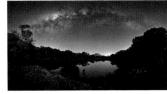

130
LUC PERROT *(Réunion Island)*
The Milky Way View from the
Piton de l'Eau, Réunion Island

131
LUIS ARGERICH *(Argentina)*
The Rise of the Giant Emu

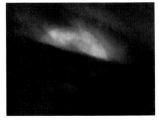

133
CHRIS WARREN *(UK)*
Transit of Venus 2012 in
Hydrogen-Alpha

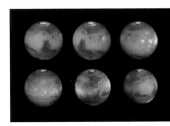

135
DAMIAN PEACH *(UK)*
Mars in 2012

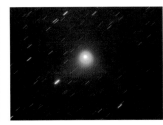

136
GRAHAM RELF *(UK)*
Comet C/2009 P1 (Garradd)

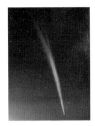

137
PHIL HART *(Australia)*
Lovejoy's Tail

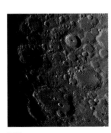

138
MICK HYDE *(UK)*
Tycho to Clavius

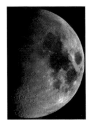

139
DAVID CAMPBELL *(UK)*
116 megapixel Moon Mosaic

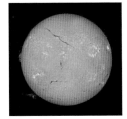

140
PAUL HAESE *(Australia)*
Active Sol

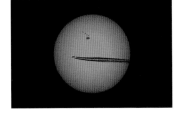

141
DUNJA ZUPANIC *(Croatia)*
Sunny Airlines

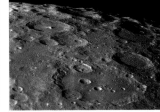

142
GEORGE TARSOUDIS *(Greece)*
The South Pole Area with the
Great Crater Clavius

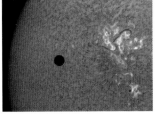

143
TED DOBOSZ *(Australia)*
Venus Transit of Sun in H-Alpha
Band

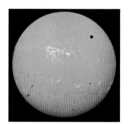

144
PAUL HAESE *(Australia)*
Venus Transit

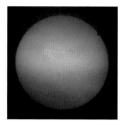

145
CHRIS WARREN *(UK)*
Transit of Venus 2012 in
Hydrogen-Alpha (Stacked)

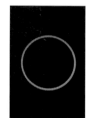

146
TED DOBOSZ *(Australia)*
Sun in H-Alpha Band

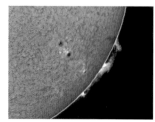

147
PHIL MCGREW *(USA)*
Annular Eclipse

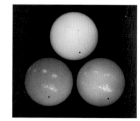

148
PETER J. WARD *(Australia)*
Tri-colour Transit

149
GEORGE TARSOUDIS *(Greece)*
The Great Area of the
Crater Tycho

150
PAUL HAESE *(Australia)*
Saturn 2012

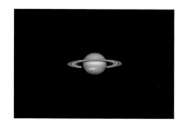

151
TROY TRANTER *(Australia)*
Saturn Super Storm

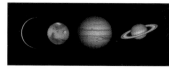

152
DAMIAN PEACH *(UK)*
Worlds of the Solar System

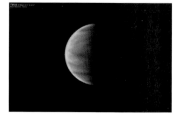

153
GEORGE TARSOUDIS *(Greece)*
Planet Venus 2012

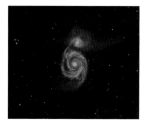

155
MARTIN PUGH *(UK/Australia)*
M51 – The Whirlpool Galaxy

156
ROGELIO BERNAL ANDREO
(USA)
Simeis 147 Supernova Remnant

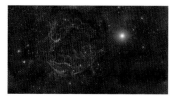

157
BILL SNYDER *(USA)*
IC 1396 – Elephant-Trunk Nebula

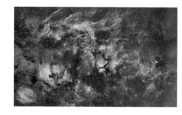

158
J.P METSÄVAINIO *(Finland)*
Cygnus

159
ROBERT FRANKE *(USA)*
The Perseus Cluster – Abell 426

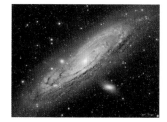

160
AGGELOS KECHAGIAS *(Greece)*
The Andromeda Galaxy

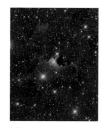

161
OLEG BRYZGALOV *(Ukraine)*
Sarpless-136: 'Ghost' in Cepheus

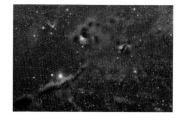

162
LEFTERIS VELISSARATOS *(Greece)*
IC 359 & UG C2980 Spiral

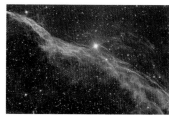

163
ROBERT FRANKE *(USA)*
NGC 6960 – The Witch's Broom

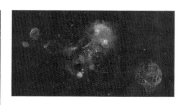

164
J.P. METSÄVAINIO *(Finland)*
Auriga Panorama

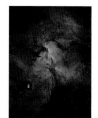

165
MARTIN PUGH *(UK/Australia)*
NGC 6188

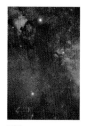

166
BRENDAN ALEXANDER *(Ireland)*
The Wing of the Swan

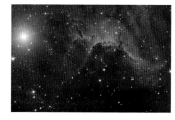

167
GEORGE VIDOS *(Greece)*
IC 5067 – The Pelican Nebula

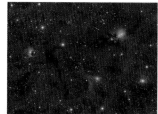

168
LEONARDO ORAZI *(Italy)*
From Aries to Perseus

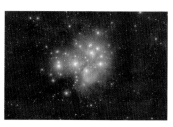

169
TOM O'DONOGHUE *(Ireland)*
The Pleiades Star Cluster in
Taurus

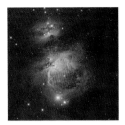

170
MICHAEL SIDONIO *(Australia)*
The Smoking Sword

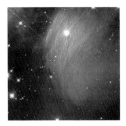

171
LEONARDO ORAZI *(Italy)*
Merope Reflection Nebula

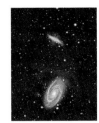

172
JULIAN HANCOCK *(UK)*
M81–82 HaLRGB

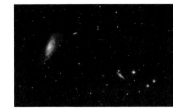

173
LÓRÁND FÉNYES *(Hungary)*
M106, NGC 4217, 4226, 4231, 4232

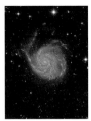

174
OLEG BRYZGALOV *(Ukraine)*
M101 – The Pinwheel Galaxy and
Supernova SN 2011fe

175
ROLF OLSEN *(New Zealand)*
The Circumstellar Disc around
Beta Pictoris

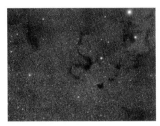

176
VANGELIS SOUGLAKOS *(Greece)*
Snake Nebula

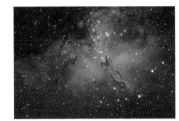

177
BILL SNYDER *(USA)*
M16 – Eagle Nebula Hybrid
Image

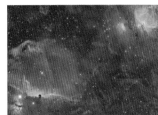

178
AGGELOS KECHAGIAS *(Greece)*
Horse and Orion Wide Field

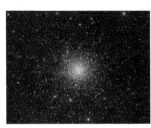

179
ROLF OLSEN *(New Zealand)*
The Nearest Globular –
Messier 4 in Scorpius

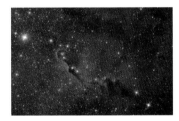

181
LÓRÁND FÉNYES *(Hungary)*
Elephant's Trunk with Ananas

182
SIMON BELCHER *(UK)*
Moonrise over Snowdonia

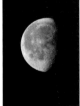

183
PHIL MCGREW *(USA)*
Space Station Flies
across the Moon!

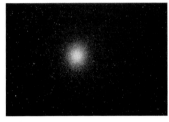

184
PAULA RITCHENS *(Australia)*
Omega Centauri NGC 5139

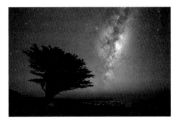

185
MARK GEE *(New Zealand)*
Tree under the Stars

186
SCOTT TULLY *(USA)*
Venus and Pleiades in
Zodiacal Light

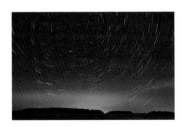

187
KEVIN PALMER *(USA)*
Aurora and Star Trails

188
LAURENT LAVEDER *(France)*
Facing Venus-Jupiter
Close Conjunction

189
MIGUEL CLARO *(Portugal)*
It's Raining Stars

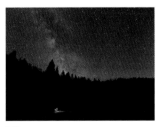

191
STEVEN CHRISTENSON *(USA)*
Lost in Yosemite [C 033706]

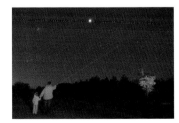

192
TAMAS LADANYI *(Hungary)*
Mira mira Mira

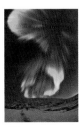

193
OLE C. SALOMONSEN *(Norway)*
Celestial Illumination

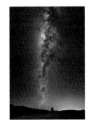

194
LUC PERROT *(Réunion Island)*
The Milky Way from the
Volcano Road

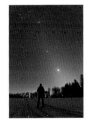

195
JACK FUSCO *(USA)*
Zodiacal Light and Man

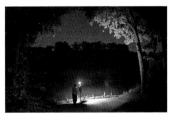

197
TAMAS LADANYI *(Hungary)*
Photographer and Jupiter

198
THOMAS READ (UK)
The Sunflower Galaxy

199
NICK HOWES (UK)
The Heart of the Spider

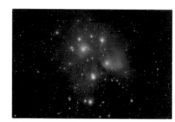

201
JACOB VON CHORUS (Canada)
Pleiades Cluster

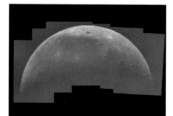

203
LAURENT V. JOLI-COEUR
(Canada)
Daytime Lunar Mosaic

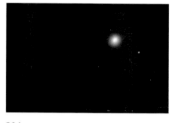

204
CARL ADAMS-WAITE (UK)
Orion, Pleiades, Venus and
Jupiter Arc

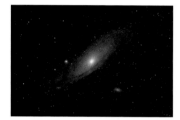

205
JACOB VON CHORUS (Canada)
Andromeda Galaxy

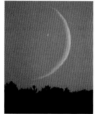

206
LAURENT V. JOLI-COEUR
(Canada)
Colorful Moonset

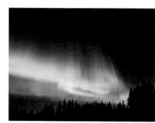

207
JATHIN PREMJITH (India)
Heavenly Showers

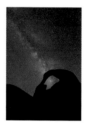

208
THOMAS SULLIVAN (USA)
Mobius Arch and Milky Way

209
JESSICA CATERSON (UK)
Stargazers

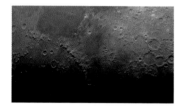

210
JACOB MARCHIO (USA)
Lunar Mountains

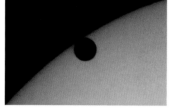

211
JATHIN PREMJITH (India)
The 'LOVE'ly Touch

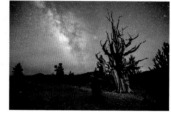

213
THOMAS SULLIVAN (USA)
Origins of Life on Earth